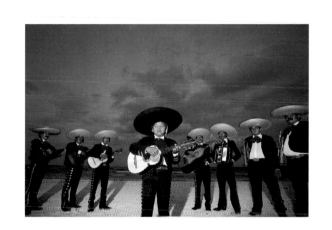

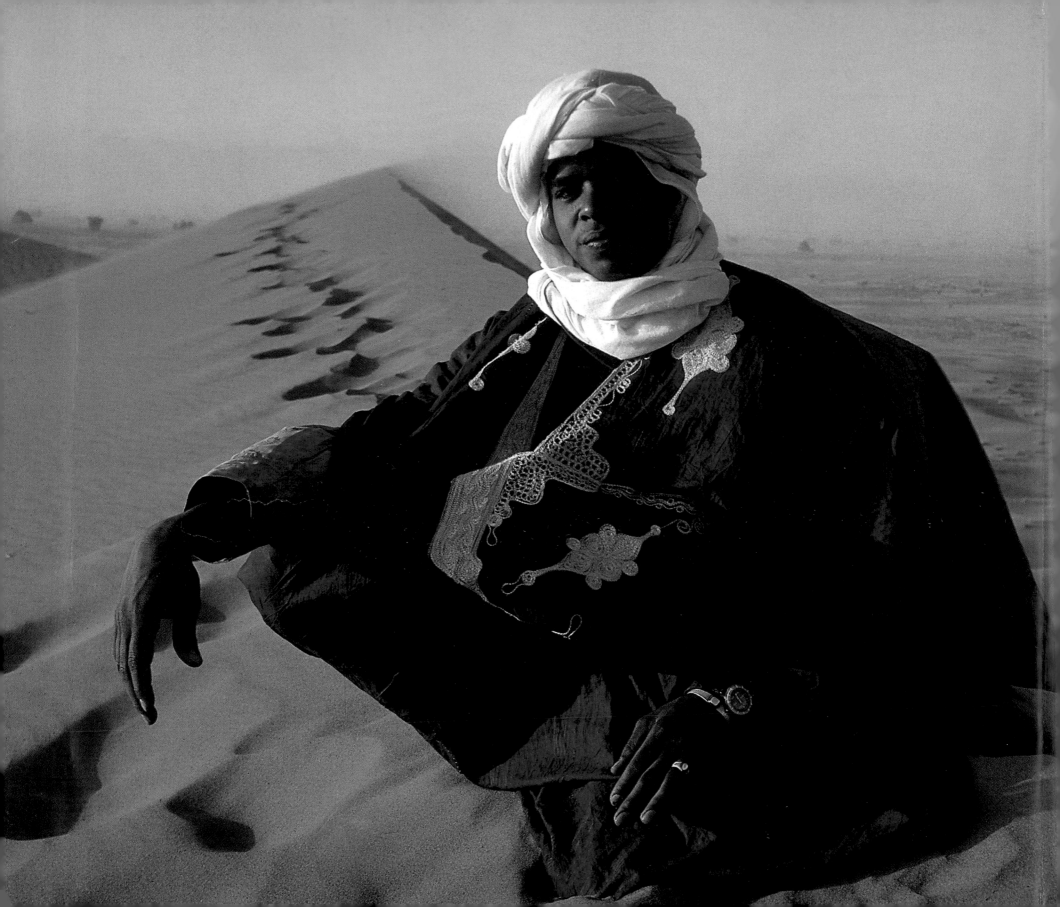

TRAVEL PHOTOGRAPHY

CHRISTIAN HEEB

DETLEV MOTZ

David & Charles

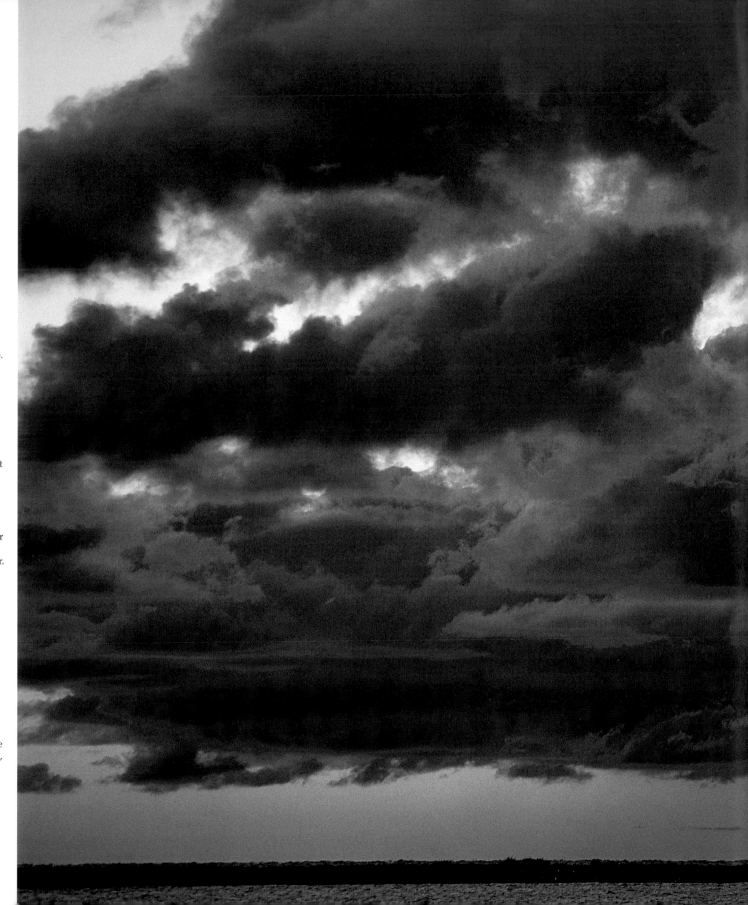

p 1: I pointed my flash directly at this young Mariachi musician in Mexico, so that he stood out clearly from the rest of the group.

p 2: Our guide in the Sahara posed for this evening shot. A violent sandstorm was blowing up, so I used a cheap Tamron zoom to spare my expensive Nikon lenses.

Right: To capture this sunrise I took a taxi from my hotel on Michigan Avenue in Chicago to Lake Michigan at half past four in the morning.

p 6: I used a telephoto lens to heighten the effect of this flock of grazing sheep and evoke the image of New Zealand as sheep country.

A DAVID & CHARLES BOOK

First published in the UK in 2003
Copyright © Verlag Georg D. W. Callwey GmbH & Co.
KG 2002

Distributed in North America
by F&W Publications, Inc.
4700 East Galbraith Road
Cincinnati, OH 45236
1-800-289-0963

Christian Heeb and Detlev Motz have asserted their right
to be identified as authors of this work in accordance
with the Copyright, Designs and Patents Act, 1988.

A catalogue record for this book is available from the
British Library.

ISBN 0 7153 1697 4 hardback
ISBN 0 7153 1698 2 paperback (USA only)

Printed in Singapore by KHL
for David & Charles
Brunel House Newton Abbot Devon

Visit our website at www.davidandcharles.co.uk

David & Charles books are available from all good
bookshops; alternatively you can contact our Orderline
on (0)1626 334555 or write to us at FREEPOST EX2 110,
David & Charles Direct, Newton Abbot, TQ12 4ZZ
(no stamp required UK mainland).

All details have been painstakingly researched
and carefully checked. However, no responsibility
can be taken for any changes or inaccuracies.

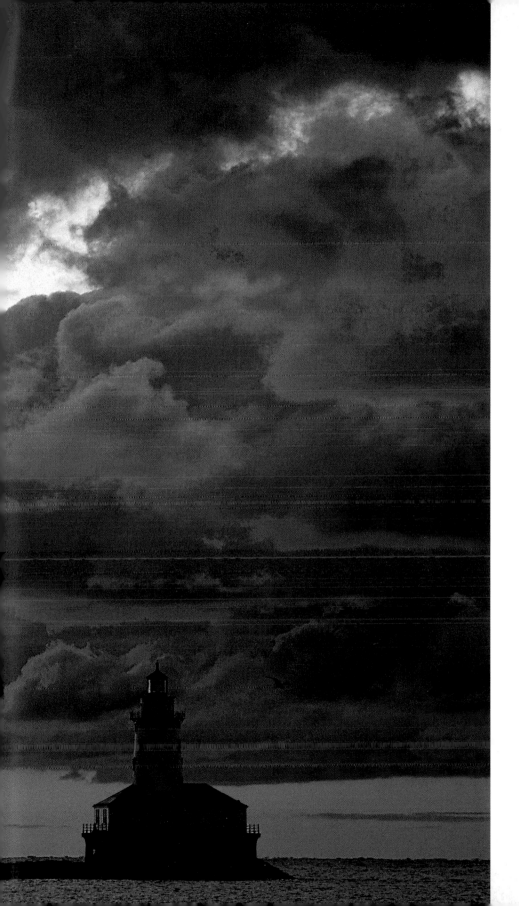

CONTENTS

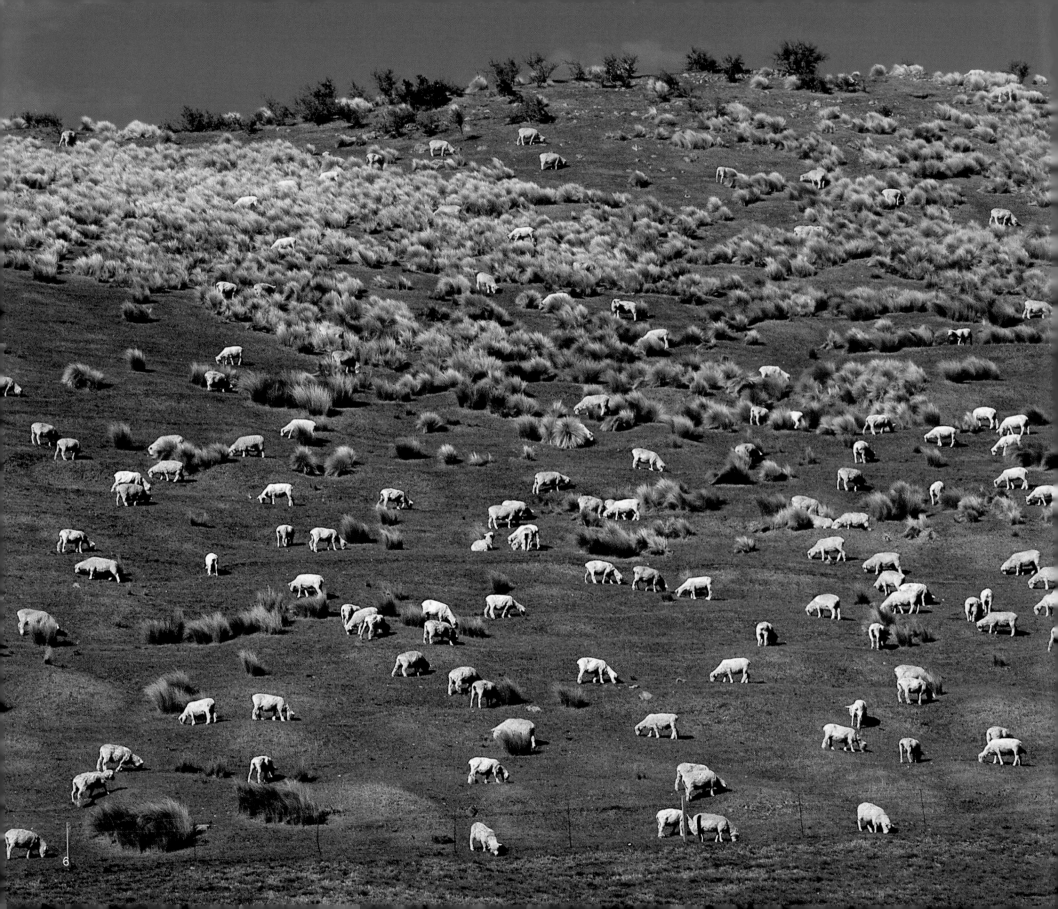

 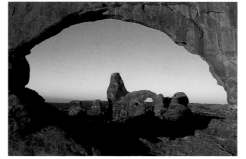 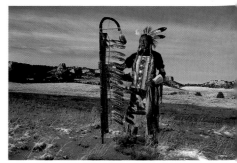

PREFACE

DETLEV MOTZ ON CHRISTIAN HEEB

IN 1988, WHEN I WAS JUST GETTING TO KNOW HIM, CHRISTIAN HEEB SAID, 'I HAVE GIVEN UP EVERYTHING FOR MY NATIVE AMERICANS'. TODAY HE IS, IN MY OPINION, ONE OF THE GREATEST TRAVEL PHOTOGRAPHERS.

I first got to know Christian Heeb through his competition photography. He began in 1983 in the *Foto-Creativ* competition with a photograph of a bowl of fruit. Portraits followed in 1984, and in 1985 his first picture of a Native American appeared. I can't recall now whether the subject was a Blackfoot Indian, but I do remember that it was his 'favourite Indian' at the time. Dee Brown's book *Bury My Heart at Wounded Knee* was the introduction to Native American affairs.

When I visited him in St Gallen in 1988, he wanted to leave his everyday life behind. He had, in fact, just got back from a trip to America, which had lasted a year and a half. Because he was especially interested in Blackfoot Indians, he had visited the American Indian Museum in Zurich to find out all he could. English literature was another source – even then he was painstaking in his background research.

He took 500 Kodachrome films with him, 50 of which came back showing Native American subjects. The rest were used for travel impressions. Christian Heeb has managed to do something that most people can only dream about: he has made his hobby his job, he has managed to leave everyday life behind, and to my mind he is now one of the most successful travel photographers, not just in America.

We have remained friends, and the Internet has strengthened our relationship. He writes to me from all over the world, from wherever he has set up camp. I must admit, I often envy him this.

HAVE CAMERA, WILL TRAVEL

ONLY THOSE WHO

REMAIN AMATEURS

IN THEIR HEARTS

WILL BE SUCCESSFUL

IN THE END – BOTH

IN THEIR HEARTS

AND IN THEIR

PICTURES.

In the Ceder Mountains of South Africa a thunderstorm is brewing. The heat is an overwhelming 45°C, and the air is full of electricity. The bizarre red formation of rocks glitters like a fevered dream in the golden sunset. For 20 minutes the world exists for my eyes only – the number of subjects are far too many to count. I hardly feel the heat, nor do I notice the sweat soaking my T-shirt or the grazes on my legs. My tripod with the Pentax 6 x 7 camera stands on a crag.

The Nikon equipment is in the bag on my back. The light is changing the landscape continuously. A new subject calls for a change of position. After an hour of exhausting work with the camera, with many changes of lenses and films, the sun finally disappears in the dark clouds. While I drink a whole bottle of water, my wife (and business partner in Heebphoto) counts the films I have just taken. There are ten. The trip has been successful.

When asked what I like doing best in life, it would be taking pictures in the wild, especially in the mountains with no people around. My favourite light is that during thunderstorms. Photography has always

been my most beloved hobby, and exploring the landscape behind the next mountain range has been my greatest passion. Being a travel photographer is the only profession which includes all my hobbies. I still meet fellow countrymen who note my profession with astonishment. 'Can you really live on that?' is the most frequently asked question. The answer is yes, though not under normal conditions.

Our life is travel photography. We do not know a private life in its classic sense. For four months a year we live on our ranch in Oregon, USA. Our companies are registered in the USA and Switzerland, our key customers are in Germany, and our two most important agencies are Look in Munich and Hémisphères in Paris. For eight months a year we travel around the world taking pictures, the focal point being North America. When we are away we work seven days a week from dawn till dusk. Communication with our clients is 90 per cent via the Internet.

To sum all this up: only those who commit their entire life to travel photography have a real chance to succeed. The heydays of classical travel photography are long gone. The pictures of the pioneers in our profession, who dragged their huge cameras through unknown landscapes to show us Europeans what the big wide world looked like, are now exhibited in museums or buried in archives. Even pictures from pioneers like Ernst Haas or Emil Schulthess get lost in the endless flood of photos. There is hardly a place in the world that has not already been photographed

over and over again. Travel photographers are becoming more and more henchmen for tourism, suppliers of travel brochures and tourist magazines.

The work itself should be the main focus. Pictures do not last forever, but the memory will remain with you until the end of your life. That is why I only photograph subjects that really fascinate me. For the amateur, the future professional and the already successful travel photographer it is vital to choose topics carefully. A photo journey is always a journey back to yourself. Travel strongly influences our future and enriches our lives.

With this book, and together with my longstanding friend and mentor Detlev Motz, I am passing on to you my philosophy and my experience in both travel and landscape photography, which has developed over the last twelve years.

Happy are those who remain amateur. Those who photograph to earn money are at risk of burn-out one day. Only those who remain amateurs in their heart will be successful in the end – both in their hearts and in their pictures.

Christian Heeb

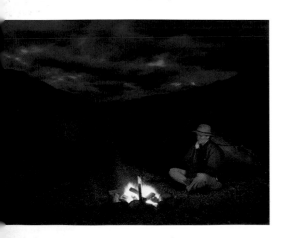

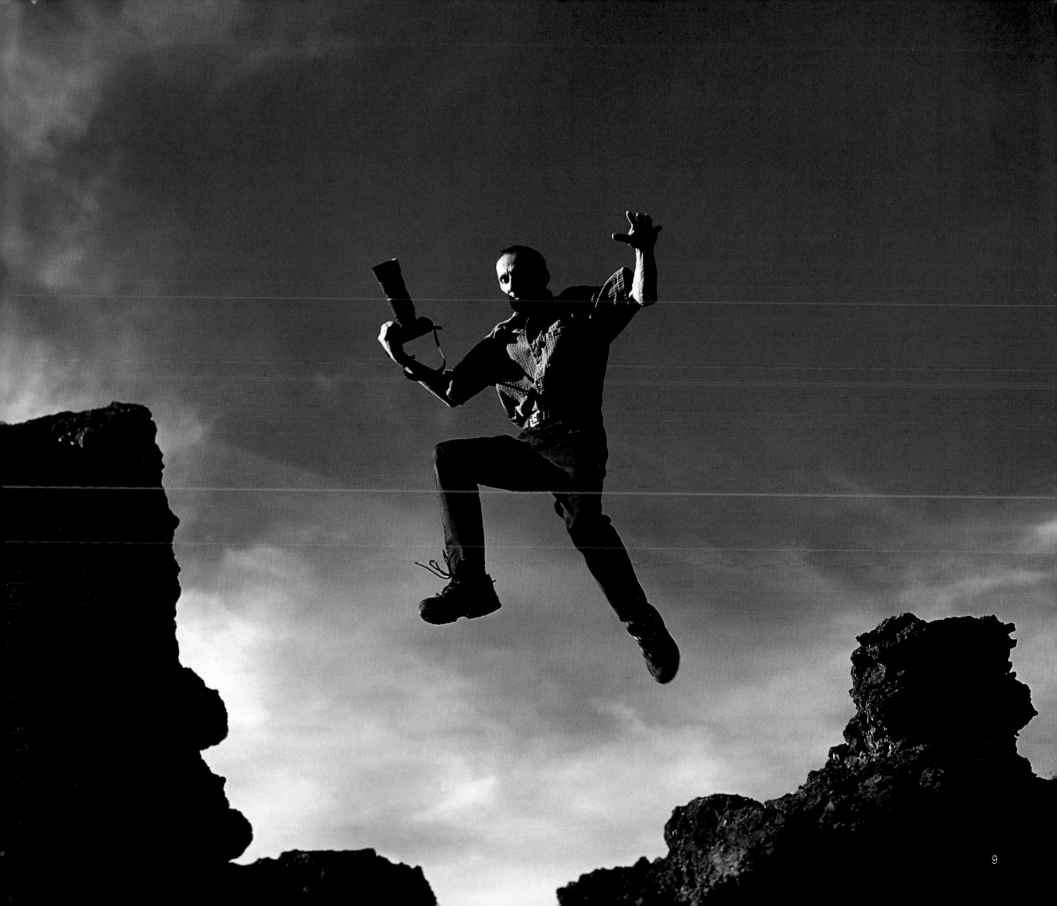

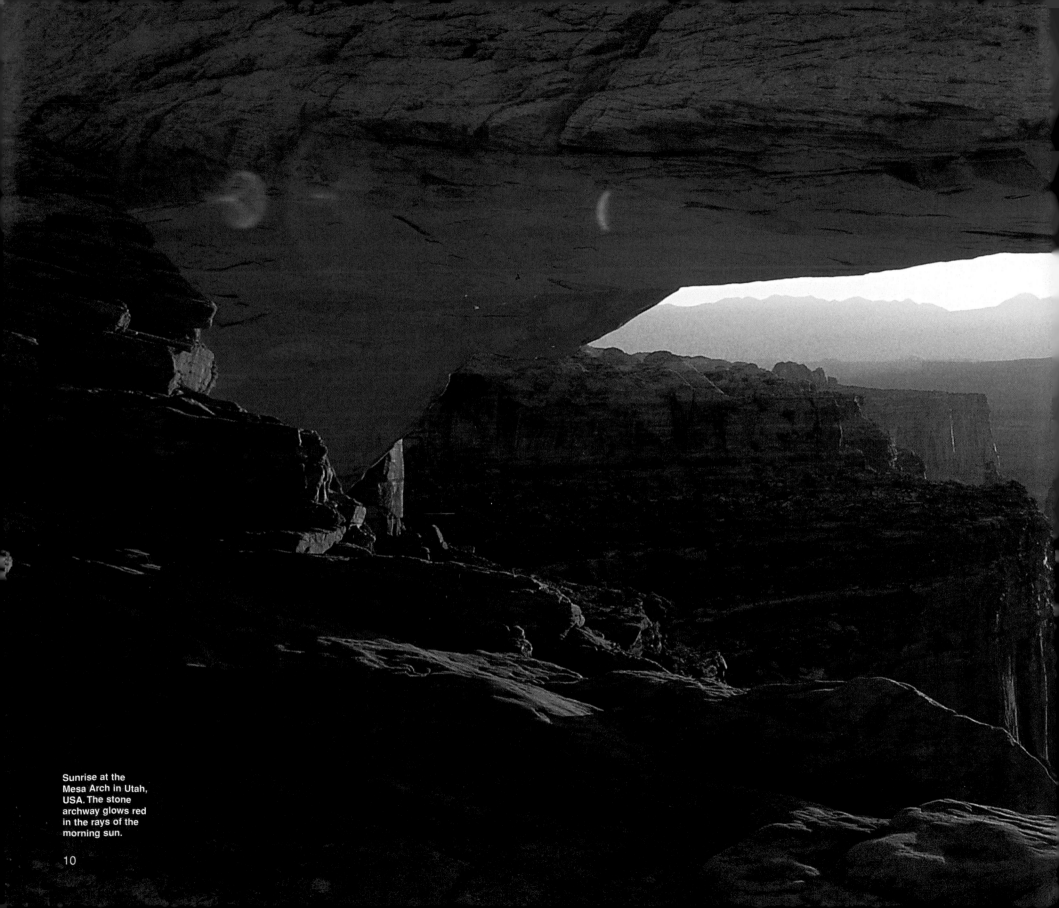

Sunrise at the
Mesa Arch in Utah,
USA. The stone
archway glows red
in the rays of the
morning sun.

LIGHT AND LANDSCAPES

MOST OF US ARE NOW SEASONED TRAVELLERS. THIS

HAS MADE FINDING AN ORIGINAL SUBJECT, ONE

THAT HASN'T ALREADY BEEN PHOTOGRAPHED

FROM ALL ANGLES, MUCH MORE DIFFICULT.

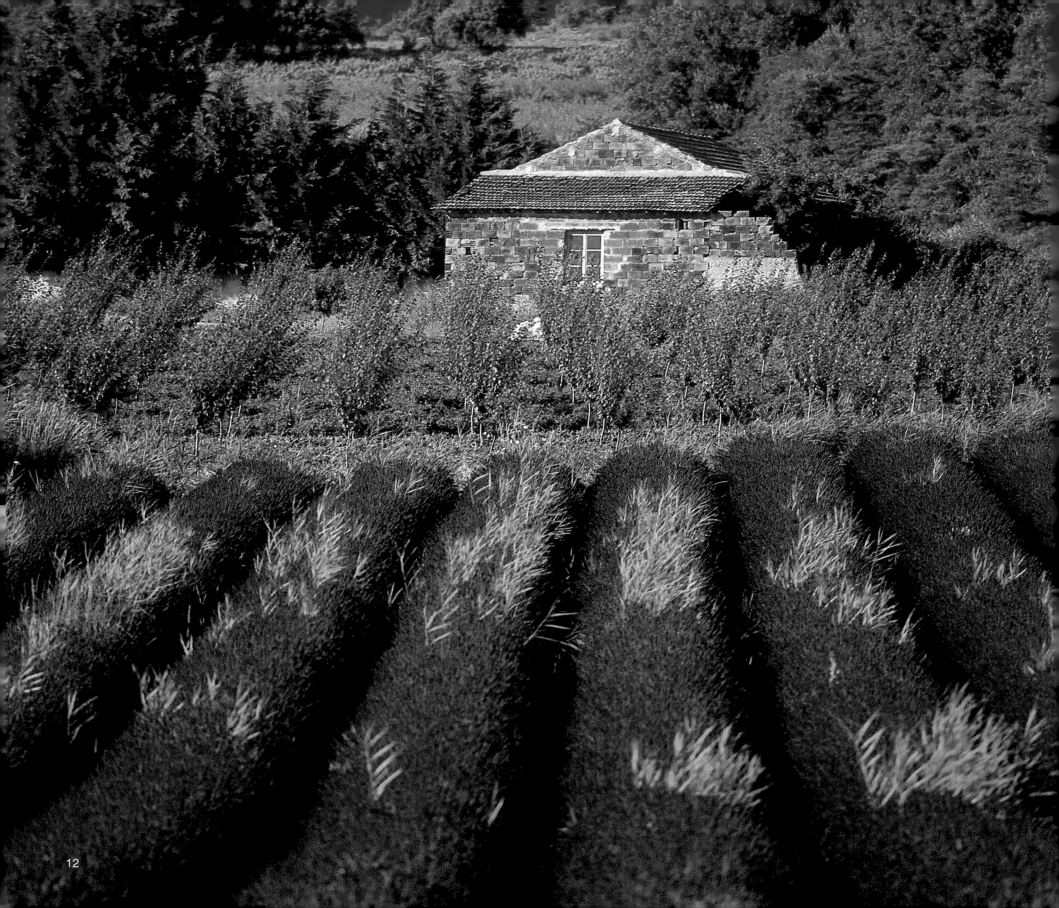

LIGHT AND LANDSCAPES

The amateur photographer is most at home with landscapes. In travel photography, the landscape is an essential part of a wider spectrum. Magazine articles often start with a spectacular landscape, followed by portraits of people or animals and architectural details, probing deep into the heart of a region.

The most common results are conventional landscape photos in calendars and glossy coffee-table books. Fixed focal lengths of 18–200mm are used for landscape photography. It's almost always best to use a tripod for good-quality pictures: the longer the focal length, the higher the tripod setting.

If a landscape is to come alive in a photo, it will be through the light – a barren, uninteresting desert landscape can turn into a magical, dreamlike world in the evening or in stormy weather. As a general rule, the most impressive landscape photographs are taken around sunrise or sunset.

The light and atmosphere of the early morning work best for me. In the morning you are usually on your own, and the air is still fresh and clear. I have gained so much in the way of personal fulfilment from mystical morning mists, hoar frost and the birdsong of so many early mornings – and that's even before I think about the stunning lighting effects.

There is always an exception to every rule, however, and if you shoot during thunderstorms, you can also get stunning shots at midday. Cloudy skies give you a good opportunity to photograph close-up details of the landscape, such as flowers, rock formations, grasses or pebbles. When in a rainforest or near a waterfall, I nearly always prefer a cloudy sky to the jarring and harsh sunlight.

Every time of day has its own subject – and vice versa. In the famous Slot Canyon in Arizona, USA, for instance, the ideal time for taking pictures is at midday, when the reflections in the canyon produce really dramatic effects.

Landscape photography is hard work. You have to be in the right place at the right time. This can mean having to pitch your tent in the most inhospitable places – in the rain, at a mountain lake, in the Canadian Rockies or in the desert. The important thing is having the will to crawl out of your warm sleeping bag early in the morning, even when the temperature is below zero. You have to be all set up and ready by the time the first rays of the sun turn the rockface red, because by the time it happens you won't have the time to set up your tripod. Waiting for the sun to set in 45°C in a sandstorm in the Kalahari is all part of landscape photography, as is trudging, soaked to the skin, through the swampy rainforest of Alaska, carrying 20kg (44lb) of camera equipment and an awkward tripod.

Landscape photography means being there in the morning at Bryce Canyon in Utah, hearing the howling of coyotes in the sand dunes of the Mojave Desert, and sleeping under the starry sky of the Australian outback. To me, landscape photography is both a tonic for the body and balm for the soul.

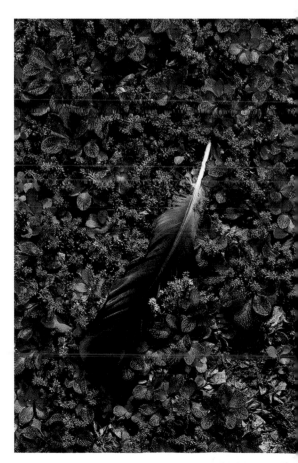

Even a raven's feather in Canada's Arctic tundra can make a good subject for a photo. Close-ups are ideal in deserted landscapes.

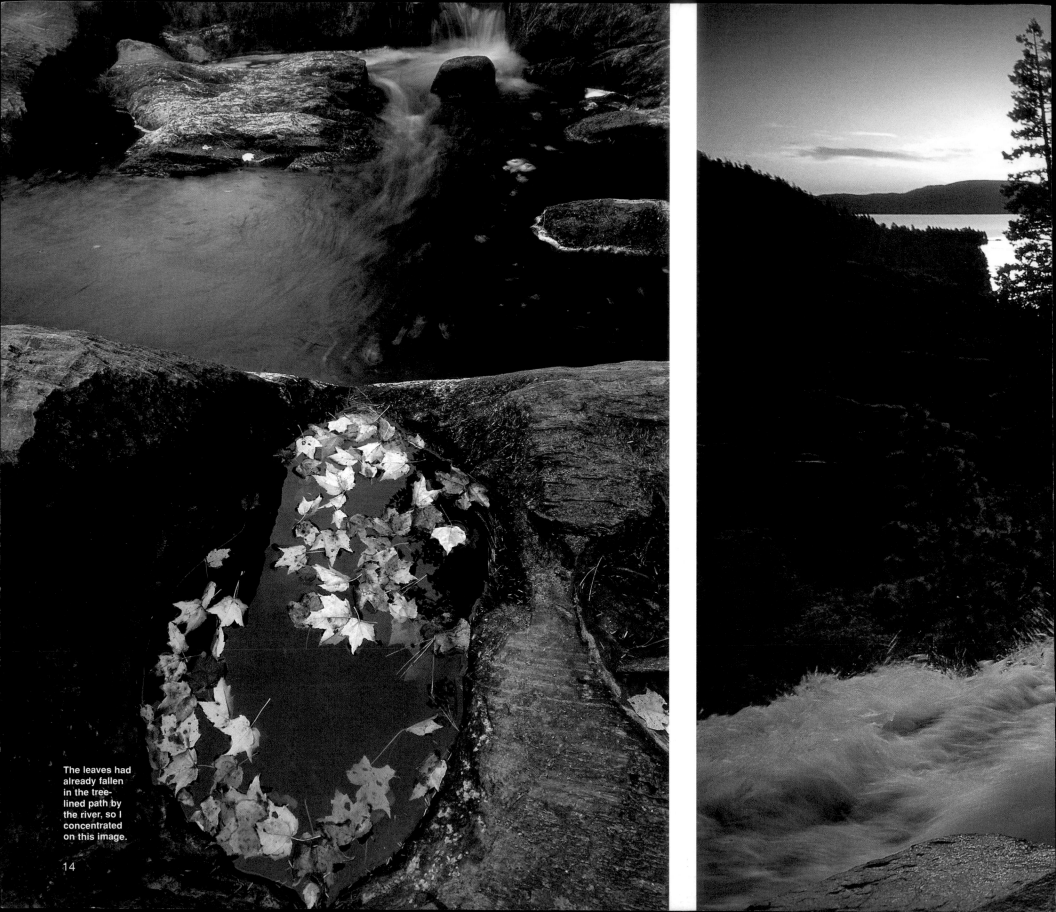

The leaves had already fallen in the tree-lined path by the river, so I concentrated on this image.

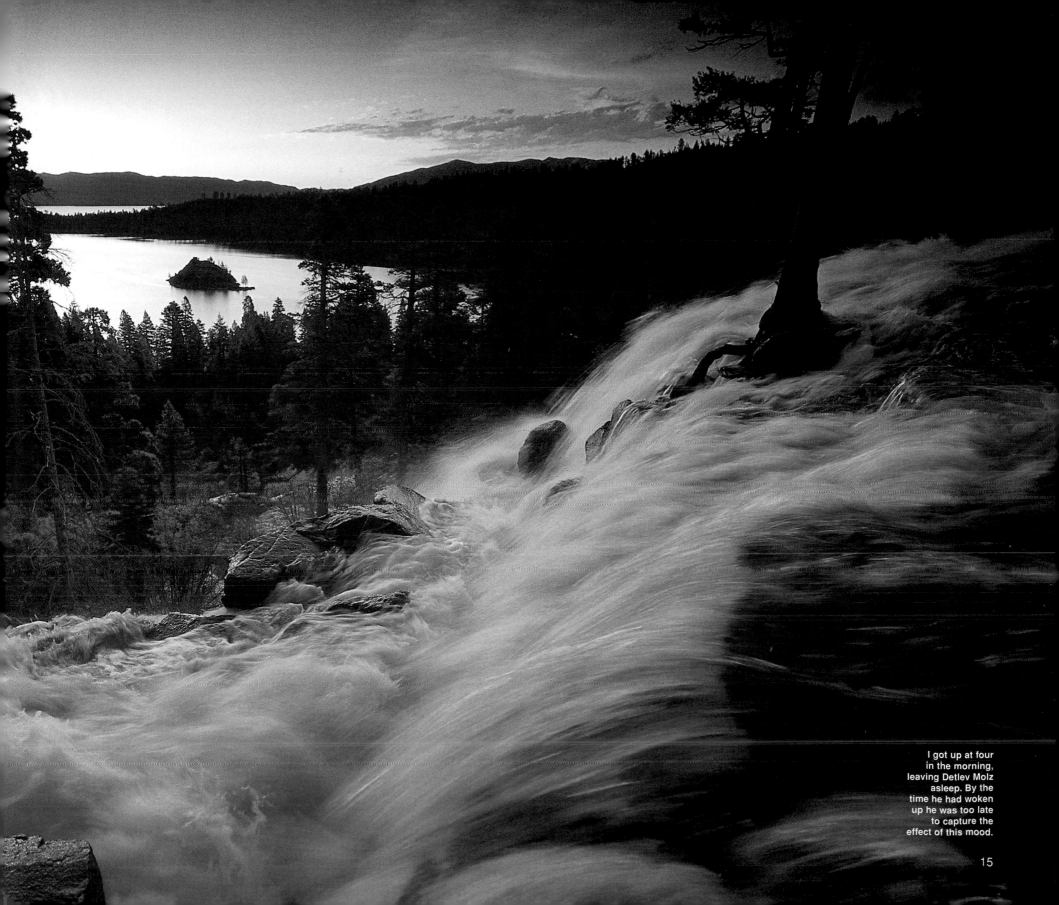

I got up at four
in the morning,
leaving Detlev Molz
asleep. By the
time he had woken
up he was too late
to capture the
effect of this mood.

15

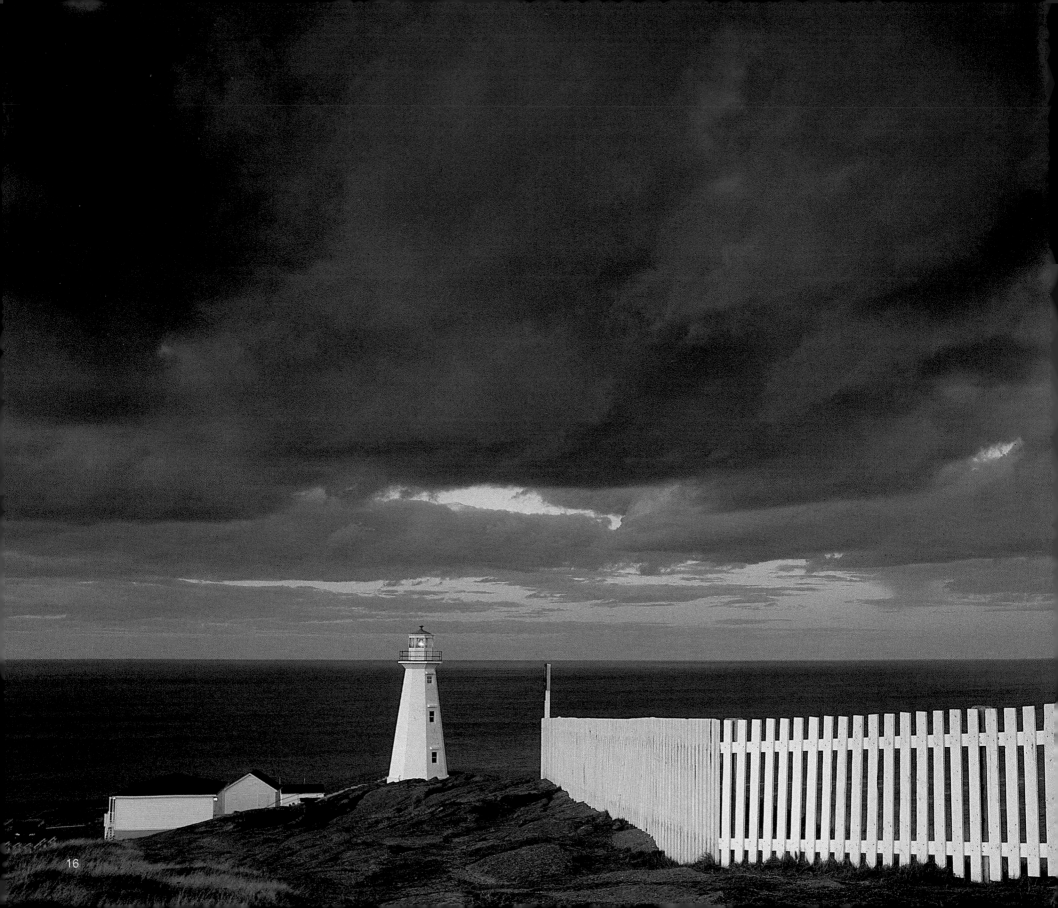

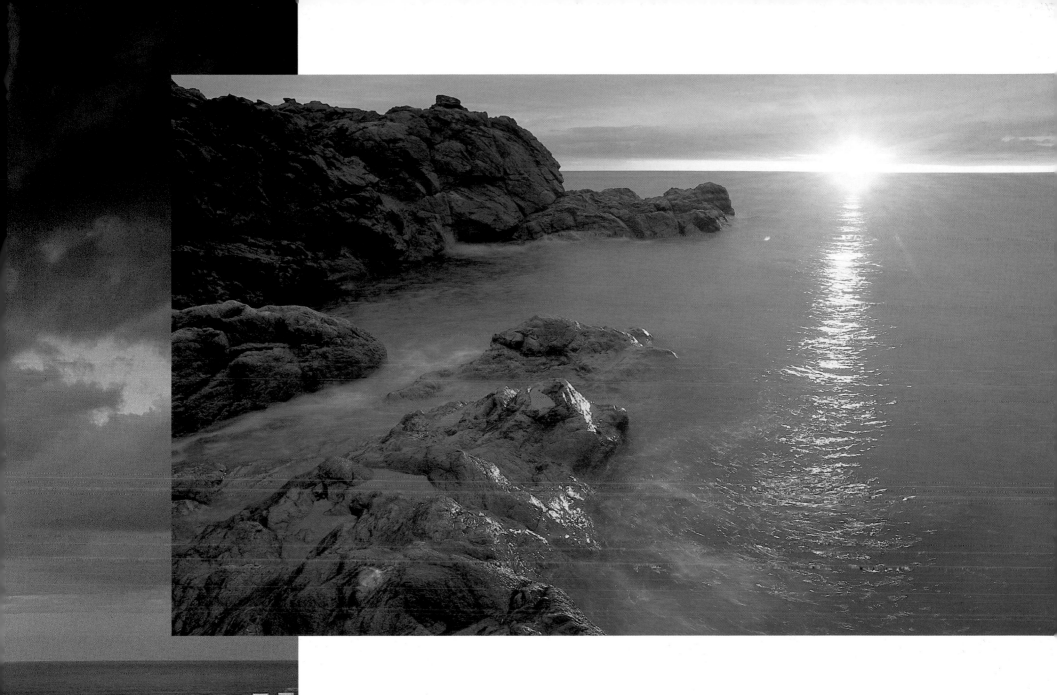

Evening mood in Newfoundland. Our camper was parked right by the lighthouse, enabling me to use the best light available in both the morning and the evening.

EARLY RISERS REAP THE REWARDS

OF LANDSCAPE PHOTOGRAPHY.

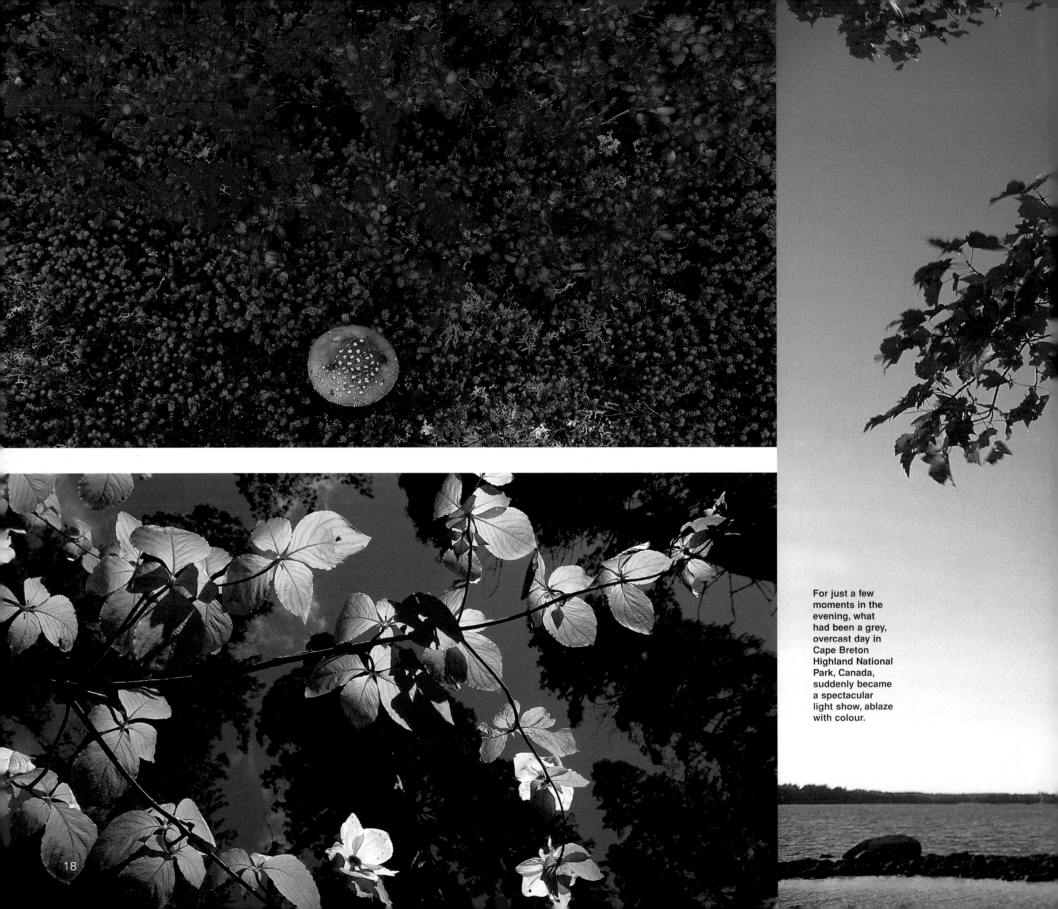

For just a few moments in the evening, what had been a grey, overcast day in Cape Breton Highland National Park, Canada, suddenly became a spectacular light show, ablaze with colour.

18

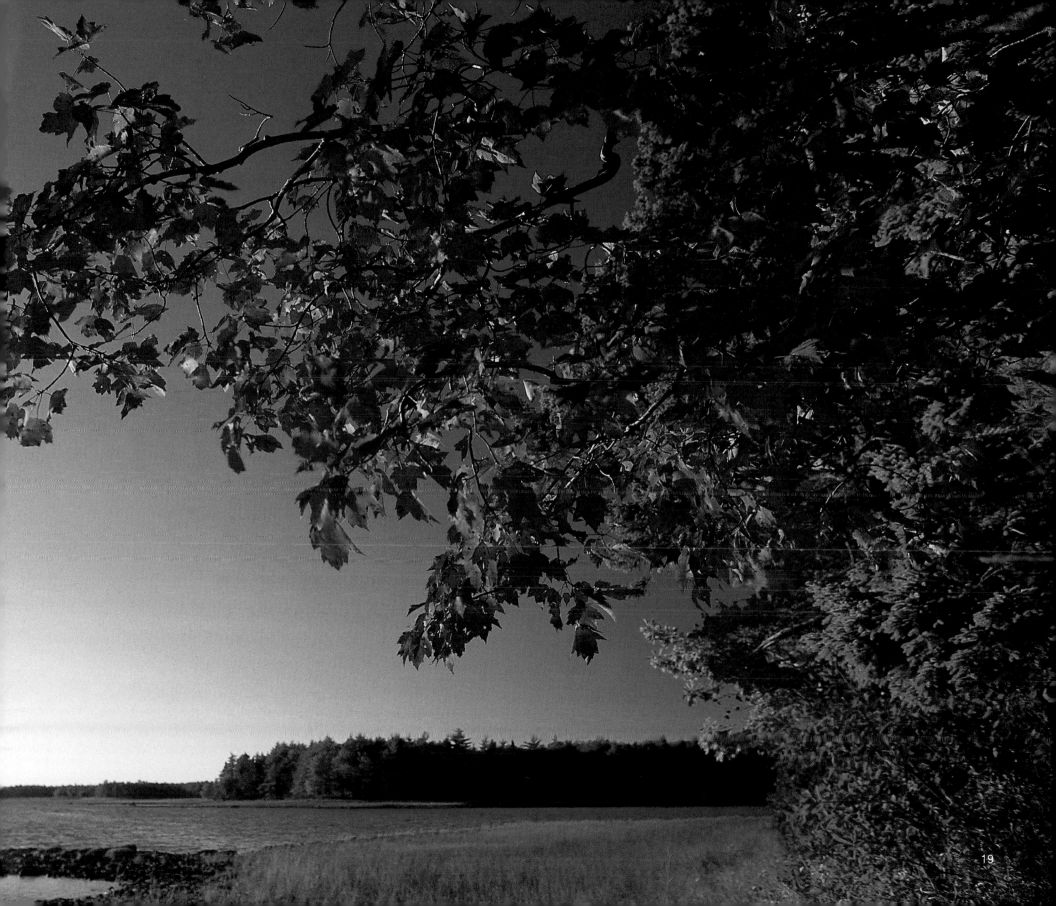

19

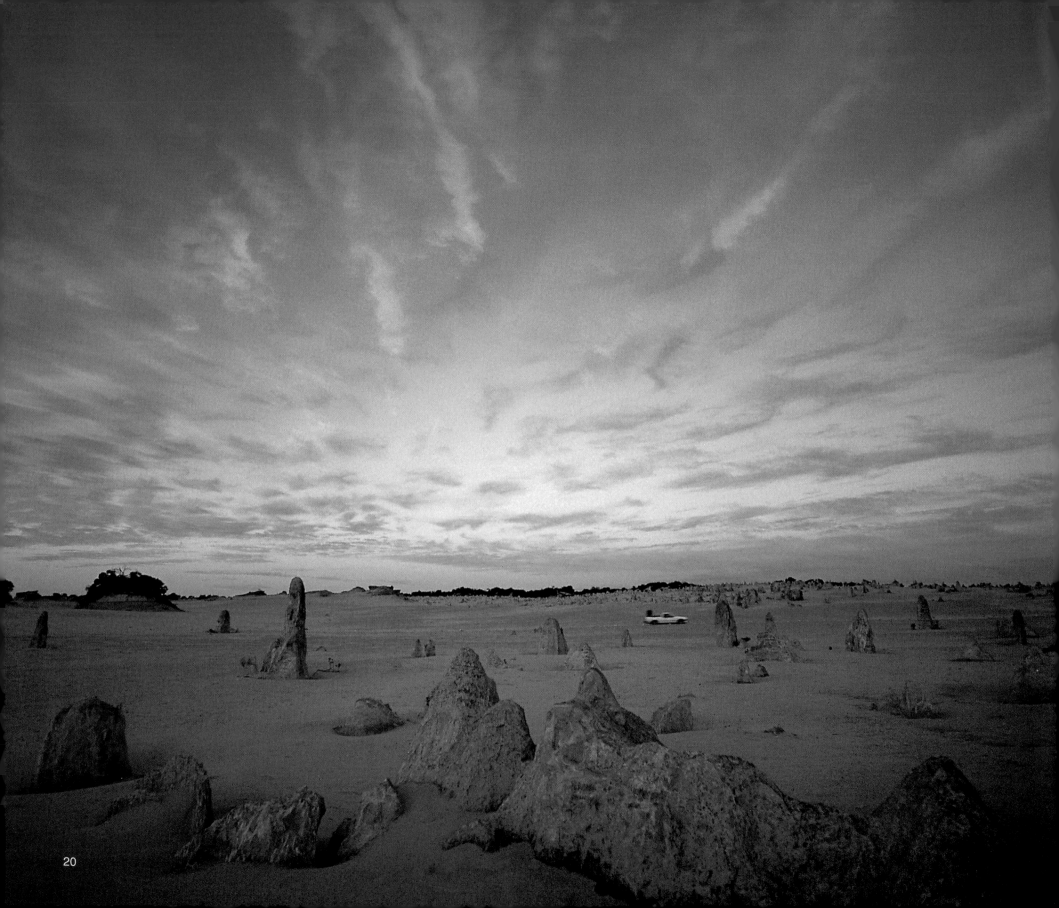

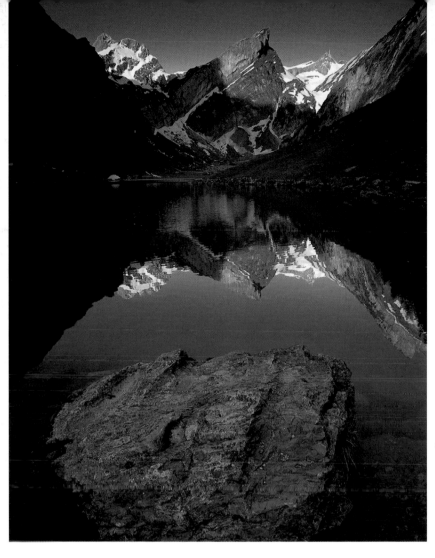

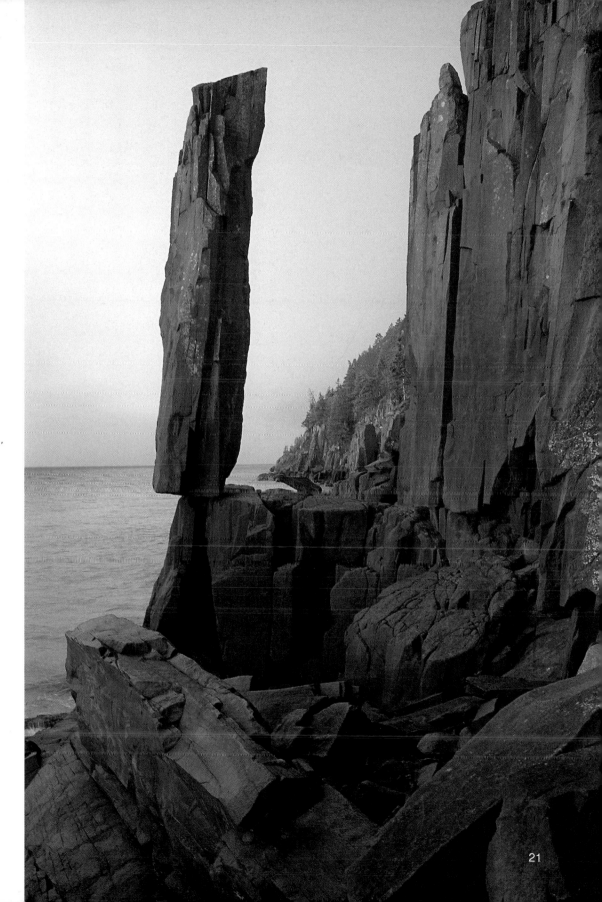

A POLARIZING FILTER

IS INDISPENSABLE

FOR LANDSCAPE

PHOTOGRAPHY.

The Pinnacles Desert in Western Australia is famous for its fascinating light effects. Clouds blowing up from the nearby coast hit the dry desert air to produce the most beautiful colour effects in the morning and in the evening.

PEOPLE, CELEBRATIONS AND EVENTS

CAPTURING LOCAL COLOUR IS A MARVELLOUS WAY TO GET GOOD PICTURES. BUT THE CAMERA MUST NEVER BE INTRUSIVE.

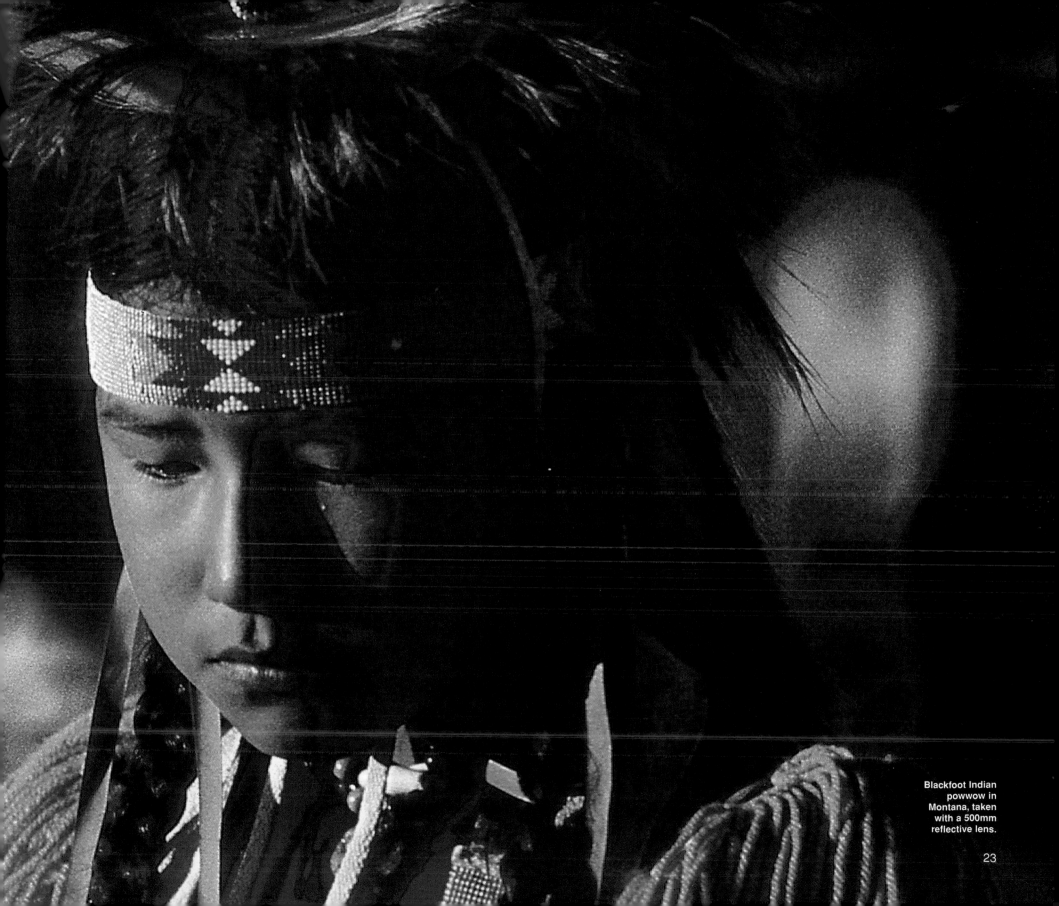

Blackfoot Indian
powwow in
Montana, taken
with a 500mm
reflective lens.

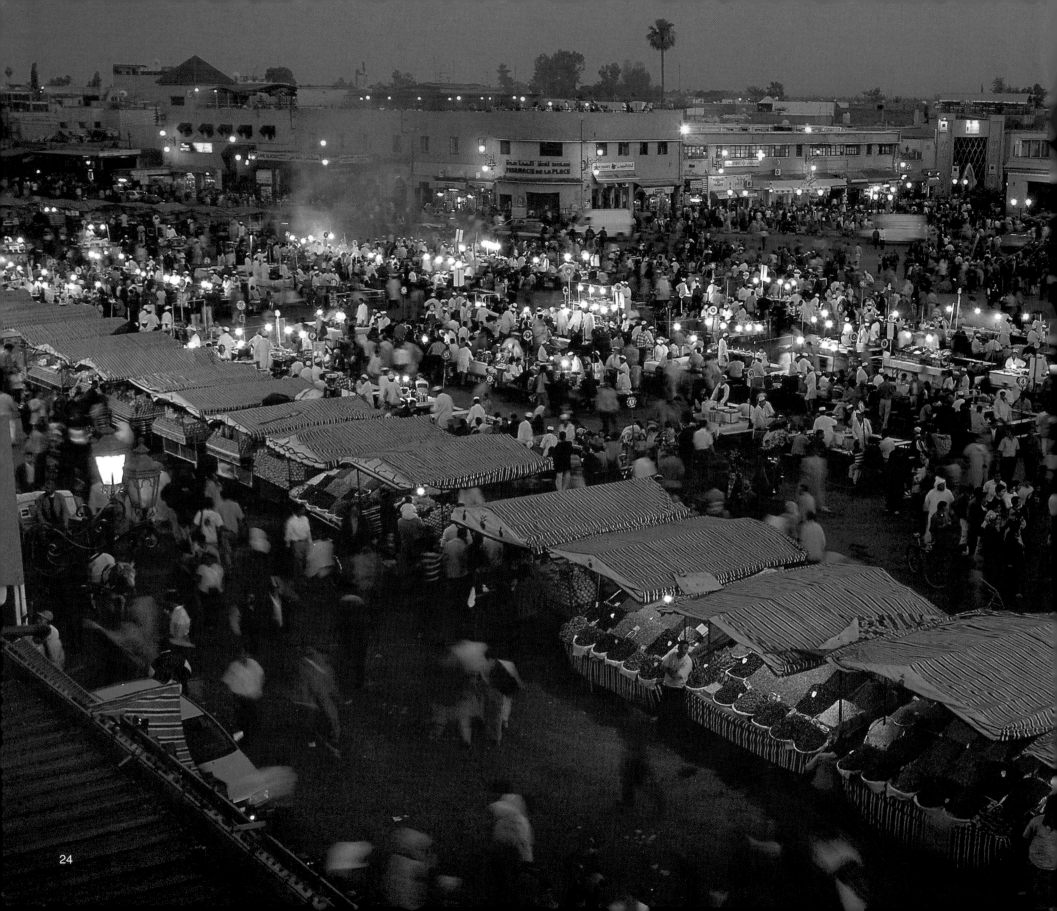

PEOPLE, CELEBRATIONS AND EVENTS

Carnival time in Trinidad, a Native American powwow in Montana or a Corpus Christi procession in Austria – occasions like these always provide excellent subjects for the serious amateur or professional photographer. The subjects you find at parades, festivals and lively carnival revelries normally make for colourful photos, as people feel at ease and are therefore willing to be photographed.

Apart from the performance itself, the spectators will often make good subjects as well. At religious events, such as those in the Native American pueblos in the southwest of the USA, you always need to obtain permission to take photographs beforehand. Elsewhere, such as at most carnivals, you just need to be at your vantage point at the crack of dawn.

Colourful antics and closely packed crowds don't just make good subjects, however; they are also a magnet for pickpockets. A small camera with a zoom lens and a photographic waistcoat are therefore recommended. Anyone who wants to be recognized as a professional photographer, which can be useful at organized events, is well advised to wear a photographic waistcoat. Personally, however, I usually wear trousers with lots of sewn-on pockets, as in normal circumstances I find photographic waistcoats too conspicuous.

Find out about the programme of events in good time – it's essential to find out the route of parades beforehand – and make a note of the best spots for taking photos. There are always good shots to be had at the starting point: the participants meet up wearing their costumes before the start and are ready to have their photographs taken.

For rodeos, football matches or cultural events, it is always worth contacting the organizers in good time. There are often special concessions for photographers: for example, you may be allowed to take pictures in front of the barriers or follow the parade; crowds of spectators can often get in the photographer's way. In any case you need fast reactions and must change your position frequently to get good photos.

To make sure that I have the right equipment for any opportunity, I usually take two cameras with 24–400mm zoom lenses. A good supply of film, ranging from 50 to 400 ISO, and a flash are mandatory.

Travelling and taking pictures with a partner is a great advantage – as I have been working as a team with my wife for years, I am particularly lucky. Regula makes a note of all my subjects in her notebook – the place, the person's name, particular features and the like will always be important later on for filing. Regula also manages to keep spectators off my back, and in portraits pays attention to details which I might overlook – an unattractive strand of hair, for instance, or a tie that needs straightening. At big events she acts as a sort of camera store while I run about in the crowd with a small camera, looking for subjects, and come back to reload.

Finally, don't lose sight of the fact that participants in parades and events love to get free pictures, and giving them your address will often stand you in good stead to take more photos next year.

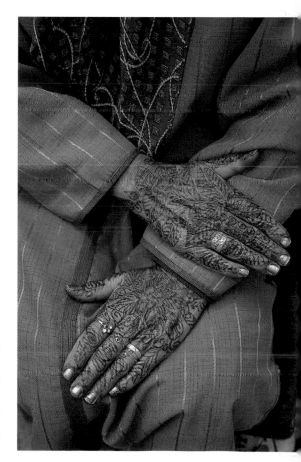

Left: **The picture of the market in Marrakesh, Morocco, was only made possible through the contacts of my guide, Mustapha Akkari.**
Right: **People often overlook details such as the hands of this Berber woman.**

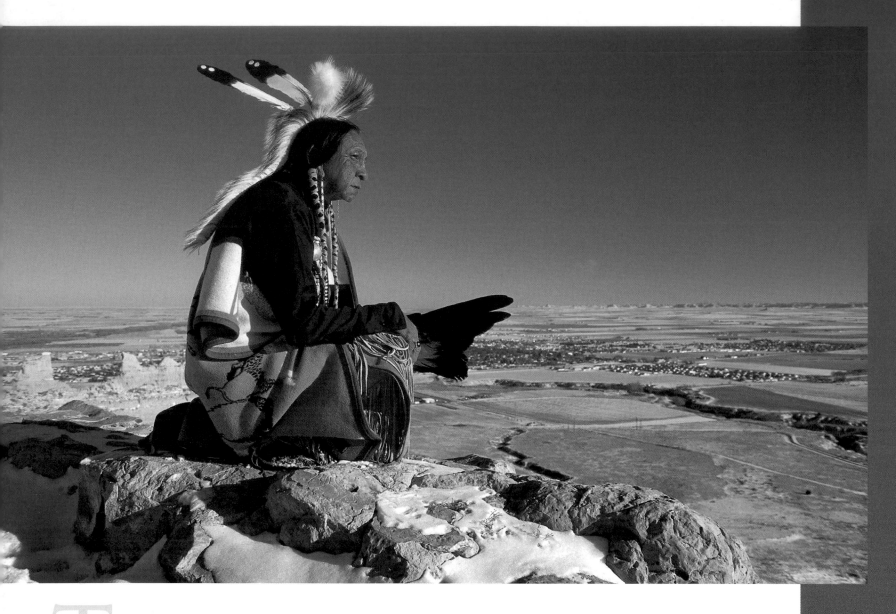

TRADITION

WE ROAMED THROUGH THE COUNTRY WITH RON HAWKS FOR THREE WEEKS, FOLLOWING THE TRACKS OF THE OLD OREGON TRAIL.

Above: **Ron Hawks, the oldest Lakota, seated on the cliff of Scotts Bluff in Nebraska, USA.**
Right: **Young Cree Indians pose for the camera shortly before their dance begins.**

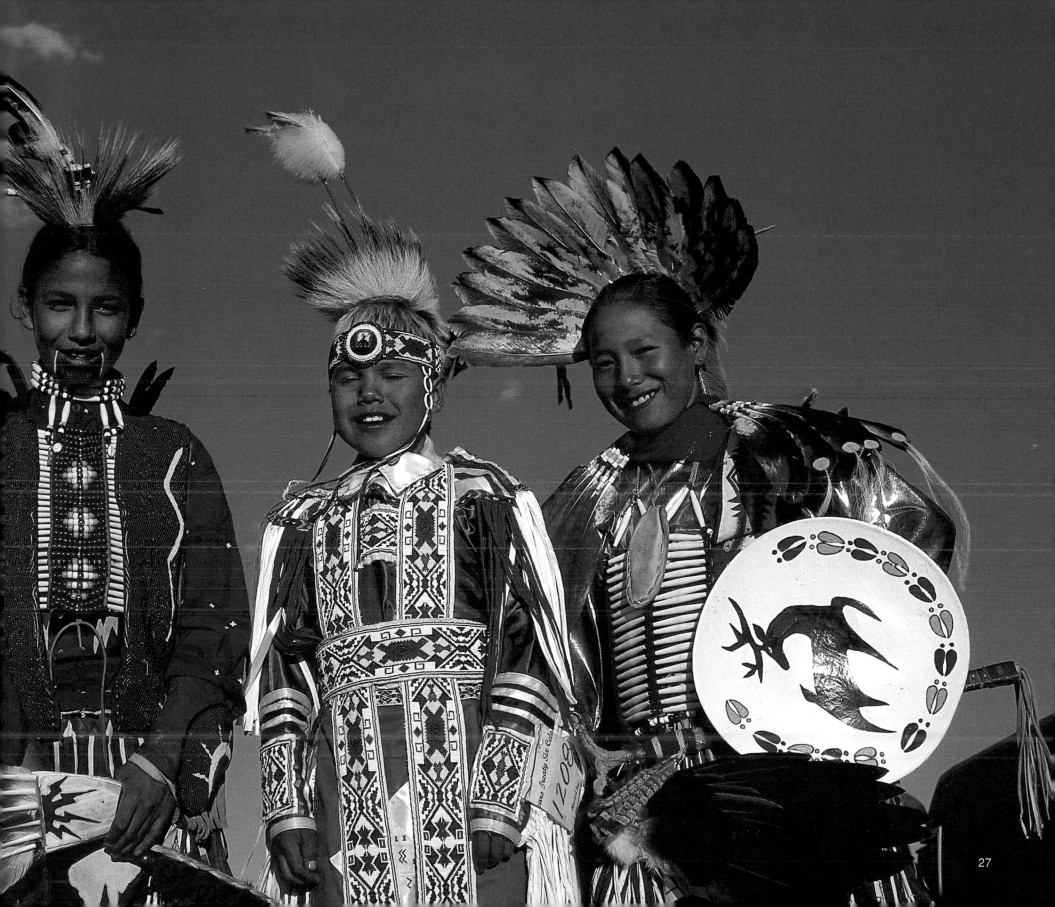

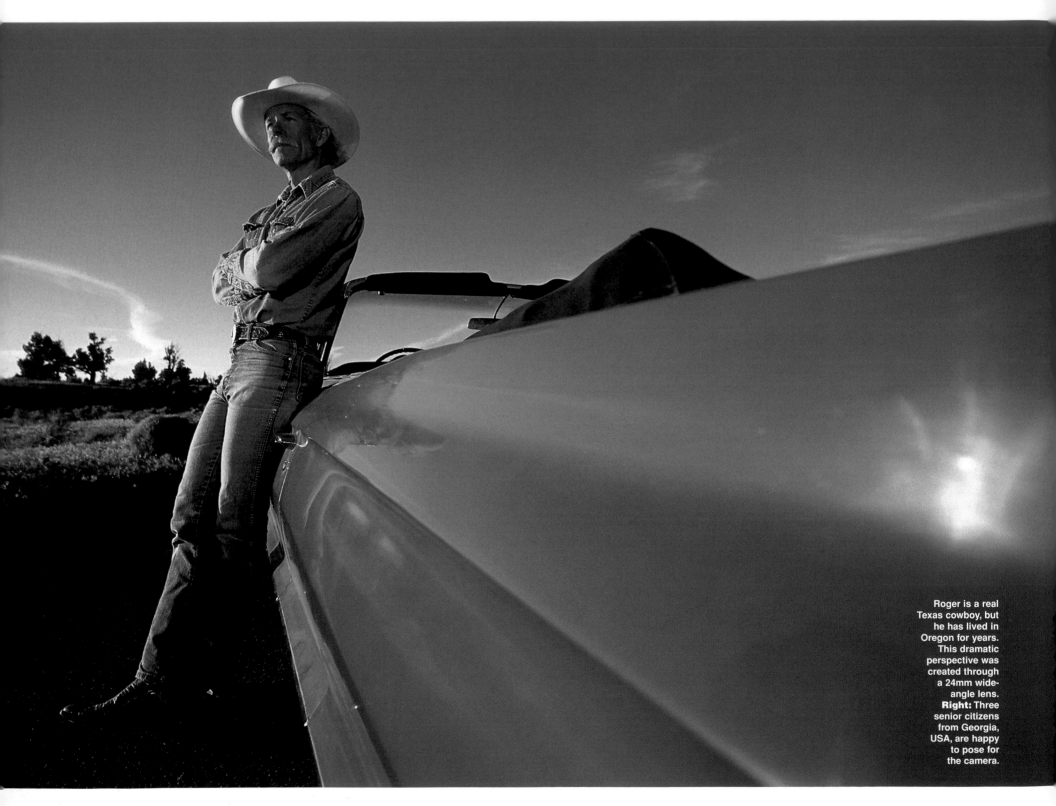

Roger is a real Texas cowboy, but he has lived in Oregon for years. This dramatic perspective was created through a 24mm wide-angle lens. **Right:** Three senior citizens from Georgia, USA, are happy to pose for the camera.

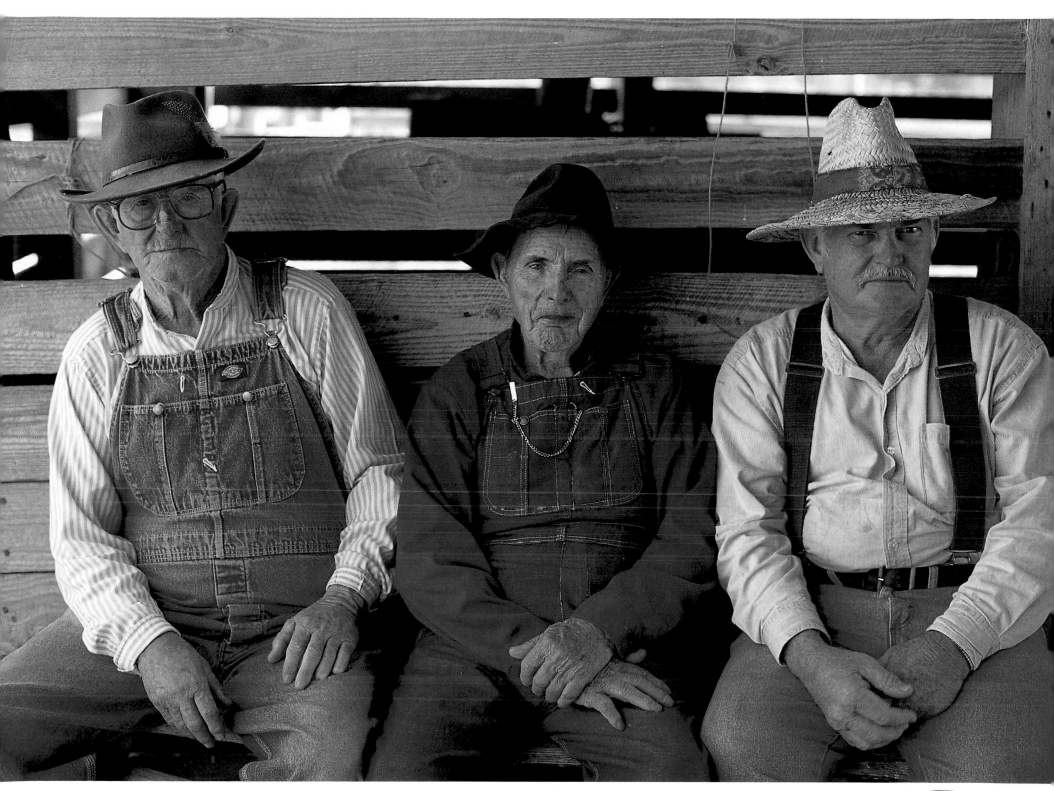

29

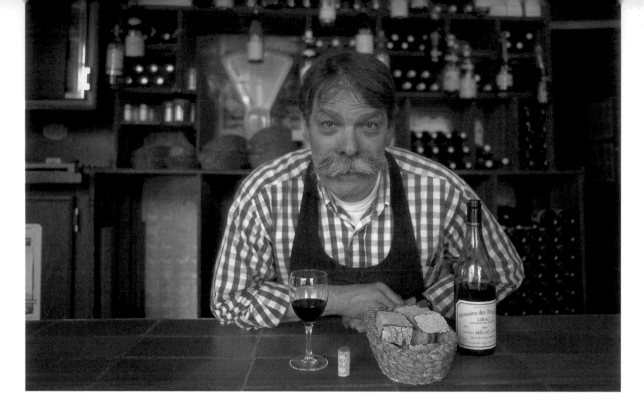

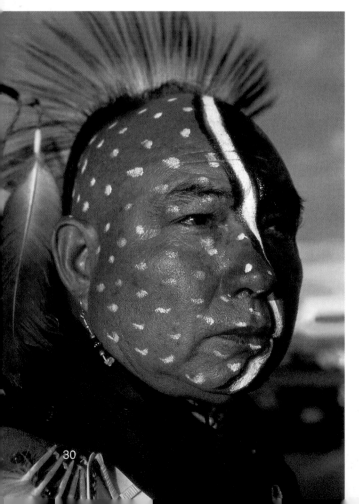

CULTURE

PORTRAITS HAVE A LOT
TO SAY ABOUT A PERSON'S
HISTORY – THEY ARE A
CONSTANT SOURCE OF
FASCINATION.

Above: **An original –
Jacques Melac in his wine
bar in Paris. To my mind
he is a born actor.**
Left: **Iowa Native
American Pete Fee poses
in the fading evening
light.**
Right: **Aborigines at a
demonstration in
Manyallaluk. Their bodies
were decorated specially
with hunting paint for
this photo.**

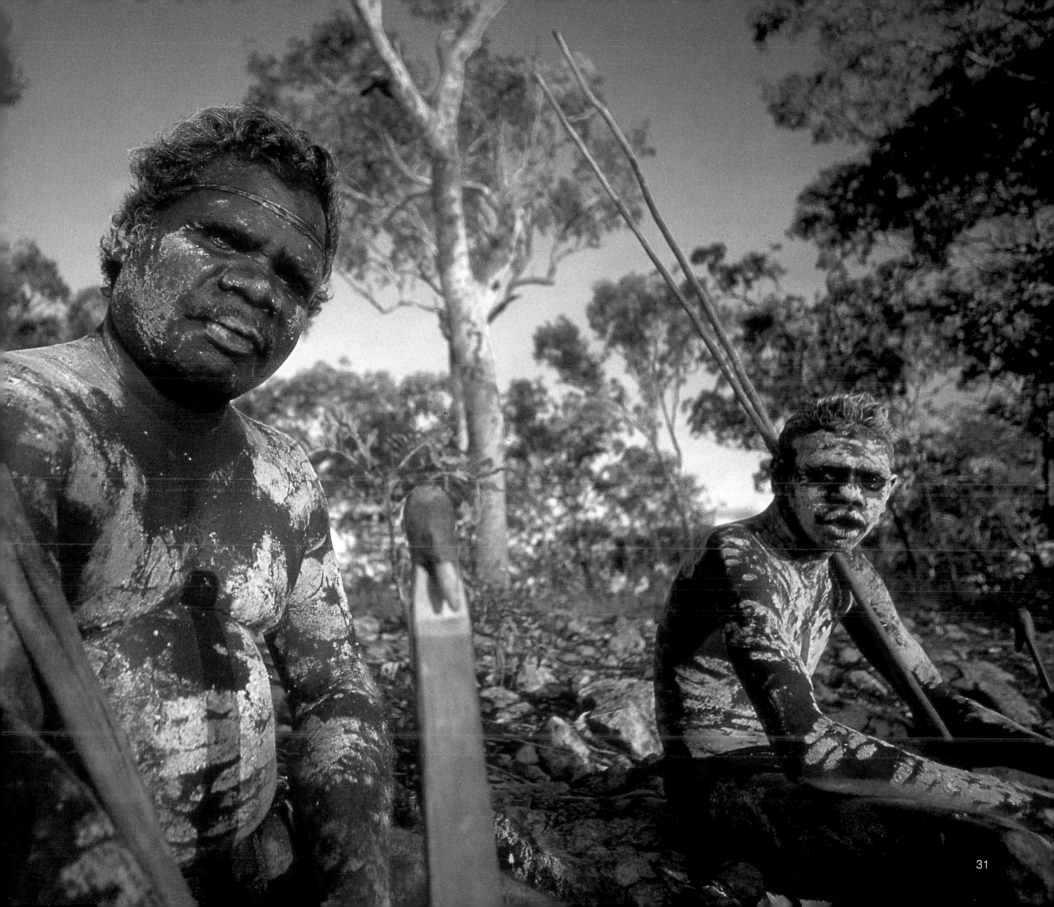

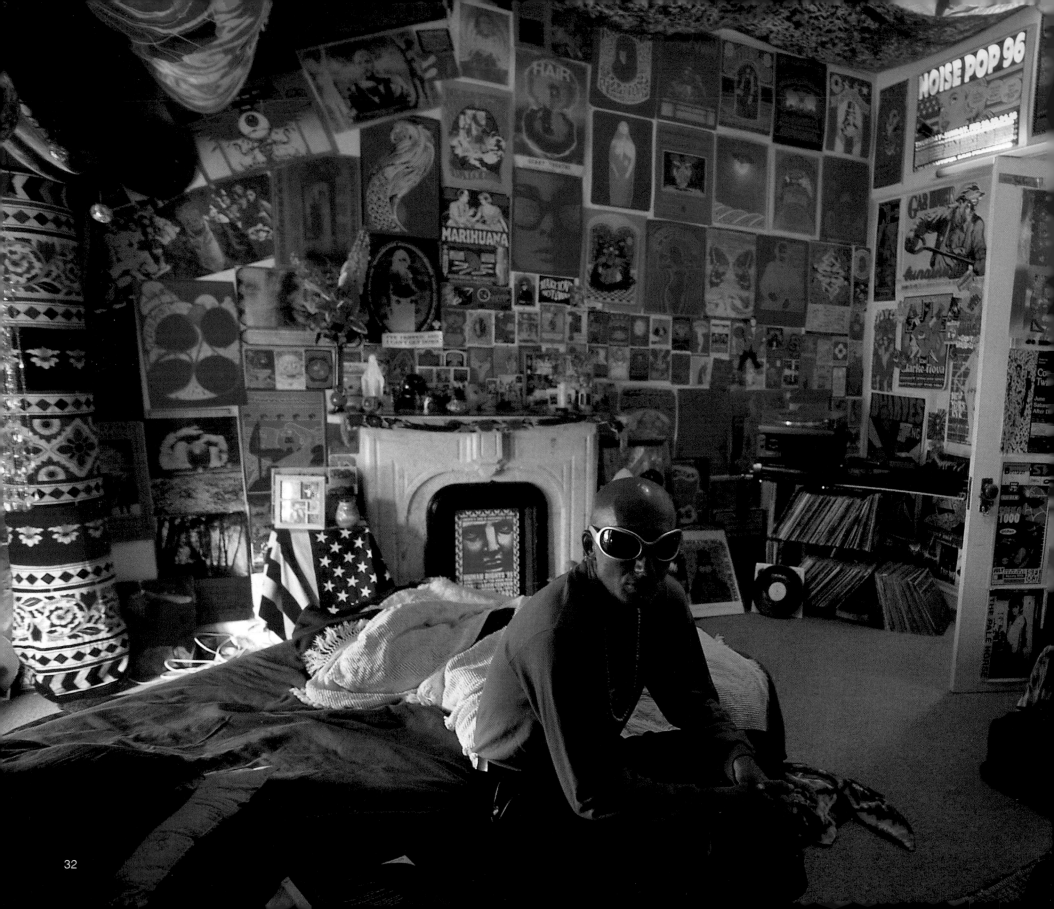

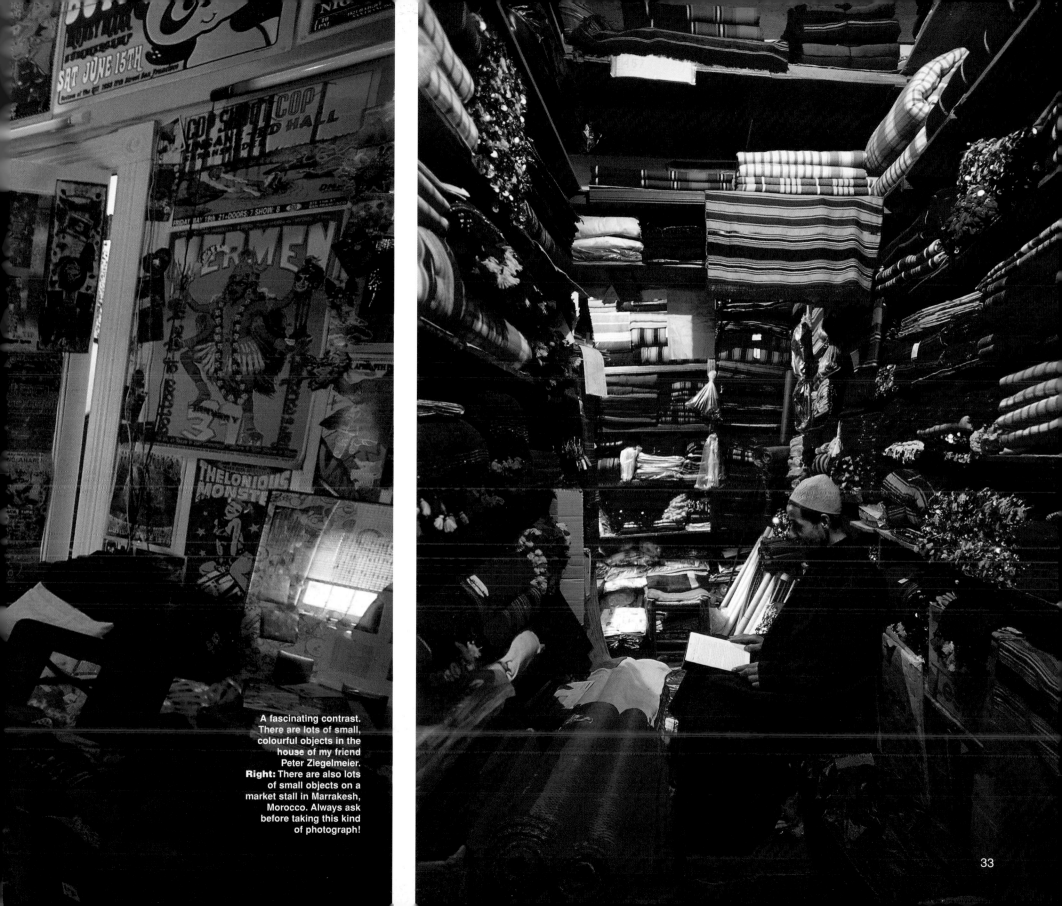

A fascinating contrast.
There are lots of small,
colourful objects in the
house of my friend
Peter Ziegelmeier.
Right: There are also lots
of small objects on a
market stall in Marrakesh,
Morocco. Always ask
before taking this kind
of photograph!

33

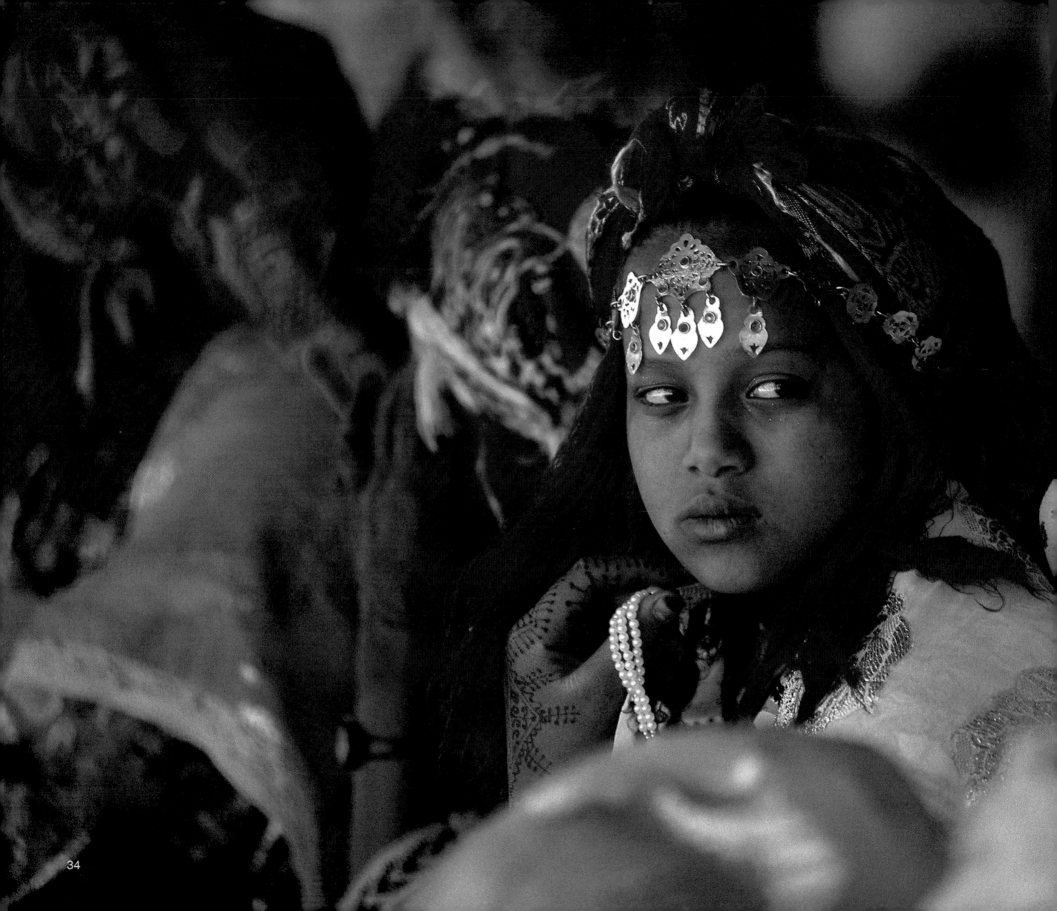

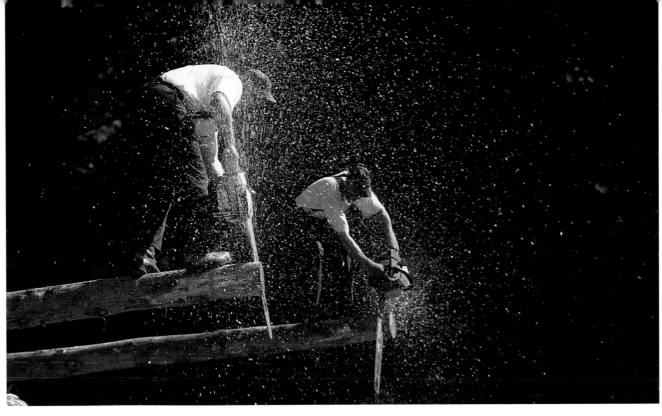

Left: **At the Festival of Roses in Morocco there is a rare opportunity to photograph Berber women, but only professionals are allowed to do so.**
Above: **The easiest way to get photos like this is at the logging festival on the Queen Charlotte Islands, Canada. The backlighting was a stroke of luck.**
Right: **Participants at a Civil War re-enactment in Georgia, USA. There are also historical festivals like this throughout Europe.**

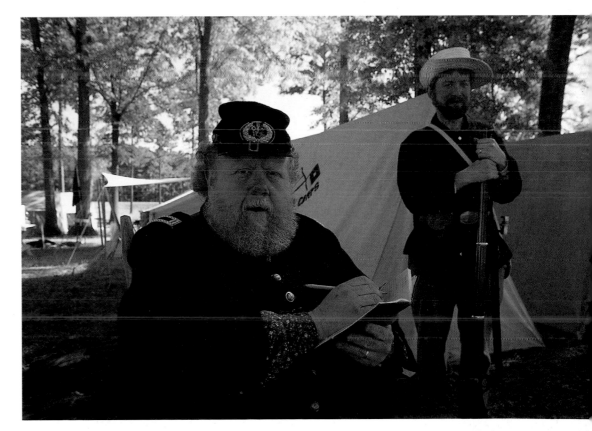

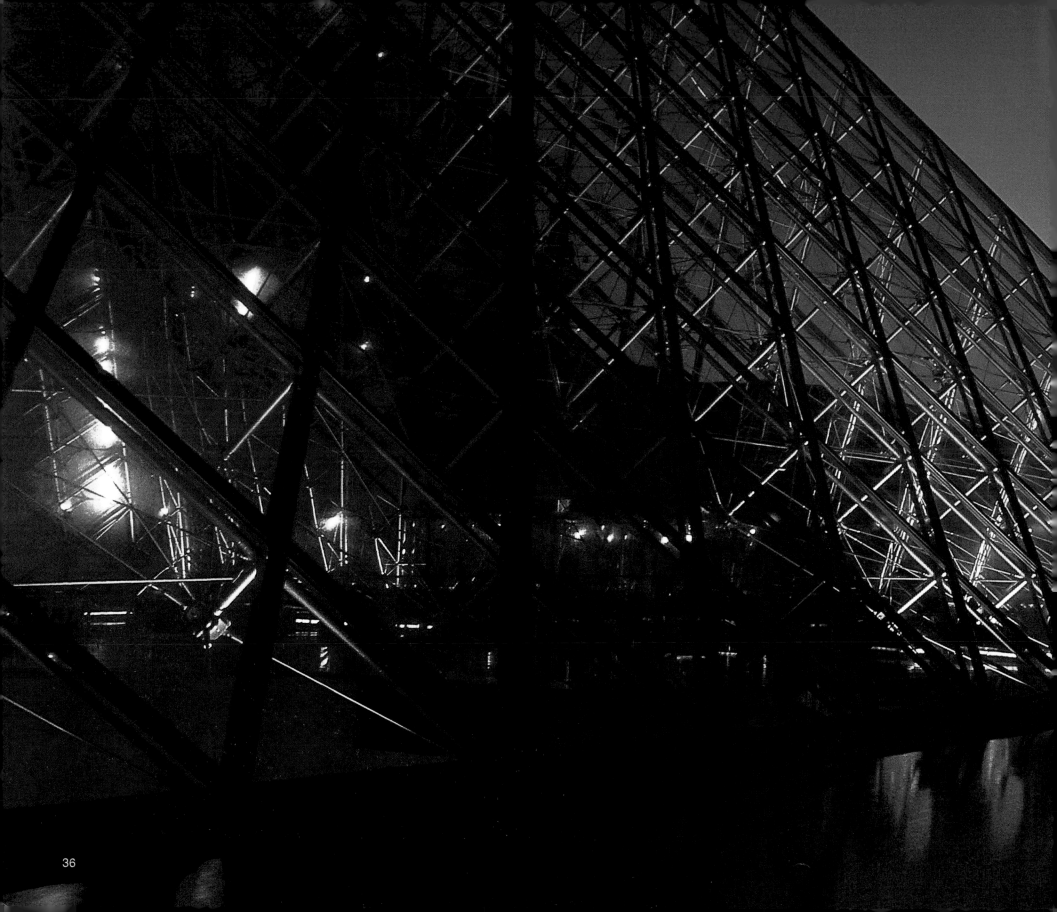

TOWNS AND ARCHITECTURE

THE TWILIGHT HOUR HAS SPECIAL
APPEAL FOR SHOTS OF URBAN
SUBJECTS AND ARCHITECTURE – BUT
YOU CAN SOMETIMES ALSO GET
STUNNING PICTURES IN MIDDAY SUN.

The Pyramid at the
Louvre in Paris,
taken with a
magenta field filter.

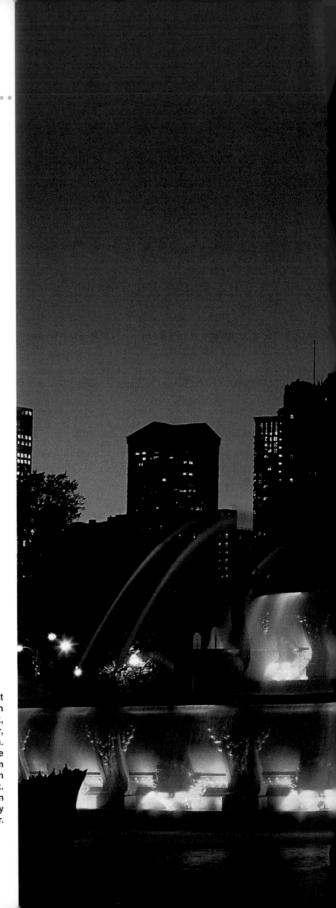

TOWNS AND ARCHITECTURE

Urban subjects for the photographer are literally out there, on the streets. Nowhere are you less dependent on the weather and natural light than in towns – in the country, if the natural landscape is too grey and winterlike, leafless trees don't make a good subject, and fields look dark and barren – in contrast, store windows and neon signs in a town or city will seem brighter than ever.

When out on the lookout for good subjects in cities, I carry my equipment in a small photographic backpack, which I can get at from the side without having to put it down. A small camera with 28–80mm and 80–200mm zoom lenses is all you need; and if you include an extra wide-angle lens for use in high-rise cities, such as New York, you're ready for action.

Go for a stroll as the streets come to life early in the morning, and take inspiration

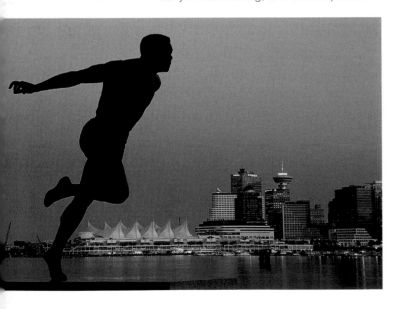

from views of a town across a river or lake in the morning light. Walk on through a street market and then, perhaps, allow yourself a break.

In the deep canyons that are formed between the buildings in New York and other modern skyscraper cities, the best time for taking photos is around midday, when the sun's rays get right down into Wall Street and the brokers come outside to eat their sandwiches at lunchtime.

The afternoon is the time when urban parks come alive, as mothers bring their children to let off steam – or you could think about taking photos of street scenes, monuments, and buildings during this time. Late in the afternoon, pop back to the hotel to change equipment.

For evening shots I set off with a tripod and a larger camera, often a medium-format camera or a more powerful telephoto lens. Use this magical time to shoot skylines over monuments such as the Arc de Triomphe, Tower Bridge, the Statue of Liberty, or the Marienplatz. Twilight, which lasts such a short time after sunset, is also a very good time to photograph store windows – there's a great range of subjects to be found in windows, and most of them photograph well at this time of day if you use a tripod.

For photographing nightlife I take yet another camera with a 24–70mm zoom lens. I push Sensia 100F slide film to 200 ASA and, of course, I take a flash with a TTL lead to be able to make non-stop flash photography.

Opportunities for architectural photography are never far away. Towns and cities all over the world have a lot in common – neon lights and high-rise blocks, store windows, museums, and monuments. So, before going off to take photos in faraway places, plan your techniques and practice closer to home.

Left: **Twilight hour in Staley Park, Vancouver, Canada.**
Right: **The Buckingham Fountain in Chicago at dusk. The fountain constantly changes colour.**

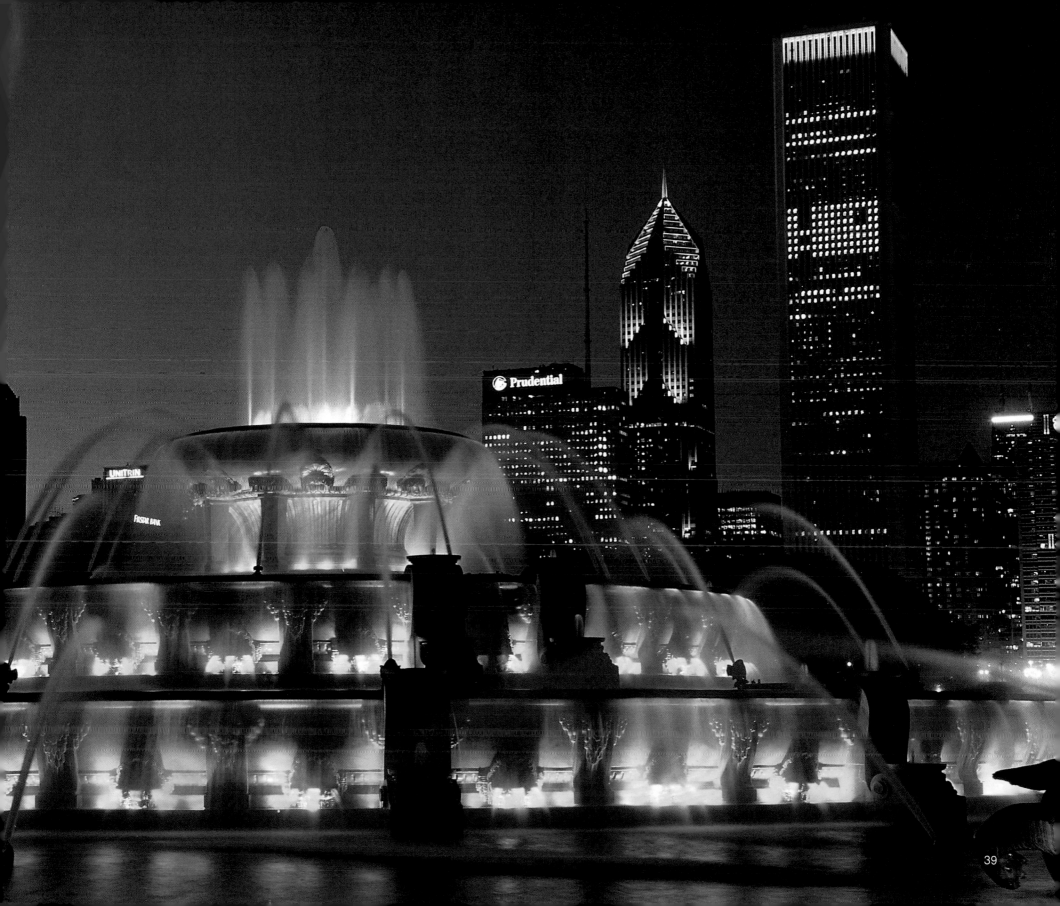

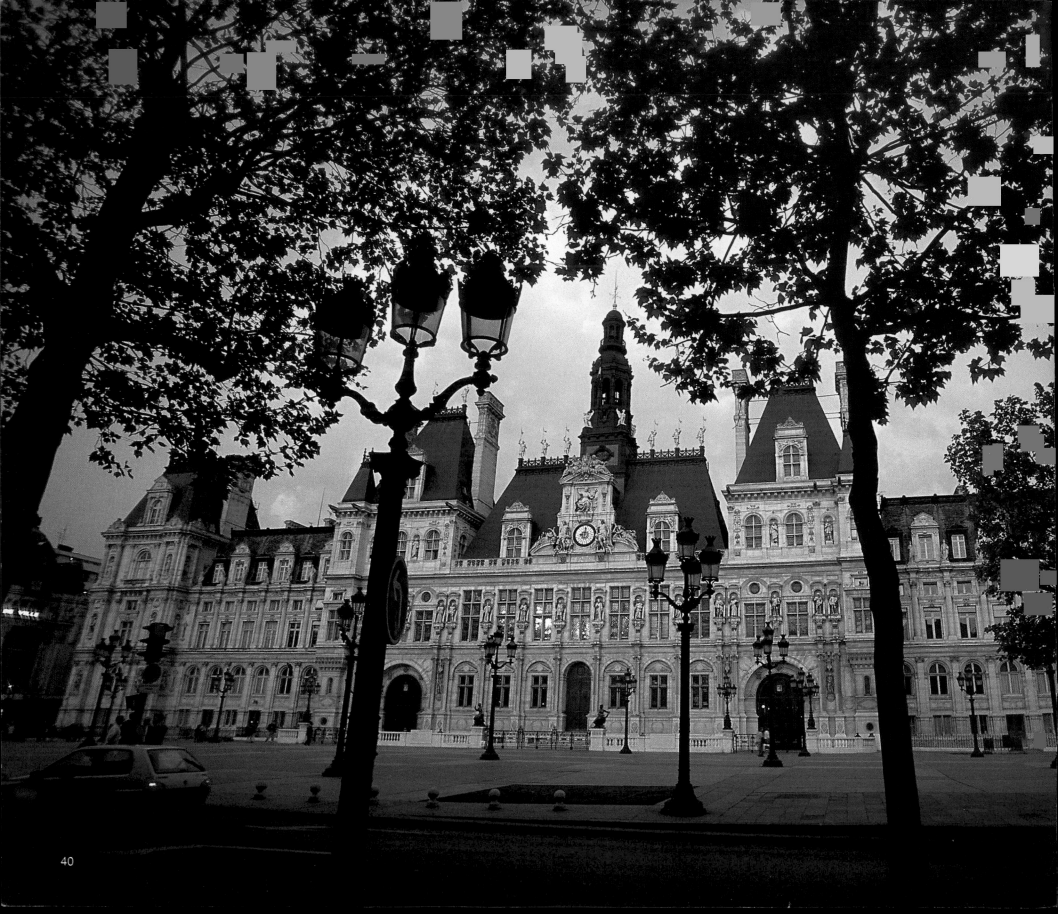

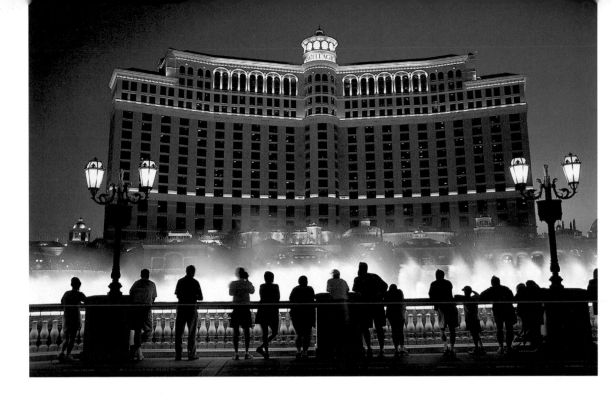

ART

AT SET TIMES A MUSICAL

WATER DISPLAY IS A

FASCINATING ATTRACTION

AT THE BELLAGIO RESORT

IN LAS VEGAS.

Above: **Without the figures, the brightly lit fountains in Las Vegas would be too light.**
Left: **When captured at the magical time of day, the Hôtel de Ville in Paris is given a touch of romance by bringing trees into the picture.**
Right: **The Arc de Triomphe in Paris, taken in the evening.**

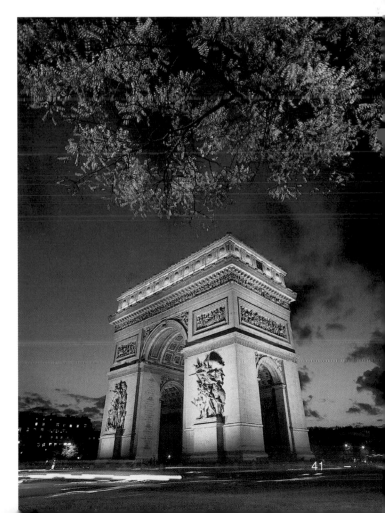

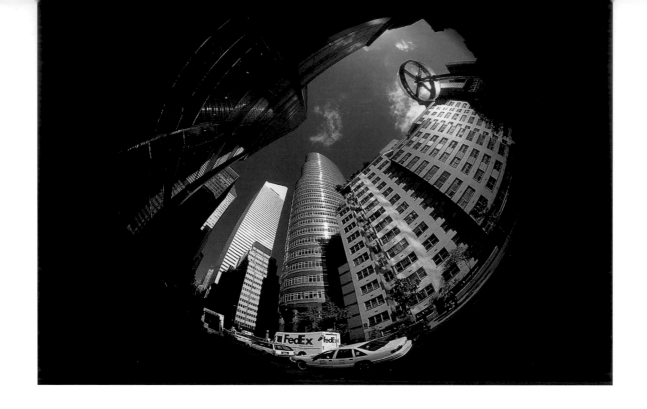

LIGHT

WITH THE RIGHT LIGHT

AND LENS, ANY

ARCHITECTURAL FEATURE

IS WORTH A PICTURE.

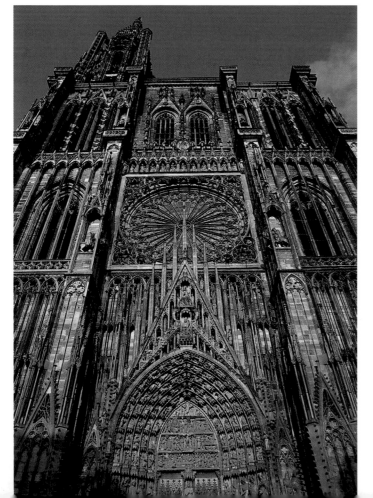

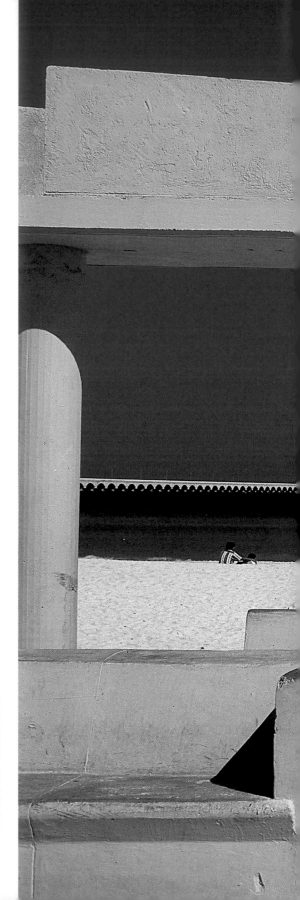

Left: **Strasbourg Cathedral, France.**
Above: **Lipstick Building in New York, taken with a fisheye lens.**
Right: **Graphic picture formation at Campeche, Mexico.**

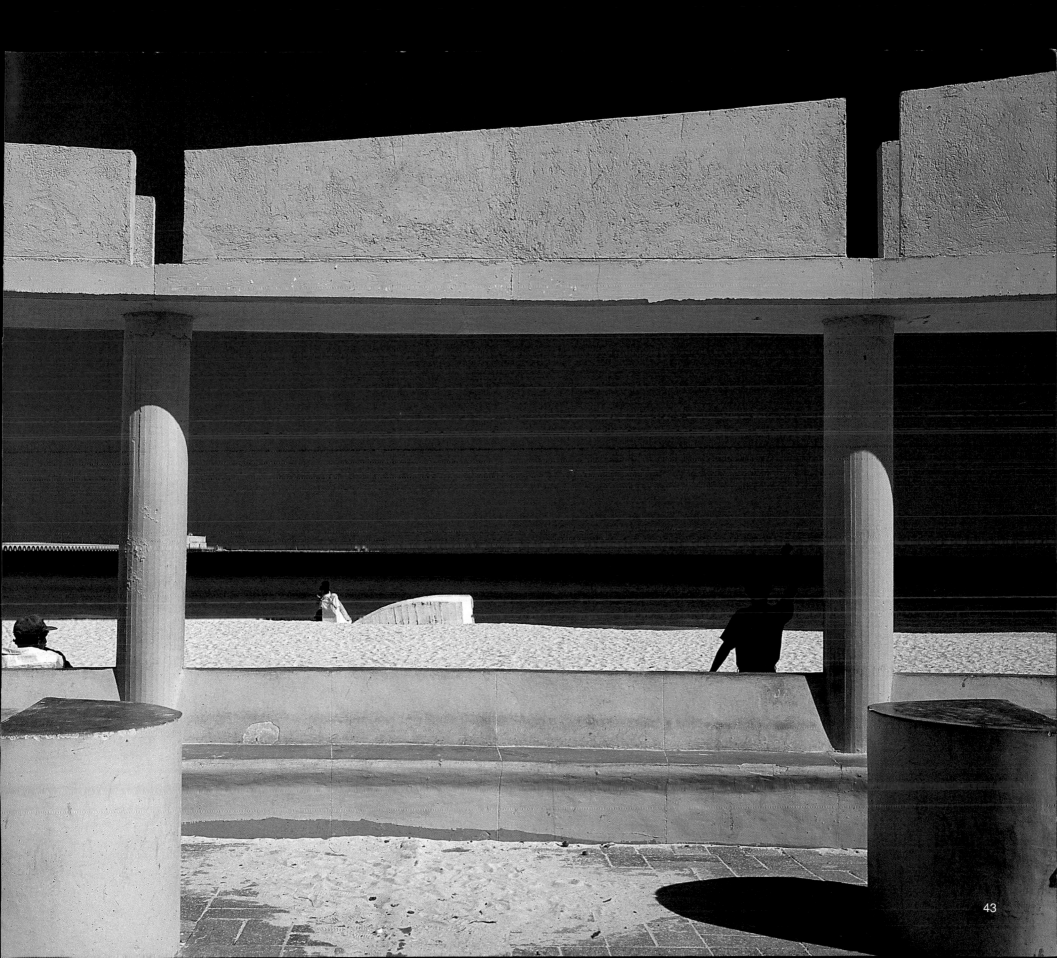

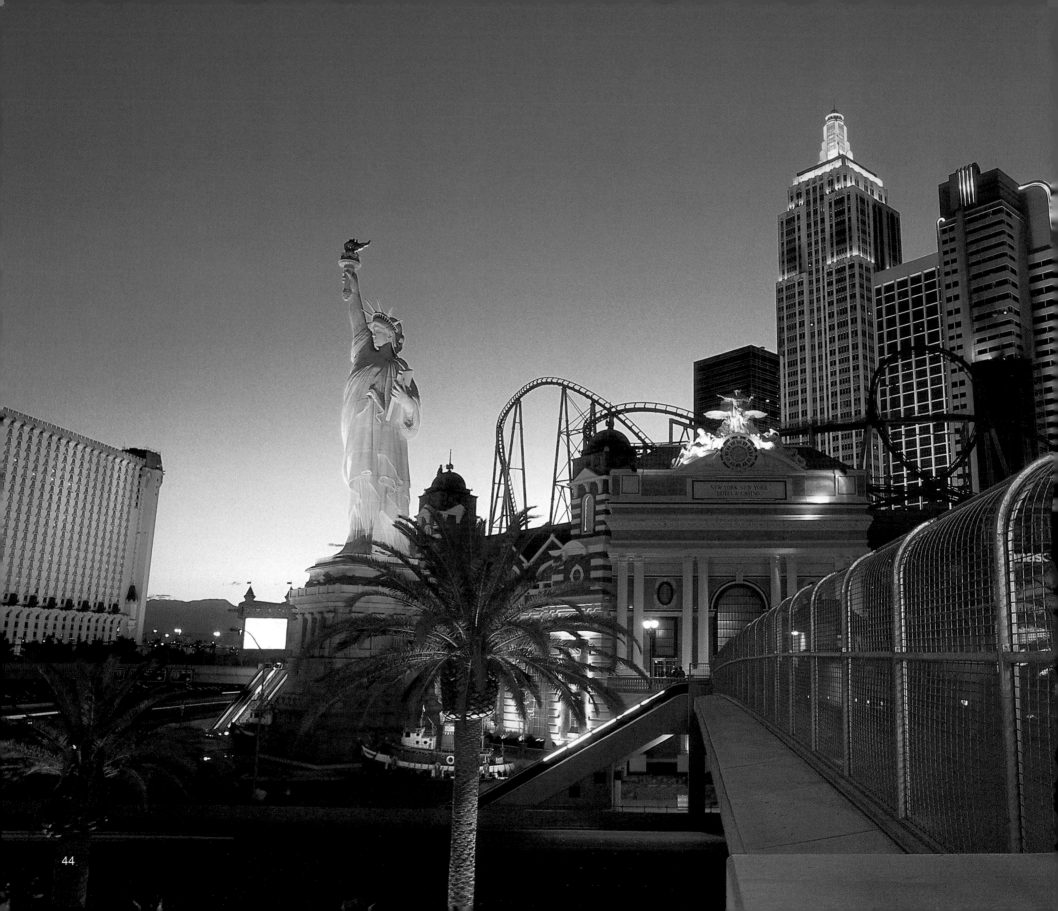

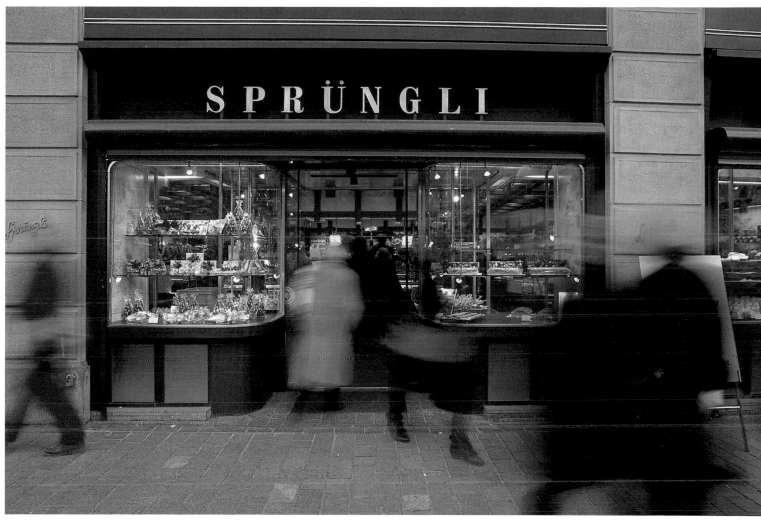

Left: **Las Vegas after sunset.**
Above:
Paradeplatz in Zurich. I wanted the people to be shadows, so I took the entrance to Sprüngli with a 3-second shutter speed during the twilight hour.

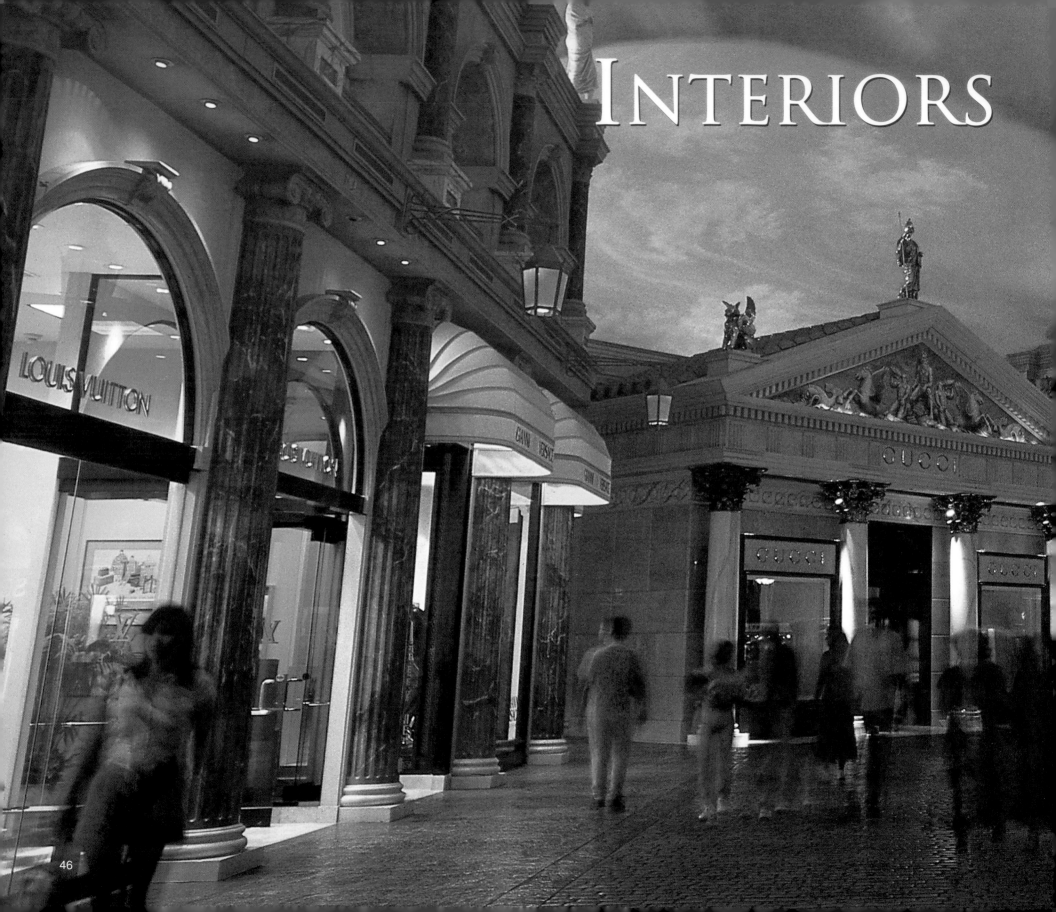

INTERIORS

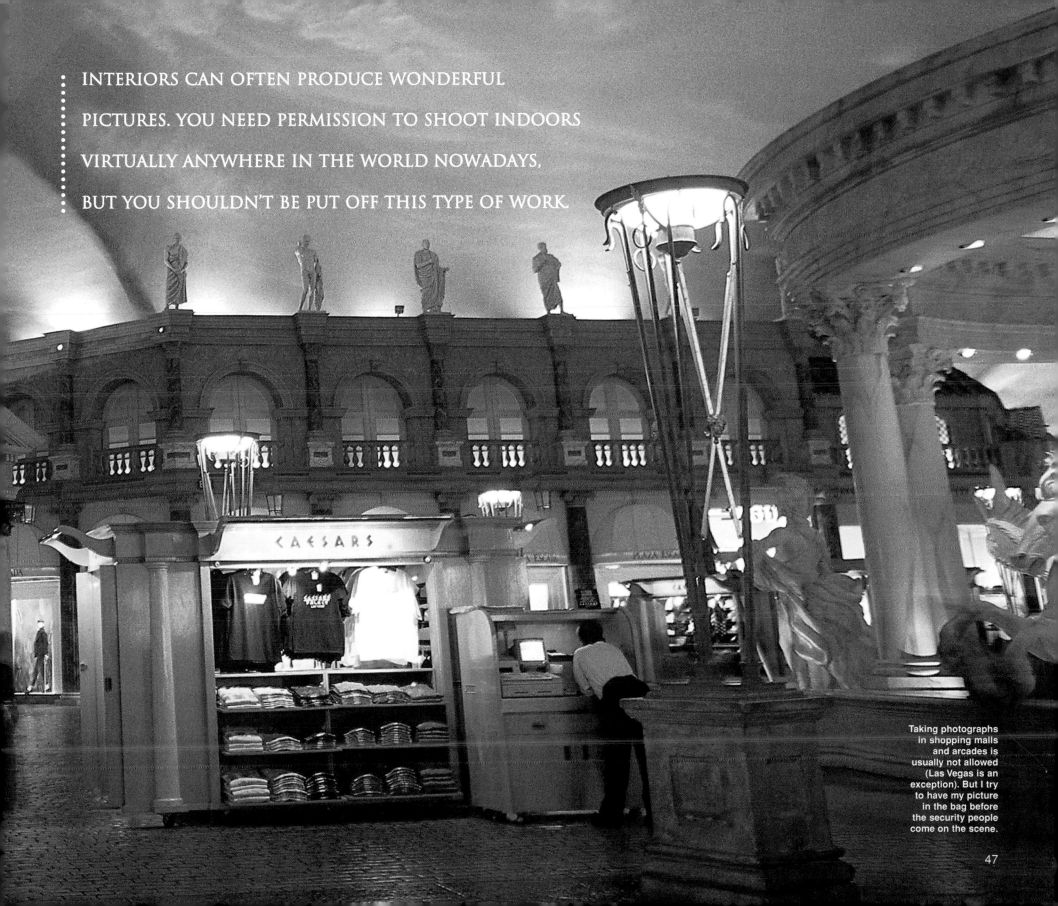

INTERIORS CAN OFTEN PRODUCE WONDERFUL PICTURES. YOU NEED PERMISSION TO SHOOT INDOORS VIRTUALLY ANYWHERE IN THE WORLD NOWADAYS, BUT YOU SHOULDN'T BE PUT OFF THIS TYPE OF WORK.

Taking photographs in shopping malls and arcades is usually not allowed (Las Vegas is an exception). But I try to have my picture in the bag before the security people come on the scene.

47

INTERIORS

Many travel photographers appear to have problems with interior shots, even though interiors often have the potential for really great pictures.

The best time for taking photos is at the middle of the day, when the sun is high in the sky and the only light coming through the windows is reflected light; this is useful, as midday is the worst time of day for landscape photography. You will definitely need a tripod. For interiors you should preferably take your pictures with the exposure into the shadow and not towards a window if you can help it. It's best if the window can be sideways on to the camera, so there is only a hint of it in the picture. Do a trial run first, working with more and more exposure – this is easy to do with modern cameras.

Shots with mixed lighting can produce really sensational results, as the cold light of day streaming through the window blends with the warm, golden glow of the electric lighting. But watch out for fluorescent lights, as the green cast of light can ruin the feel: a powerful magenta filter is a good idea here.

An 18mm wide-angle lens is suitable for interior shots, as it helps makes smaller areas appear bigger and thus gives the viewer more to look at. The same rule applies to interior shots as for all photography: you need to look at the light before taking the picture. Measure the individual fields with partial metering. If the contrasts are too high, change the picture detail slightly, switch on a few more lights or close some of the curtains.

For evening shots in poor light with long exposure times I often use a torch to make individual sections lighter –it becomes a creative paintbrush in my hands. Trying out new things is what creative photography is all about. Set rules are there to be broken, and time and time again I get the most fantastic pictures in situations where my head is telling me that it can't be done.

Interior shots are really easier than you think! Amateur photographers usually find they come out too dark – if this is the case, you aren't using the right exposure: overexposure with one aperture setting higher is often all that's needed. Anyone who wants to be on the safe side will use a negative film.

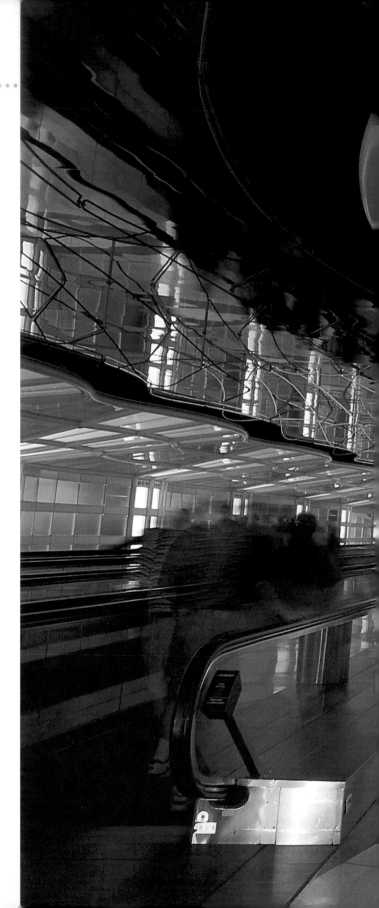

Left: **'Entertainment streets'** like this one can be found in South Africa and, of course, in Las Vegas. Right: **Chicago's O'Hara International Airport** with neon lighting.

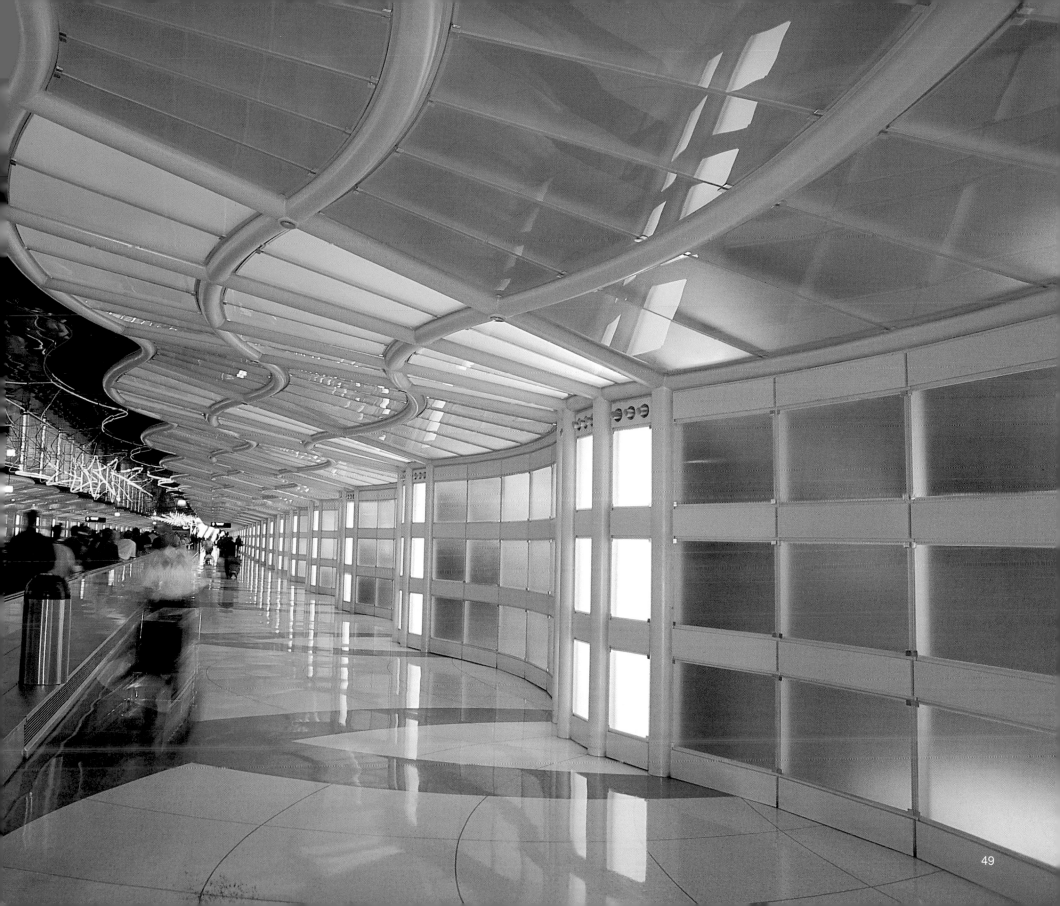

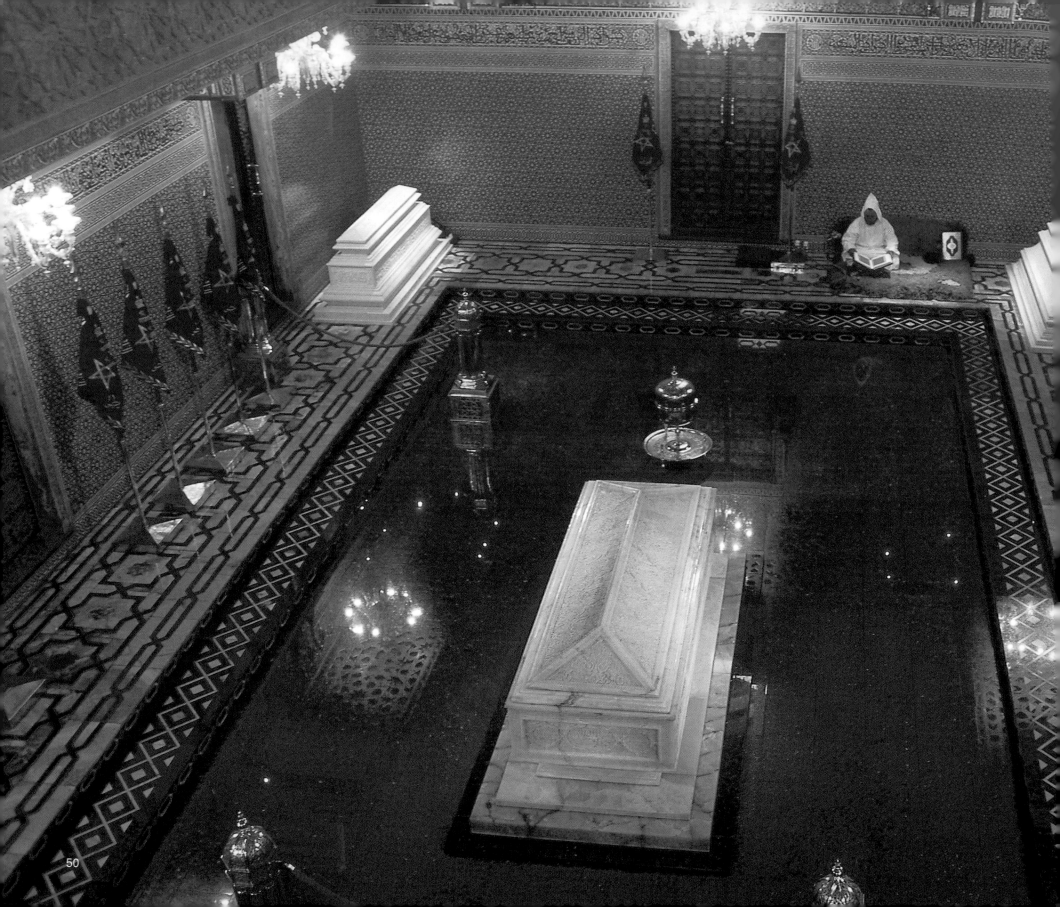

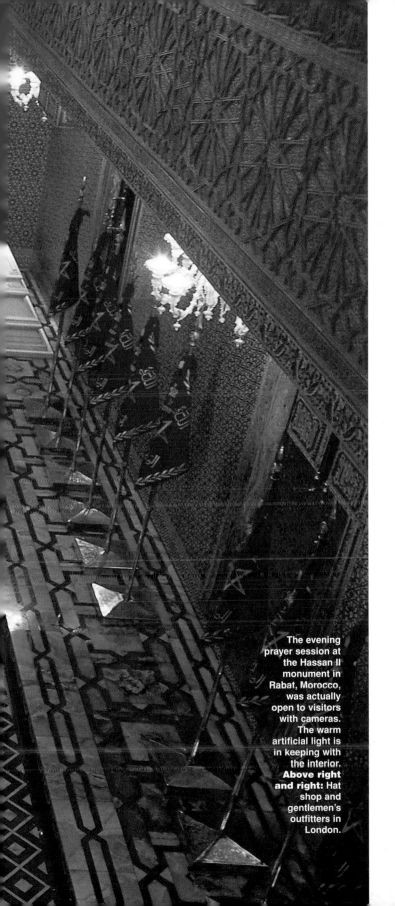

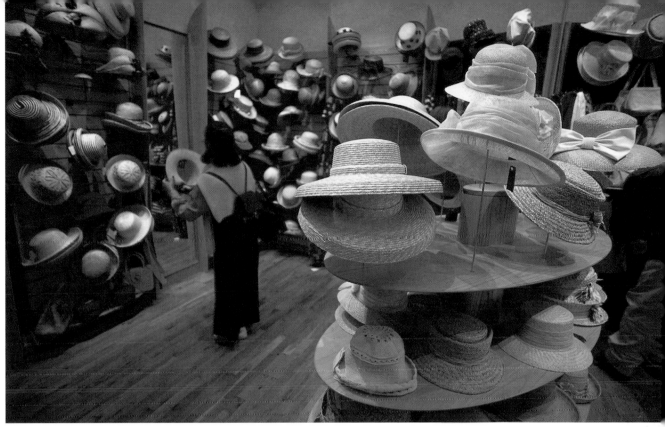

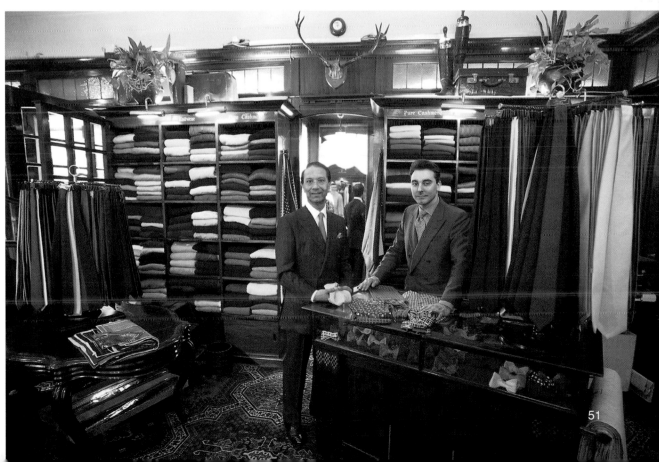

The evening prayer session at the Hassan II monument in Rabat, Morocco, was actually open to visitors with cameras. The warm artificial light is in keeping with the interior. **Above right and right:** Hat shop and gentlemen's outfitters in London.

51

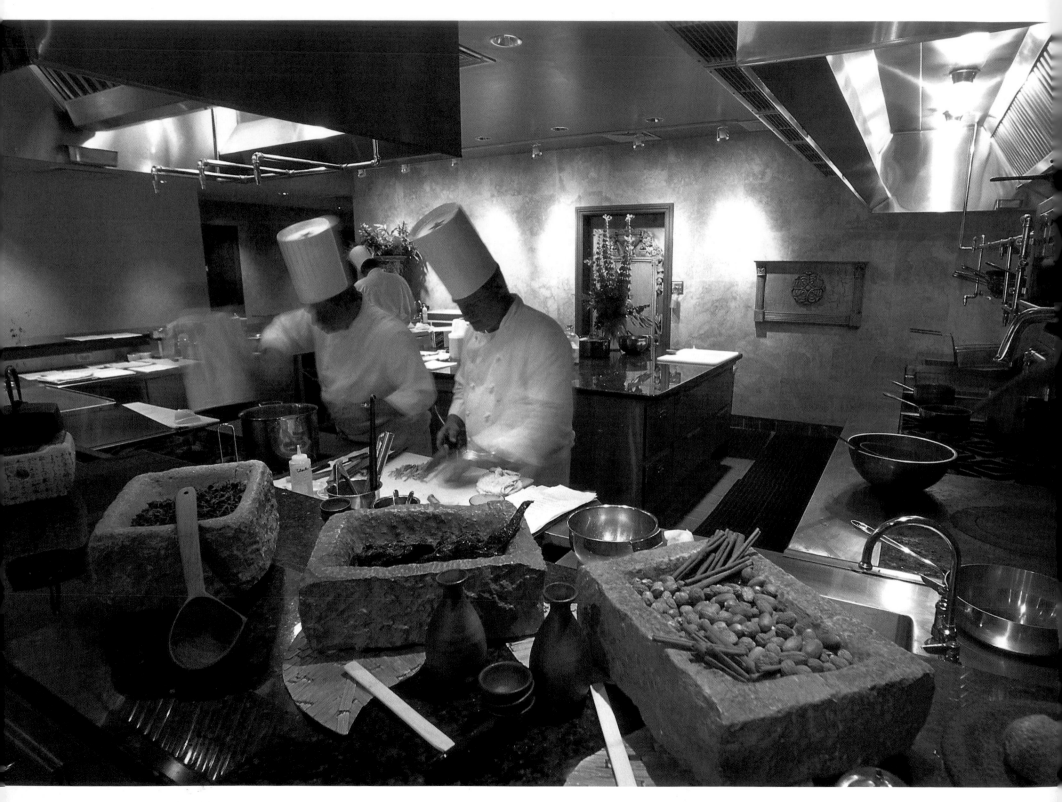

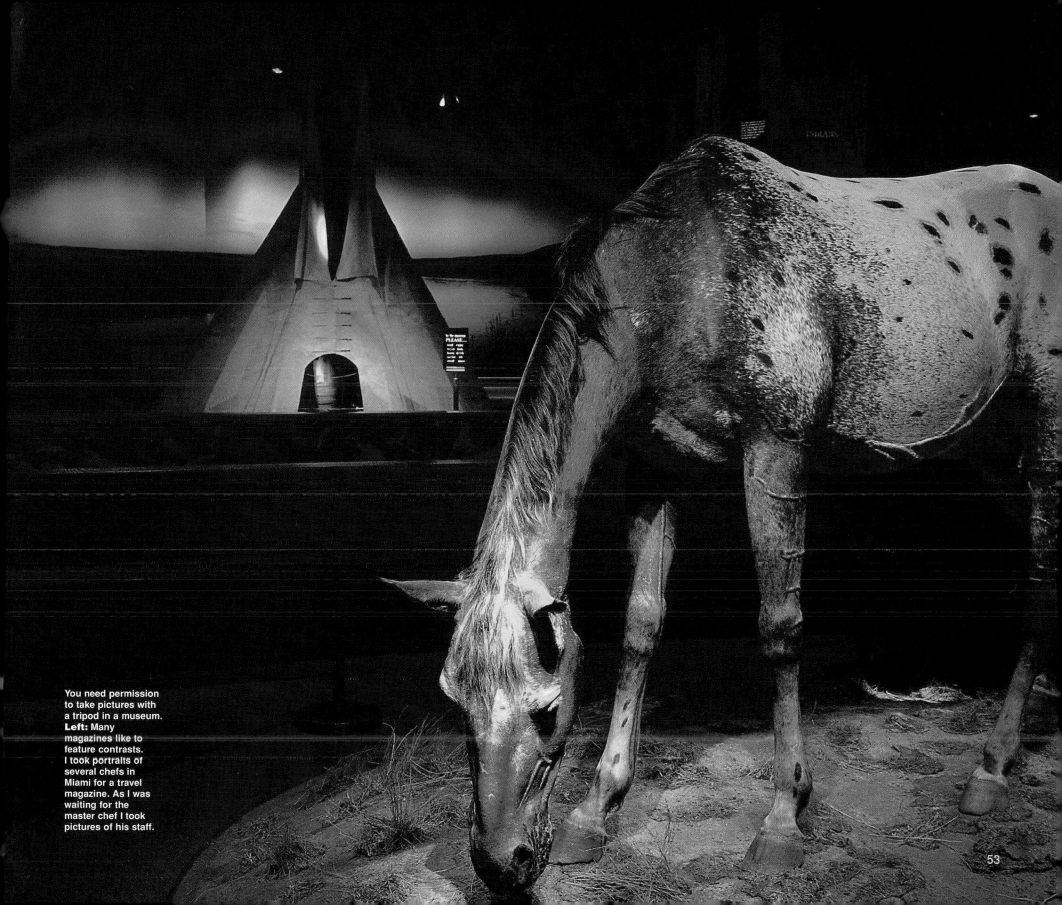

You need permission
to take pictures with
a tripod in a museum.
Left: Many
magazines like to
feature contrasts.
I took portraits of
several chefs in
Miami for a travel
magazine. As I was
waiting for the
master chef I took
pictures of his staff.

THE ANIMAL KINGDOM

AS FELLOW INHABITANTS OF THIS
PLANET, ANIMALS NEVER CEASE TO
FASCINATE – LARGE OR SMALL, WILD OR
DOMESTIC, THEY ALL CAST THEIR SPELL.

Group of
ostriches in
South Africa,
taken early in
the morning with
a 35mm lens.

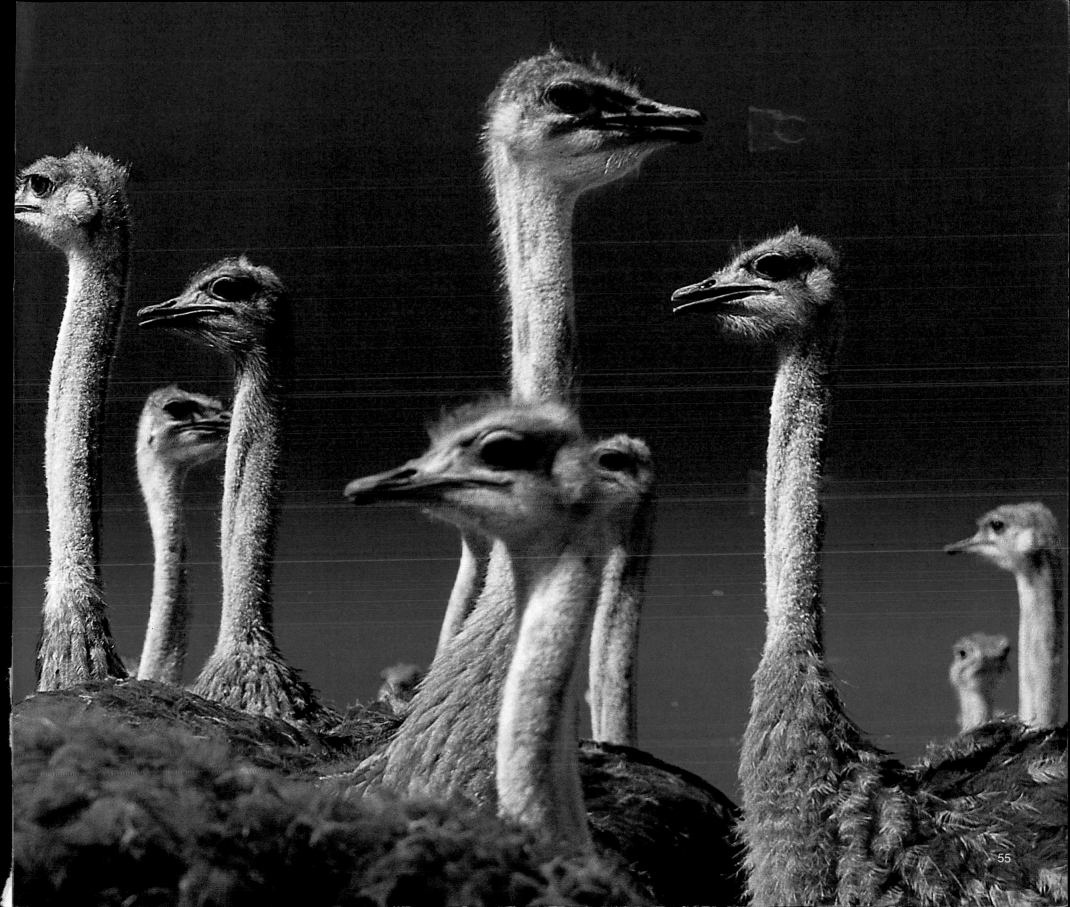

ANIMAL KINGDOM

Man has a special relationship with his fellow inhabitants of Planet Earth. They are an endless source of fascination – from birds to domestic cats, predators to elephants, photographers love taking pictures of animals. Animal pictures regularly carry off the prizes in important competitions, and animal photographers such as Art Wolfe or Frans Lanting are as famous as film stars.

In contrast to static subjects like landscapes or buildings, animal photography requires a basic knowledge of biology. Good animal pictures are the result of the photographer's hard-won experience and patience, producing an picture which does the species justice. Animal pictures are portraits of our fellow inhabitants.

One of the big problems in this field is disturbing, or even endangering wild animals for a photo. Interfering with the natural order in what may seem an insignificant or harmless way can have devastating consequences. Photographers should therefore follow this basic principle: it's better to have no photo at all than to endanger an animal in its habitat. Without realizing, you might scare a bird away from its nest, leaving its eggs unprotected, or you might disturb an owl in winter and in doing so reduce its energy for hunting.

With the erosion of habitats and the threat of extinction faced by animals today, photographers have to behave sensitively when dealing with the natural world.

A colony of gannets, a jackal in South Africa or a bird in the glowing daylight – these pictures have one thing in common: they were all taken using Fuji Velvia Film.

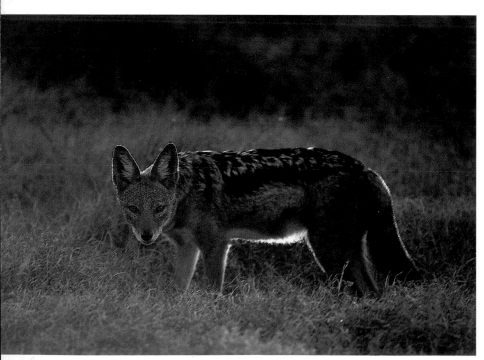

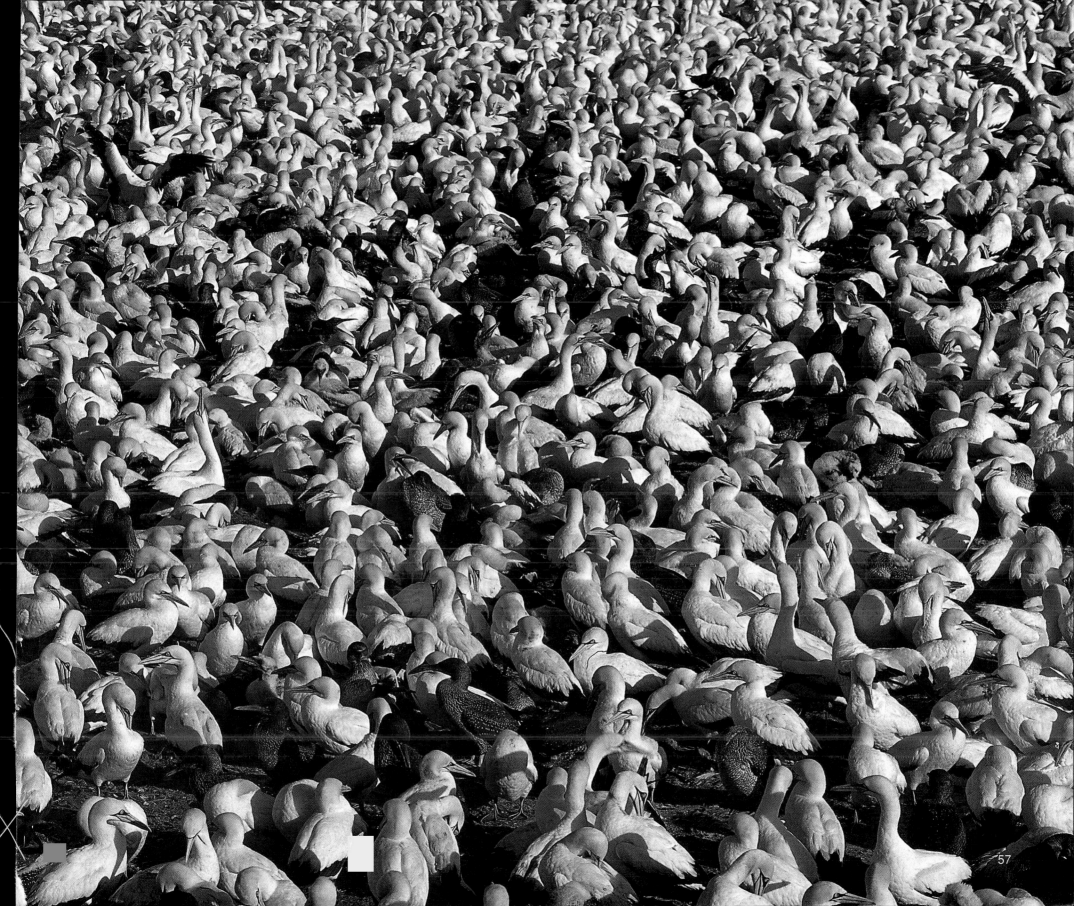

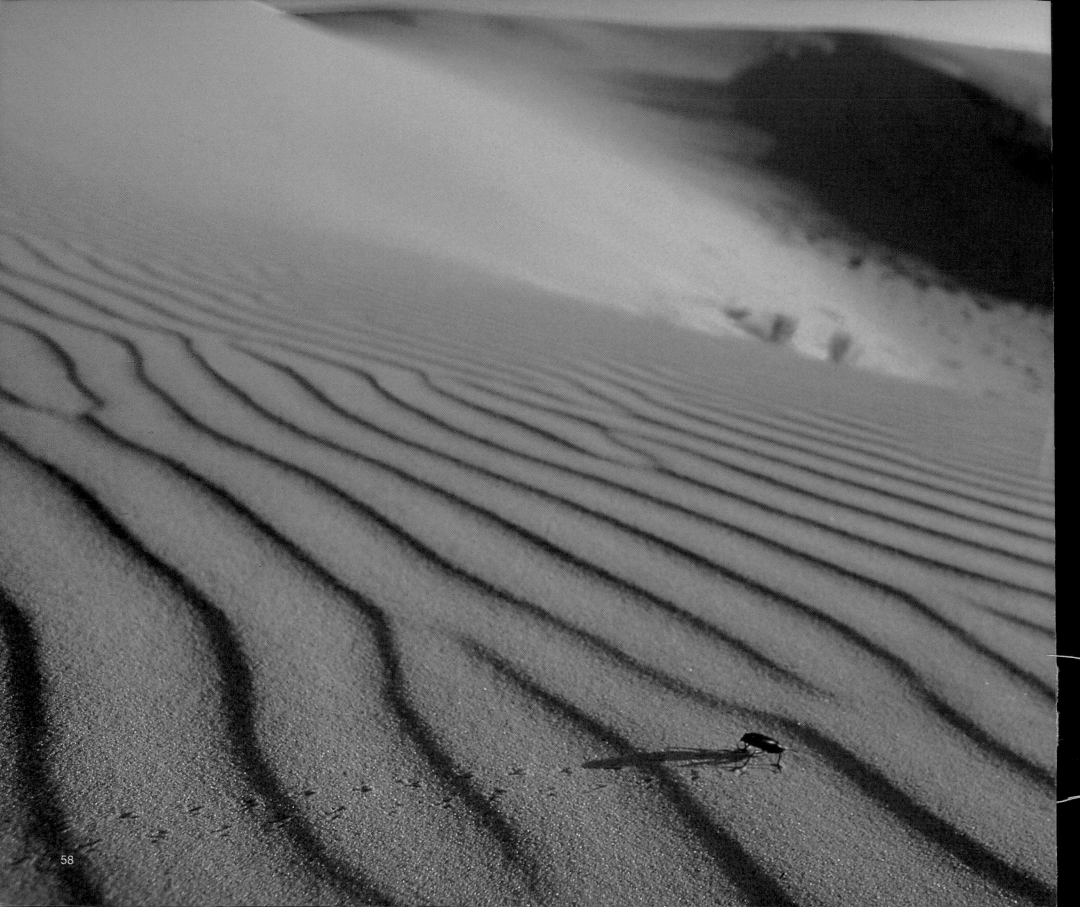

In the East Texas dunes I lay in the sand and took photos of this beetle in the evening light with my Nikon F5 and a 24mm wide-angle lens.

NATURE

ANIMALS IN THE WILD

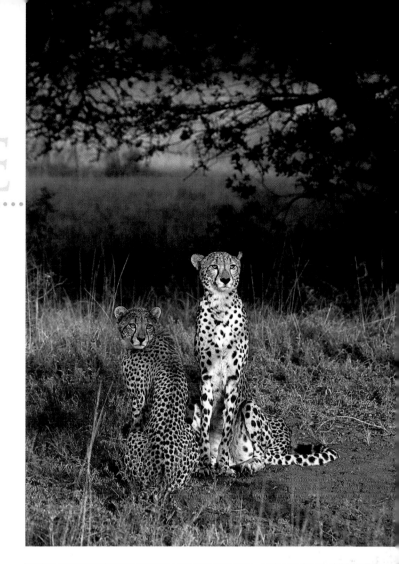

Previous experience is invaluable in animal photography. Whether you want to take bears in the Katmai National Park, Alaska, or gannets in St Mary, Newfoundland, the relevant hotspots offer the ideal opportunity to take photographs of wild animals.

Compared with a specialized animal photographer, the travel photographer is at a disadvantage, usually being pressed for time. While the animal professional can set up a hide and lie in wait, the travel photographer has to rely on a fair share of luck. The motto is: be prepared at all times.

If I'm driving through a National Park, such as Yellowstone in the USA, Etosha in Namibia or Banff in Canada, I always have a Nikon F5, with 500mm telephoto lens fitted, ready for action on the back seat of the car, plus a second camera with an 80–200mm zoom lens on my knees; the former is loaded with a 100–200 ISO film, the other with Fuji Velvia, my favourite film. On walks I keep an 80–200mm camera handy in a front pocket or loose in my hand. I always take a tripod. Then there's a 300mm telephoto lens and a converter in my rucksack.

It's often easier to take photos of animals from the car. They take you for a single entity together with the car and can't distinguish between the vehicle and the person – on foot you would be seen as a predator, something to be frightened of. A tripod clip or a small sandbag can be useful when setting up the telephoto lens in the vehicle's window frame.

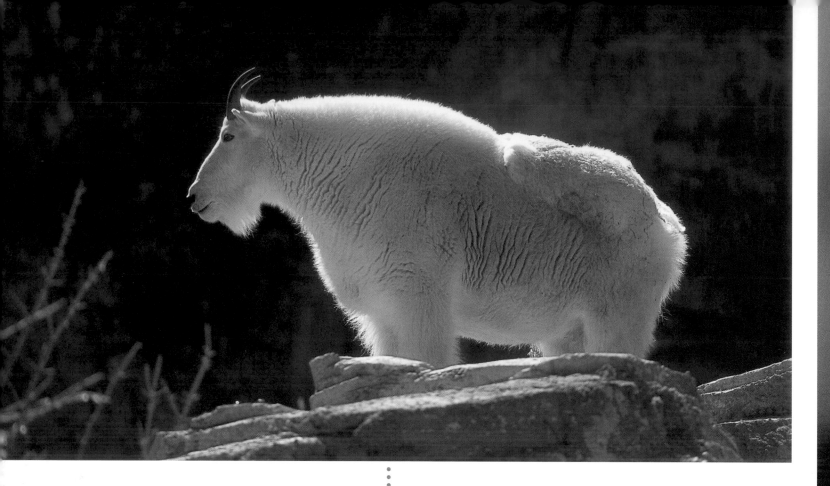

ZOOLOGICAL

ZOO ANIMALS

Zoological gardens should not be ruled out entirely for animal pictures. If you are prepared to spend a day waiting patiently at the zoo with a tripod and telephoto lens, it's possible to get lovely portraits of animals – but don't get the bars of the cage into the picture! The easiest way is to place the telephoto lens right up to the cage.

Modern zoos provide the animals with large, more natural enclosures, and therefore have more to interest the photographer. If you're thinking of selling pictures, it's important to make a note of where the photo was taken.

Above: **I took this picture of an ibex on the Gornergrat in the Valais, Switzerland, with a 300mm lens, just before sunset.**
Right: **I also used a 300mm lens to catch this lizard in Namibia.**

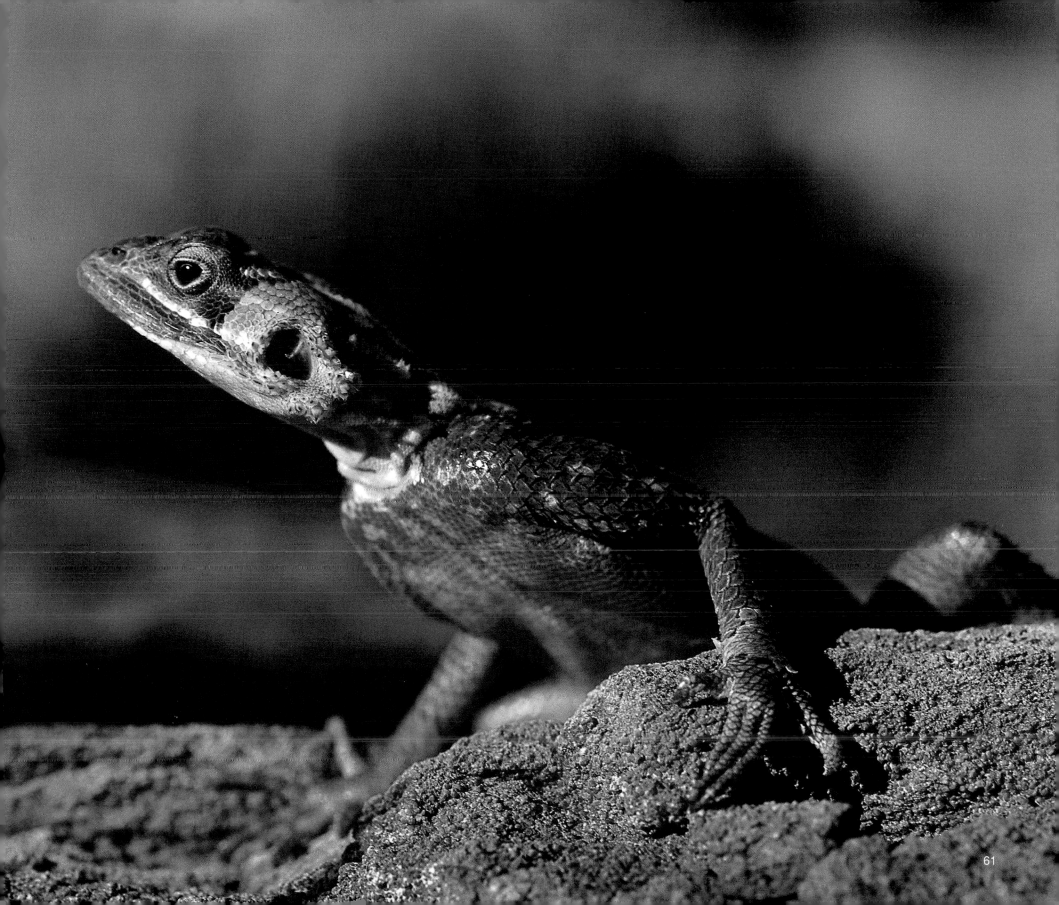

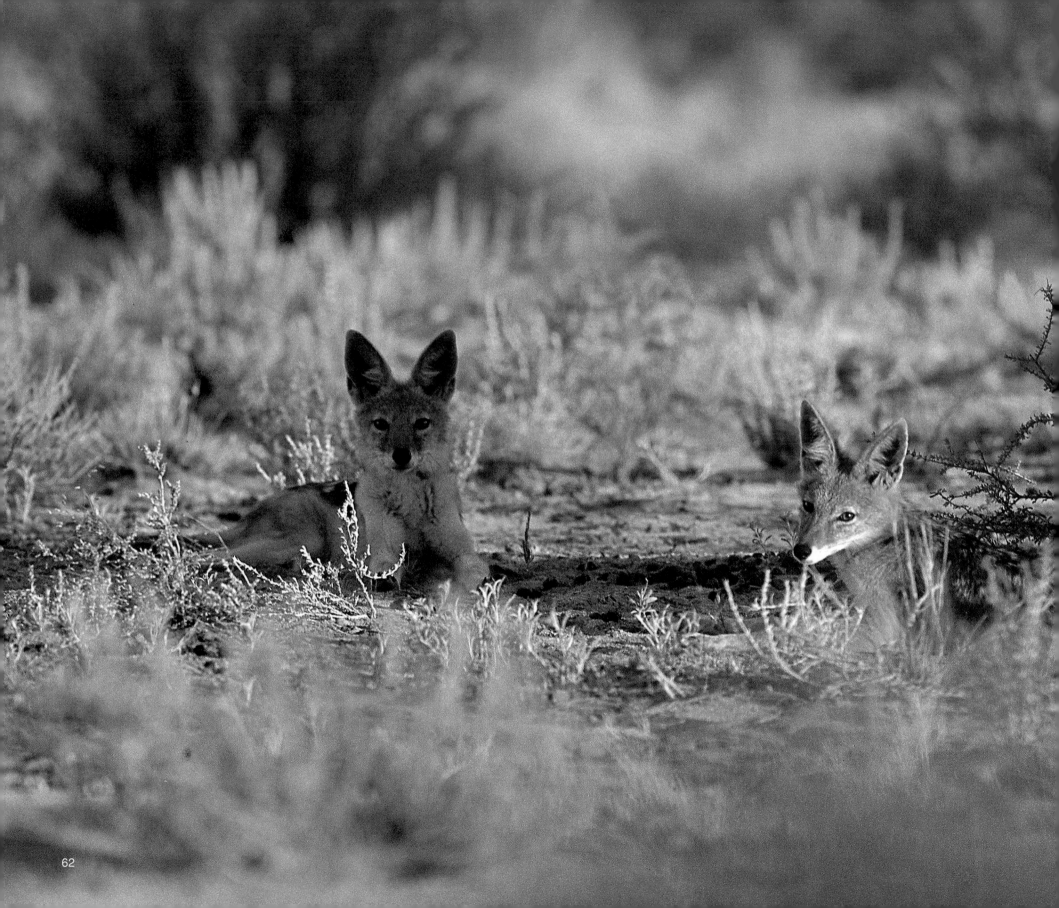

GAME FARM

ANIMALS ON THE GAME FARM

Private game reserves offer ideal conditions for superlative animal photos. Nature reserves such as Sabi Sand or Phinda in South Africa have magnificent country for safari. Anyone who can afford it can be driven directly alongside leopards, cheetahs and lions.

Although these parks are as natural as the nearby Krüger National Park, for example, they have the added advantage of open Land-Rovers that are allowed to get off the marked roads. The rangers often drive up so close to the big cats that you can snap away at them with a pocket camera. As I only had a 500mm telephoto lens with me, I occasionally had to ask to be taken farther away to get the right distance.

The USA has what are known as game farms, where you can take photos of tame pumas and lynxes if you are prepared to pay a lot of money. A lot of professional photographers use these farms and ruin the market for animal photos painstakingly captured in the untamed wild. The advantage of these game farms, however, is that big cats living wild are not put under any pressure from photographers.

The alternative is to chase pumas and lynxes up a tree with hunting dogs and then take photos in peace. In Canada, I was once lucky enough to take a photo of a lynx on a lunch break – you always need a fair share of luck.

Left: **When I had to come out into the open in the Kalahari, I noticed that I was being watched by the jackals. Of course I had my 300mm telephoto lens to hand.**

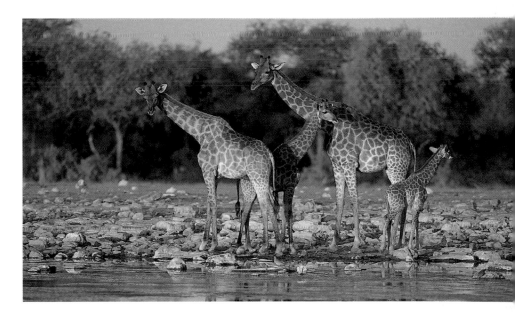

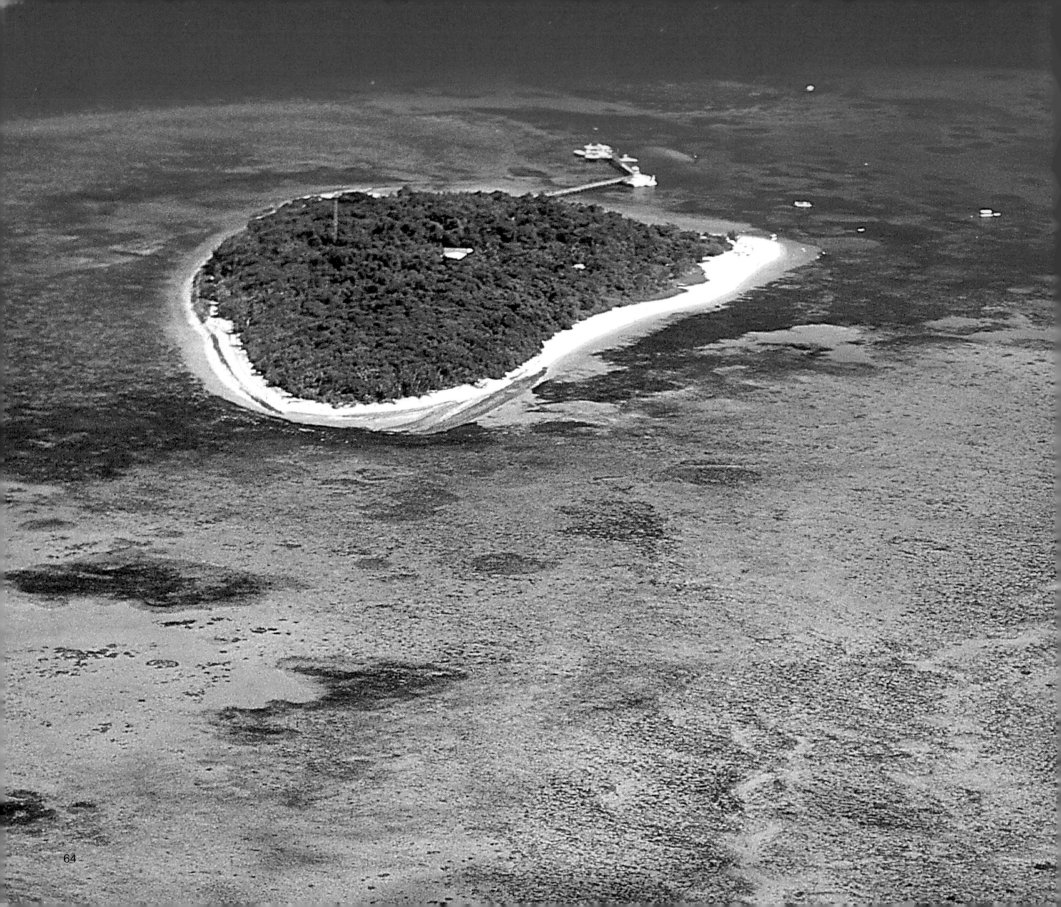

AERIAL PHOTOGRAPHY

THE BIRD'S-EYE VIEW PUTS THE

WORLD IN A DIFFERENT PERSPECTIVE,

MAKING YOU REALIZE HOW

INSIGNIFICANT MAN IS WHEN SEEN

FROM A GREAT HEIGHT.

The Great Barrier Reef in Australia. I sat in the open doorway of a single-engine Cessna to take this shot.

FASCINATING AERIAL PHOTOGRAPHY

It's a familiar scene. The scheduled flight takes off at McCarran Airport in Las Vegas. A few minutes later the Grand Canyon comes into the passengers' field of vision. As a keen amateur photographer you take a few snaps through the window, but no sooner have you pressed the shutter button than you know that when you get home you'll throw the pictures away.

It doesn't have to be like this – but taking shots through aircraft windows is hardly ever any good. The only way to take clear pictures is with the lens in the right-hand corner of the window. The aircraft then has to bank sideways, which will happen from time to time after take-off and shortly before landing.

It's far better, however, to hire a light aircraft, such as a Cessna, with a pilot on the spot. In the USA it costs $80–200 to hire a sporting aircraft with a pilot. Before the flight, remember to ask whether the window can be opened and whether the wings are mounted on the roof. Sometimes the door can also be taken off its hinges. Discuss beforehand with the pilot what you would like to take photos of, and agree on what sign language to use – the noise of the engine makes any conversation in the cockpit very difficult.

You can also take aerial photos from a balloon or helicopter. However, on a helicopter flight there is so much vibration that it is hard to take clear pictures without a gyro stabilizer, which is very expensive. On the other hand, a balloon is very slow, and it takes a long time to get to your favourite subject. In a light aircraft you shouldn't use any shutter speed under 1/250 second. 100–200 ISO slide film is ideal; but having said this, I nearly always use Fuji Velvia film. In the air I prefer a focal length of 80mm, and normally use two cameras with different focal lengths. A 28–70mm zoom is thus an ideal all-round lens for aerial shots.

Make sure to set your camera's exposure meter back by an aperture value of about two-thirds, so that the shots will automatically be somewhat underexposed, otherwise your aerial shots will be too light – but don't forget to reset it later on! Partial metering on the light areas of the landscape is also a good idea, and a polarizing filter is useful throughout the day. Avoid the harsh midday sun, and fly at sunrise or late in the afternoon. A bird's-eye view of the world with views from an unfamiliar angle will round off a travel article nicely.

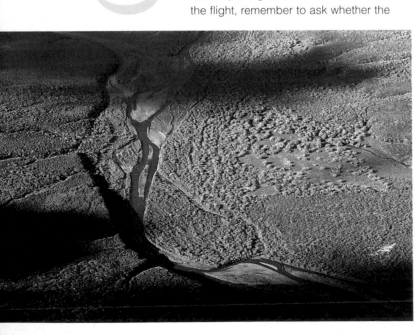

Left: **The wide branching of the river can only be shown from the air.**
Right: **I really wanted to show White Island in New Zealand in the fading evening light – but in fact it became a spectacular daytime shot.**

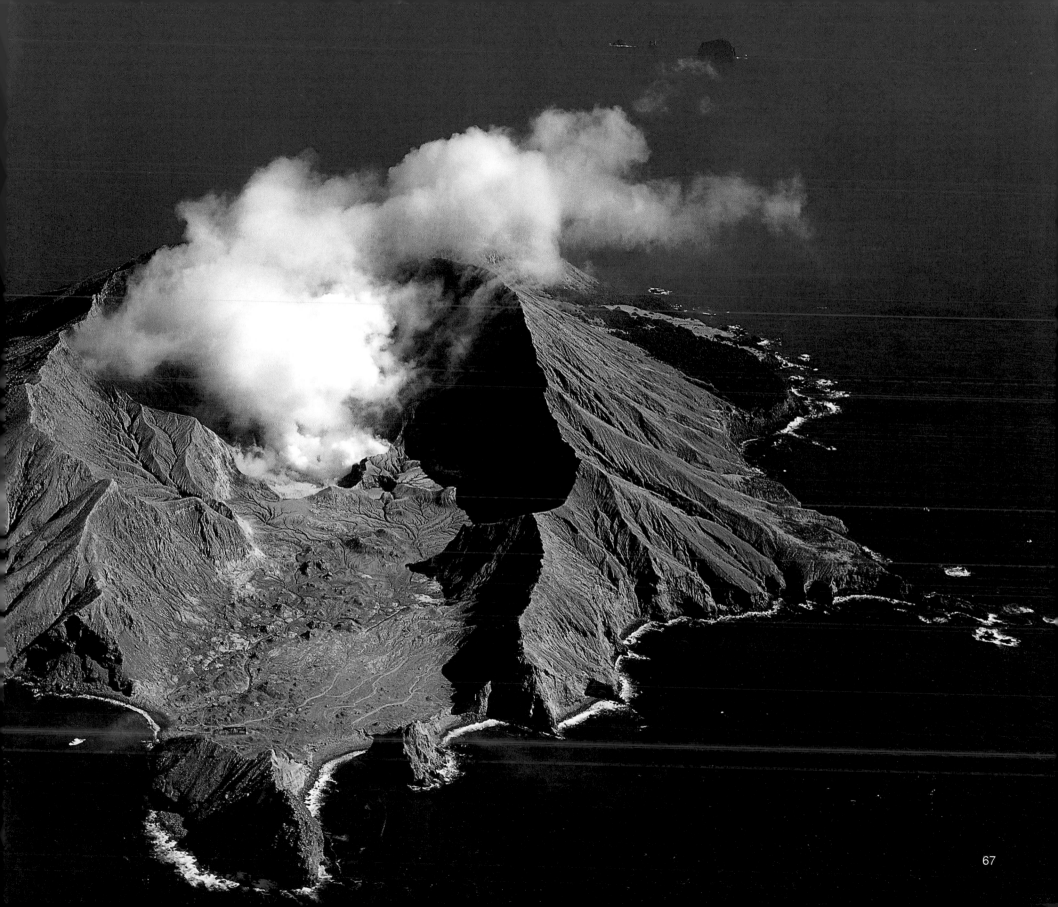

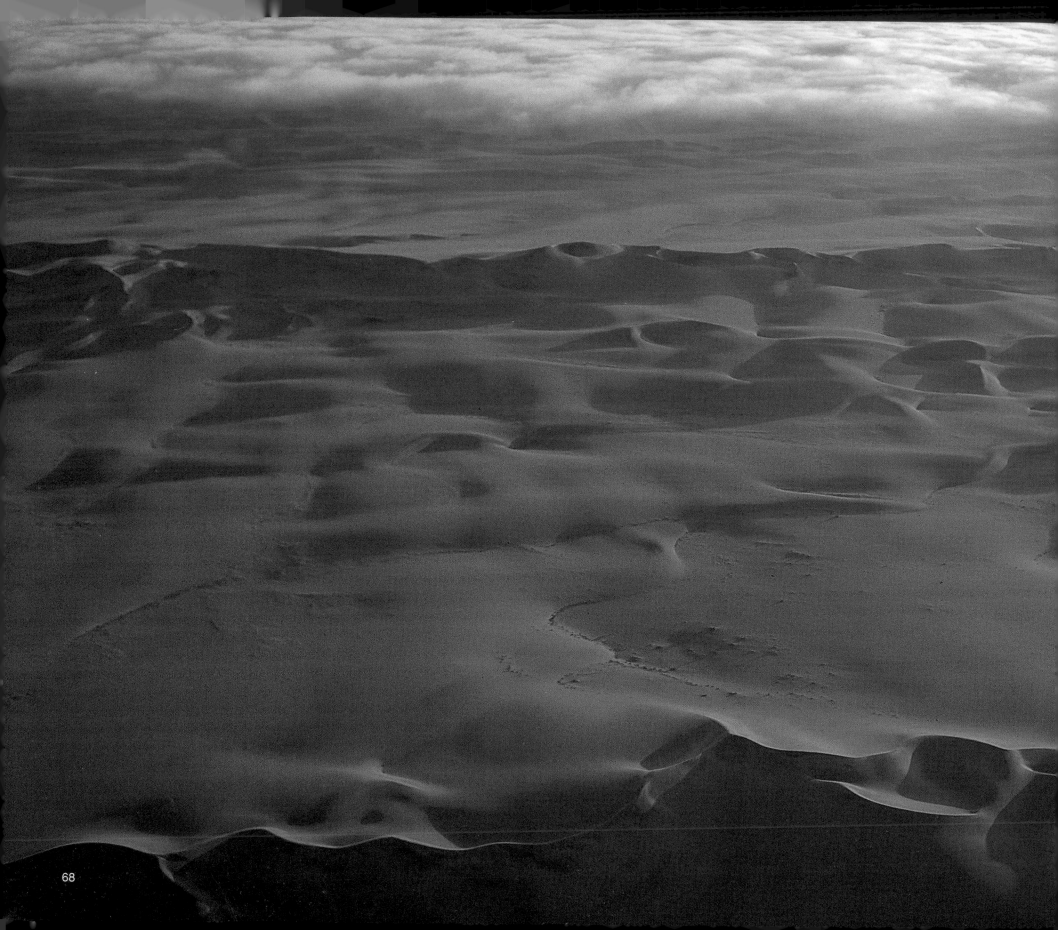

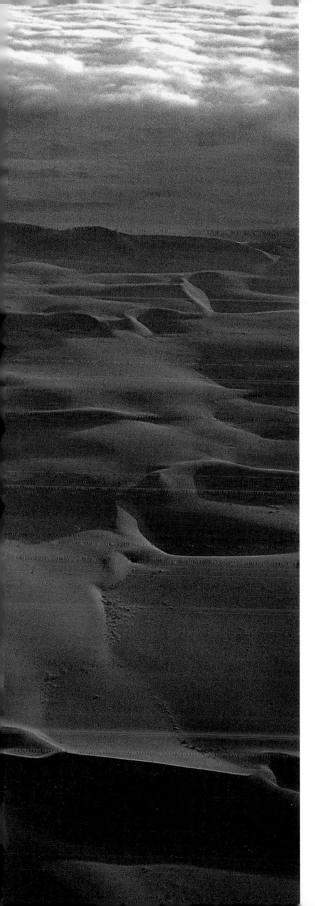

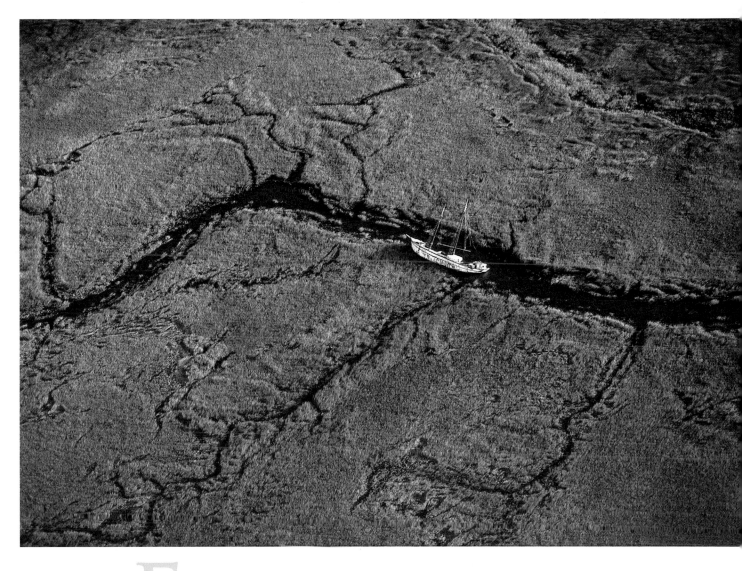

Left: **In the fading evening light we flew over the never-ending sand dunes of the Namibian desert to the nearby sea.**
Above: **I snapped this stranded yacht in Georgia's 'Low Country', in the USA.**

FREEDOM

A BIRD'S-EYE VIEW OF THE WORLD IS

ONE OF THE BEST WAYS OF

ROUNDING OFF ANY TRAVEL ARTICLE.

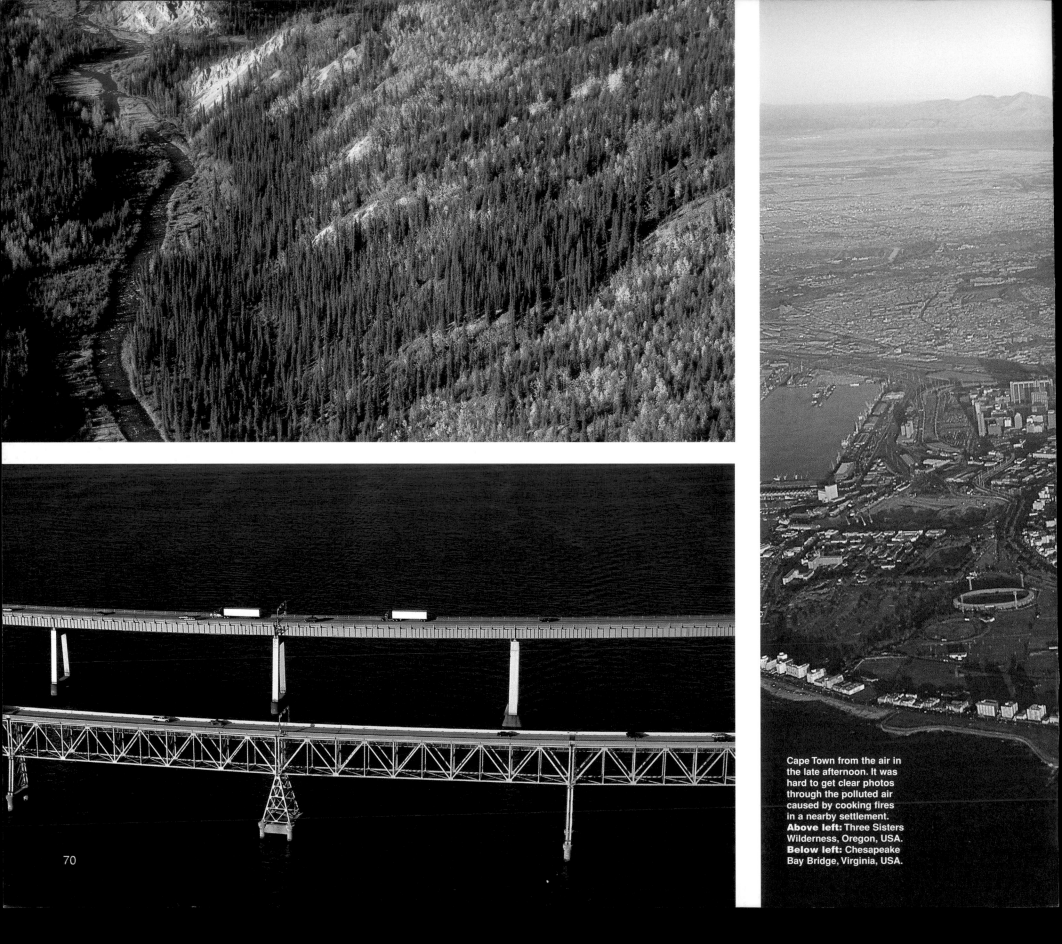

Cape Town from the air in the late afternoon. It was hard to get clear photos through the polluted air caused by cooking fires in a nearby settlement.
Above left: Three Sisters Wilderness, Oregon, USA.
Below left: Chesapeake Bay Bridge, Virginia, USA.

70

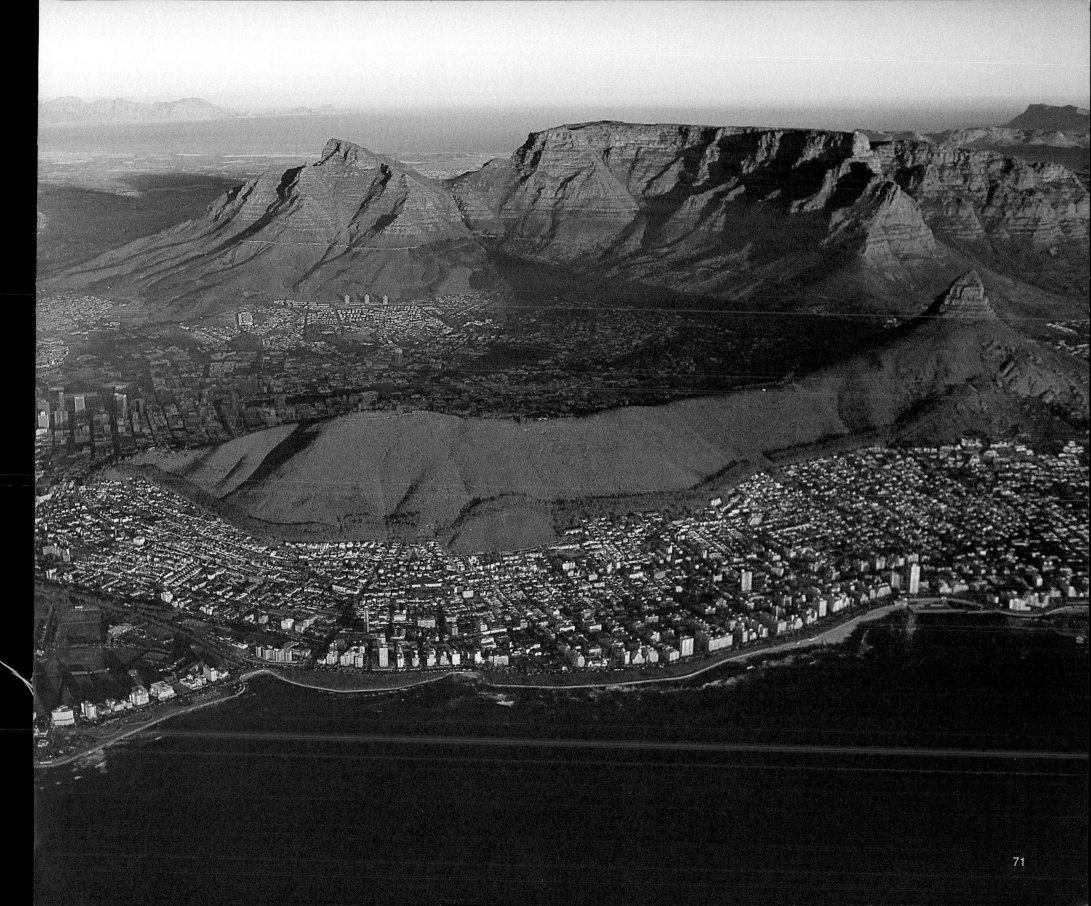

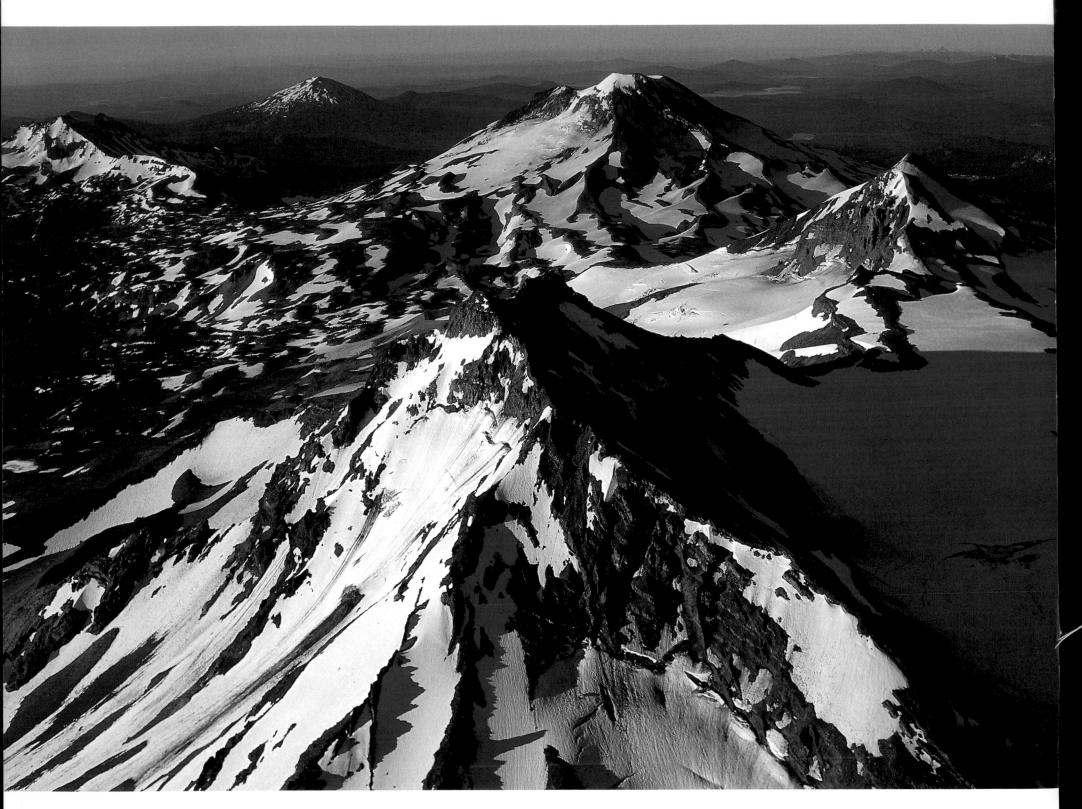

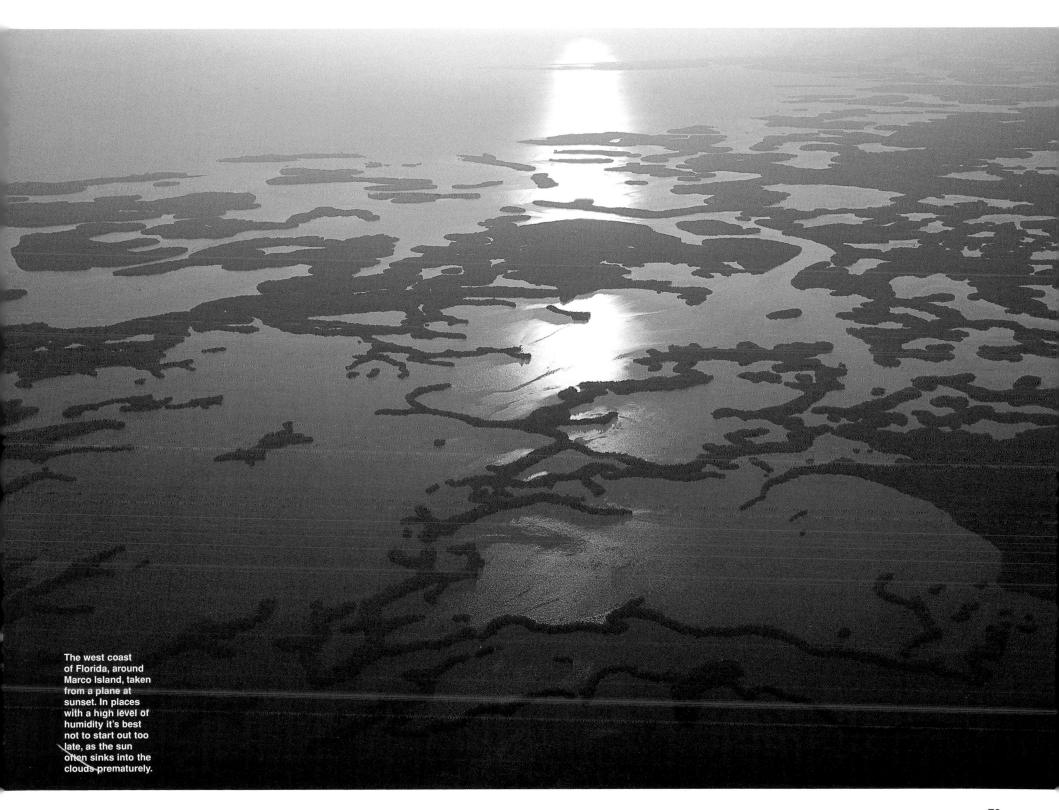

The west coast
of Florida, around
Marco Island, taken
from a plane at
sunset. In places
with a high level of
humidity it's best
not to start out too
late, as the sun
often sinks into the
clouds prematurely.

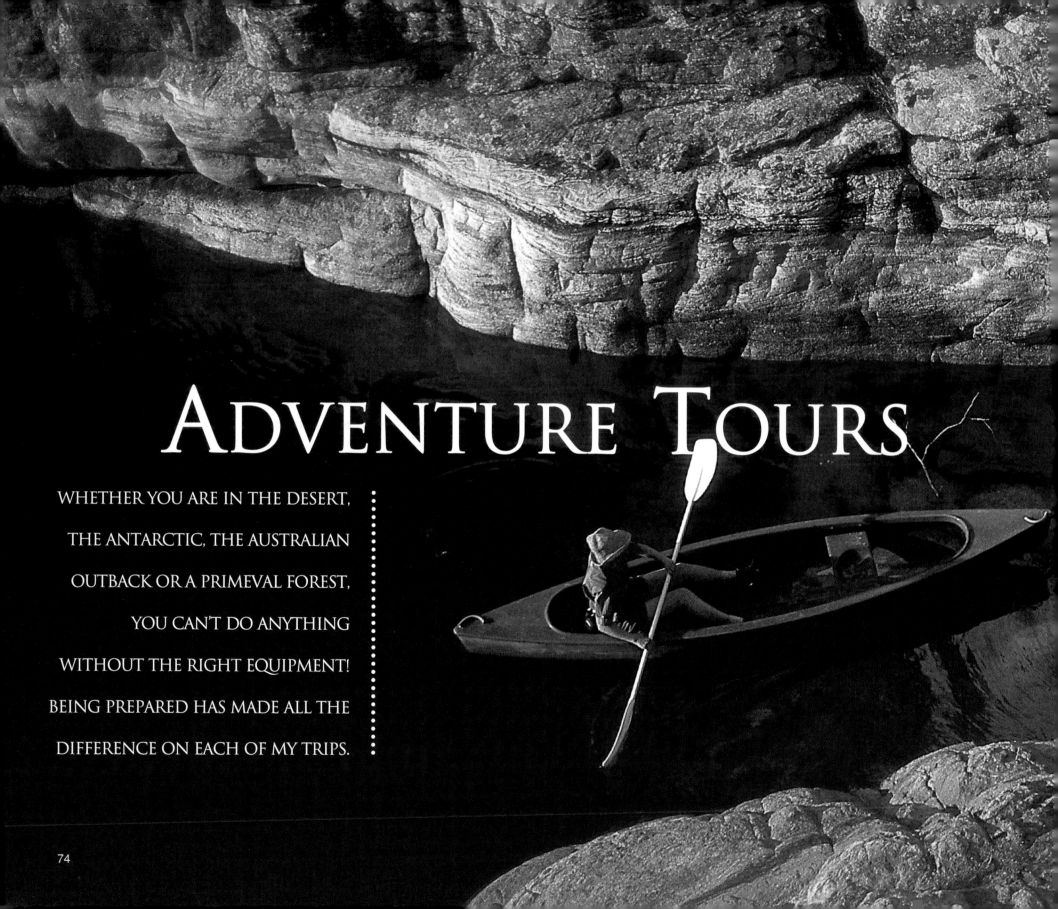

ADVENTURE TOURS

WHETHER YOU ARE IN THE DESERT,
THE ANTARCTIC, THE AUSTRALIAN
OUTBACK OR A PRIMEVAL FOREST,
YOU CAN'T DO ANYTHING
WITHOUT THE RIGHT EQUIPMENT!
BEING PREPARED HAS MADE ALL THE
DIFFERENCE ON EACH OF MY TRIPS.

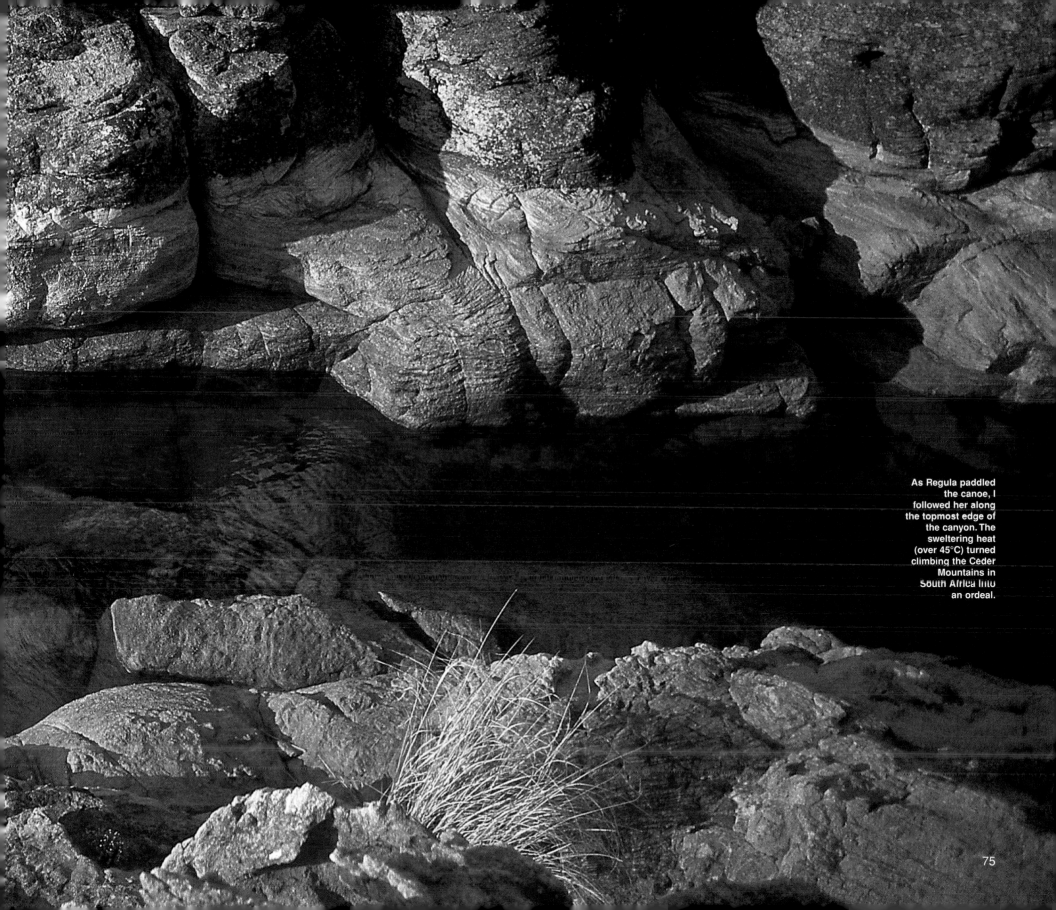

As Regula paddled the canoe, I followed her along the topmost edge of the canyon. The sweltering heat (over 45°C) turned climbing the Ceder Mountains in South Africa into an ordeal.

ADVENTURE TOURS

A sandstorm blows over the red sand dunes of Merzouga in the Moroccan Sahara. Our Iriqui guide plods on, unperturbed. Cursing, I drag my camera rucksack up the seemingly never-ending sandy slope. I'm crunching sand between my teeth, and it's getting in my eyes and ears. Up on the crest, our blue-swathed guide sits in the sand. The light of the setting sun, filtered through the sand in the air, turns the scene into a magical subject for a photo. I know that if I take my camera out of its airtight plastic case right now, it's going to cost me a thorough, and more than likely expensive, clean by a specialist – if not the camera itself. So it's better to take out a small Nikon F80 and a less

expensive Tamron zoom lens. Sand glitters on the lens, and the camera is covered in fine sand in seconds. I take half a roll of film before the sun sinks behind the horizon. At home, my technician will have to get the sand out from right inside the camera once again. Luckily, it's very rare that any serious damage is done.

Modern 35mm cameras are hardly ever designed for travelling in extreme conditions – whatever the camera manufacturers may promise in their advertising; what will it be like with digital cameras? Dampness, fine sand or severe shocks can ruin a modern camera, like my Nikon F5 or Canon EOS, in no time. So for travelling in extreme conditions it's worth packing the cheapest usable SLR camera you can find.

The equipment depends on the destination and the type of trip you have in mind. In the Queen Charlotte Islands in British Columbia, in Canada, where it almost always rains, the camera has to be kept dry. Because we make the trip in an open Zodiac and kayaks, I pack small-scale equipment (Nikon F5, 80–200mm and 35–70mm zoom lenses, filters and a Nikon 300mm) in an airtight camera case, which is strapped on at the front of the kayak. When the sea is calm and it isn't raining, I can open the case from my seat and take out the camera; and when it is raining, everything stays dry and is securely stowed.

The success of a trip depends on having the right equipment, which is bad news for your personal finances but good news for the industry. For a hike in the wilds of Canada that may last several days, I take a Lowepro belt bag. My camera, fitted with an 80–200mm lens, is close by, sitting on my stomach. Another zoom lens and the rolls of film are stowed in my side pockets for easy access. The rest of the equipment

is in my rucksack, together with a tent, food and change of clothing. I fasten the tripod on top of the rucksack or carry it in my hand along the paths.

A front pouch is the only reasonable place to pack a camera, and the lighter the camera, the better. The equipment in your luggage should also be packed in a Pelican case (a water-tight camera case), to protect your expensive equipment from dust and severe jolts.

Sometimes there is no easy answer – riding or cycling with a camera is even more frustrating. Taking photographs on horseback is virtually impossible, as horses rarely stand still. For this reason I dismount and run along on foot to get the best pictures. Obviously, the same applies to camels. On bicycles, the only place to put the camera is the saddlebag, or you can take an ultralight viewfinder camera in a small front pocket.

Before starting any tour or trip, you should definitely have a test run of packing your gear at home. Nothing is more frustrating than finding out, when you're in the middle of the Gobi Desert, that you haven't brought the right equipment.

Right: **Regula drives the bush camper through the river. There are hardly any bridges in the Australian outback.** Left: **No climb is too strenuous, even with a tripod, if it means I can get the best angle for a picture.**

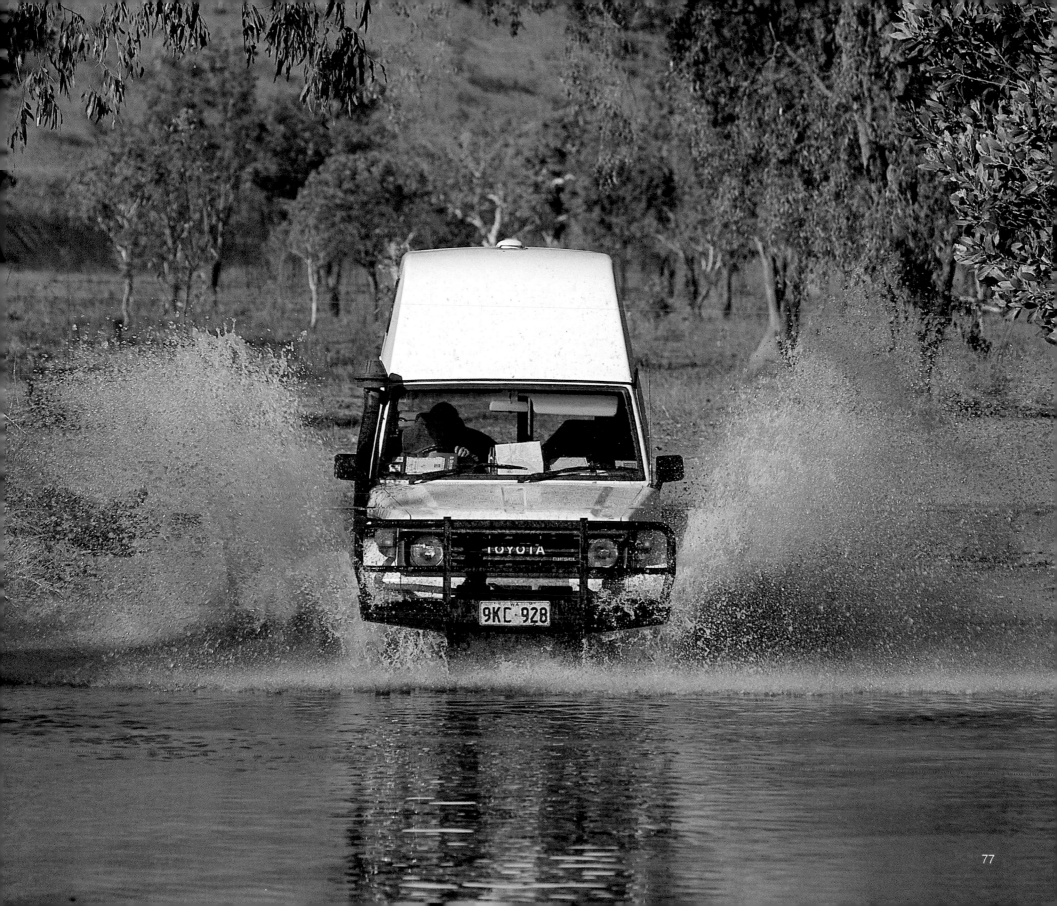

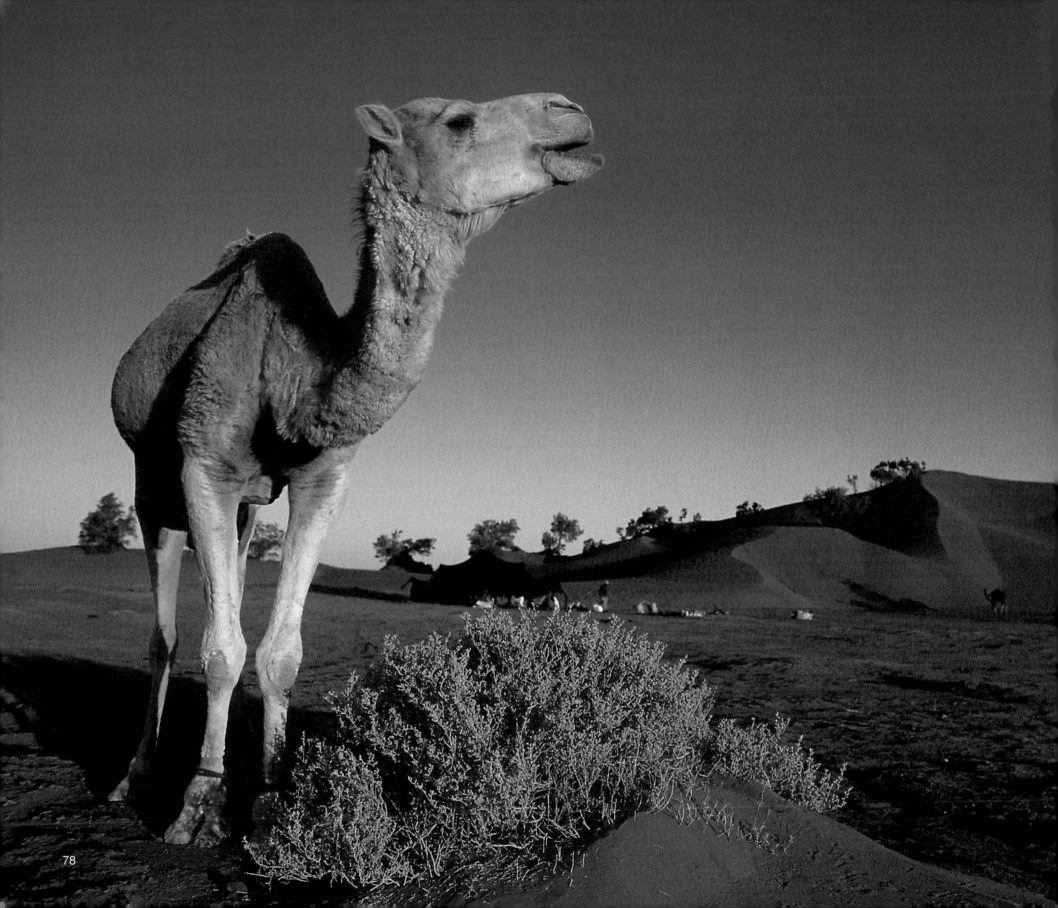

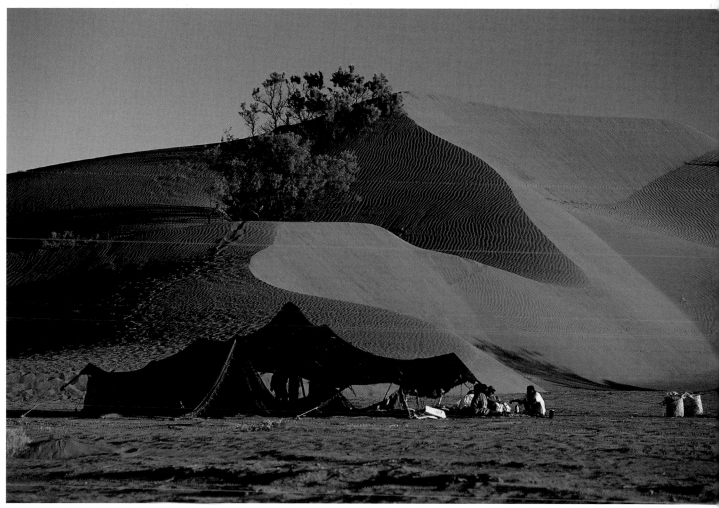

MOROCCO

Left and above:
**We were
travelling
through the
Sahara with
a caravan of
camels. We
spent the night
on blankets in
the sand dunes.**

SAND IS FASCINATING IN A

PHOTO – BUT NOT IN AN

EXPENSIVE CAMERA CASE.

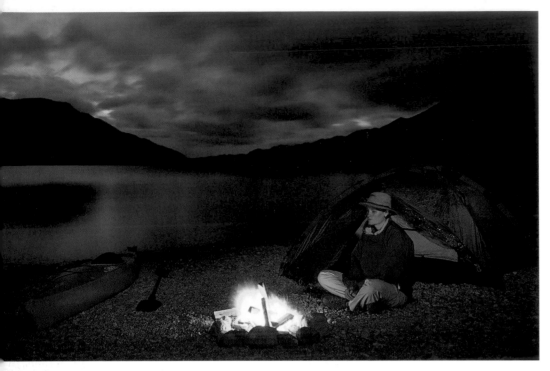

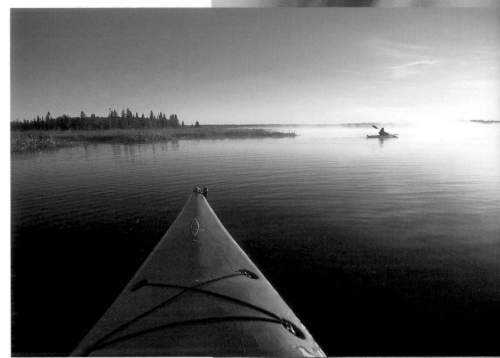

CANADA

MANY LANDSCAPES

CAN BECOME AN

OBSESSION – YOU

SIMPLY HAVE TO GO

BACK THERE OVER

AND OVER AGAIN.

Right and above left: **My wife Regula is often my subject within a subject, whether at the Lady Evelyn Falls or by the campfire.** Above right: **To take good kayak photos you need to be on your way very early in the day, so that you can experience sunrise on the lake.**

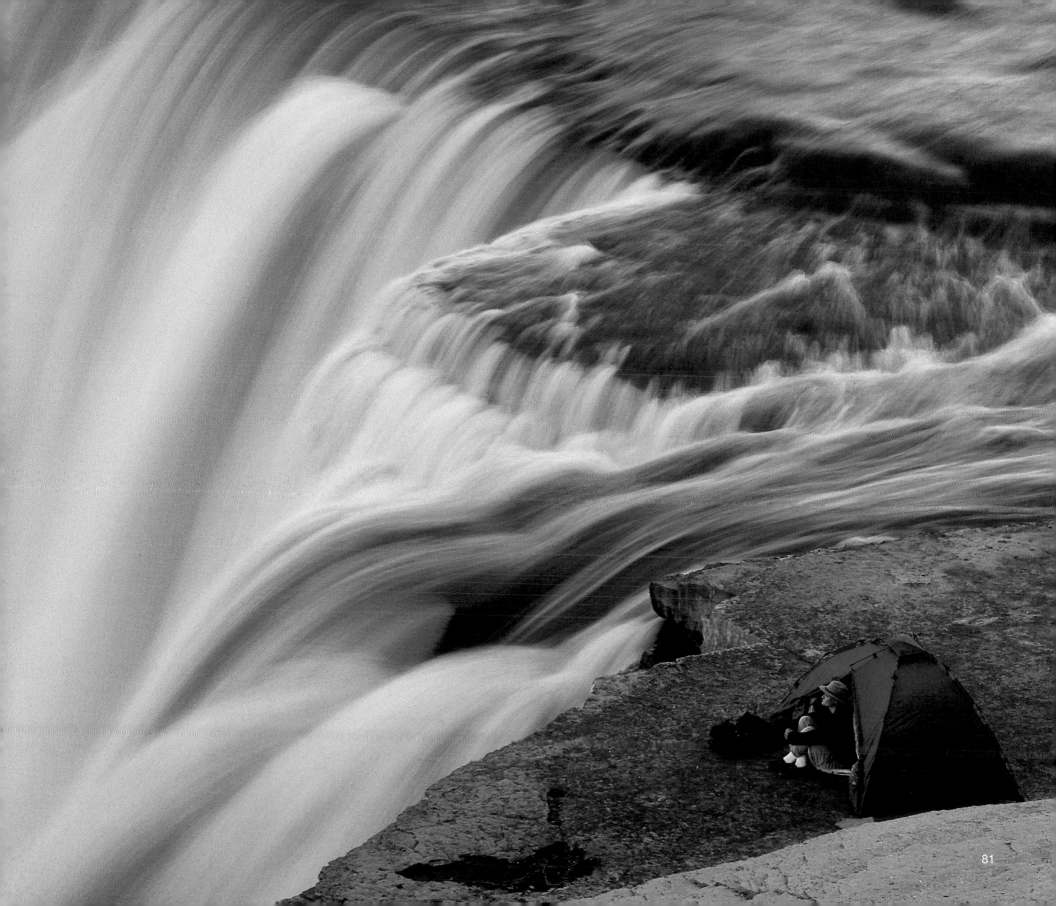

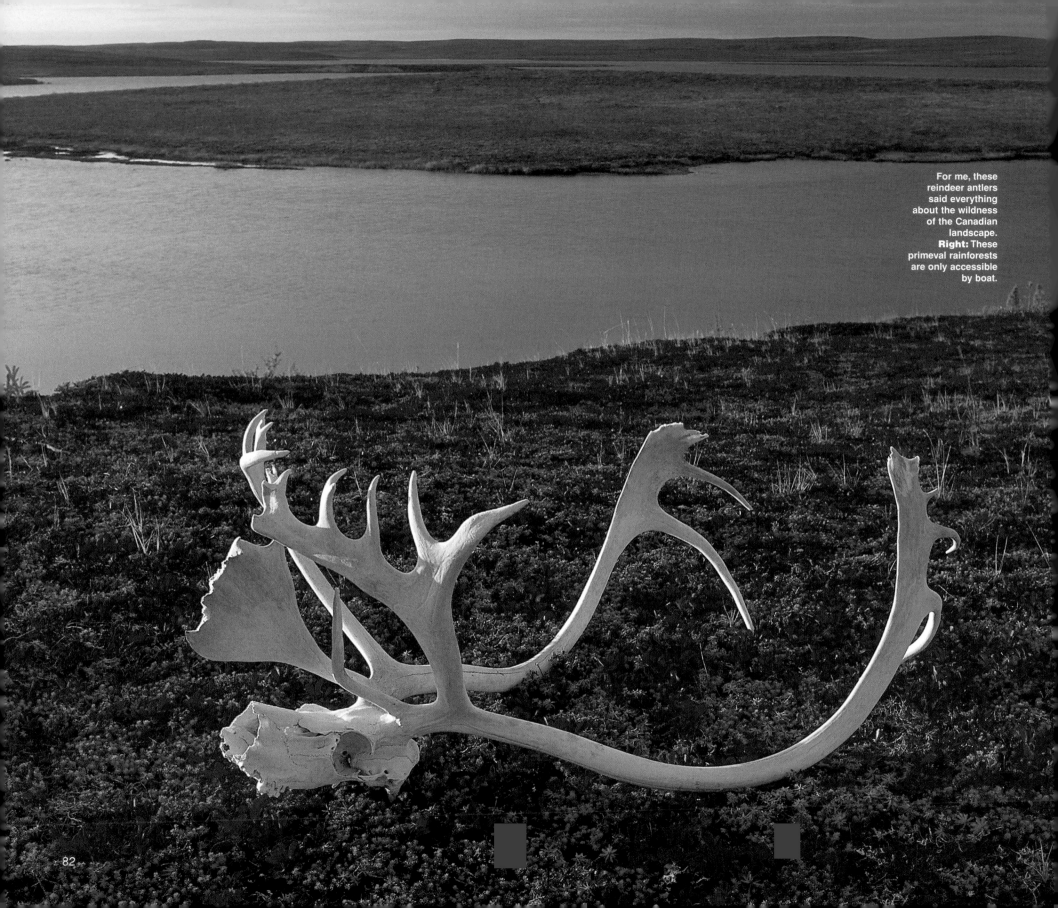

For me, these
reindeer antlers
said everything
about the wildness
of the Canadian
landscape.
Right: These
primeval rainforests
are only accessible
by boat.

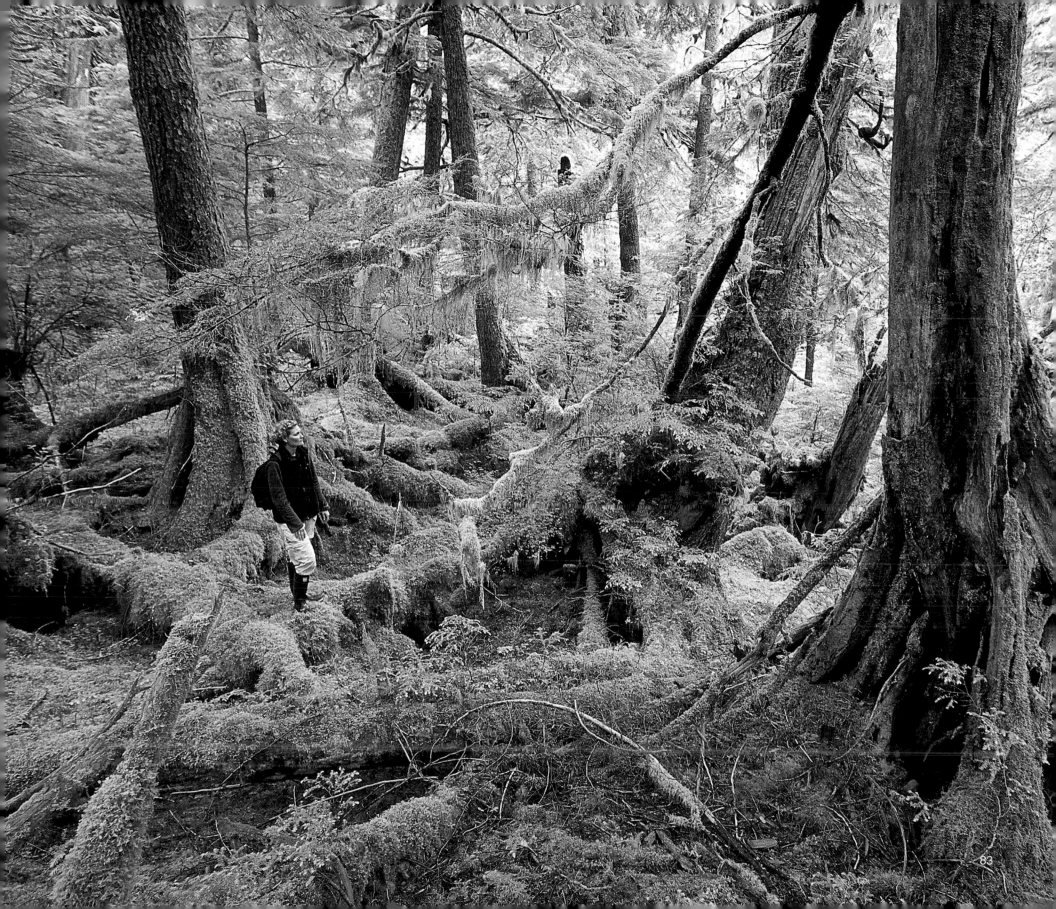

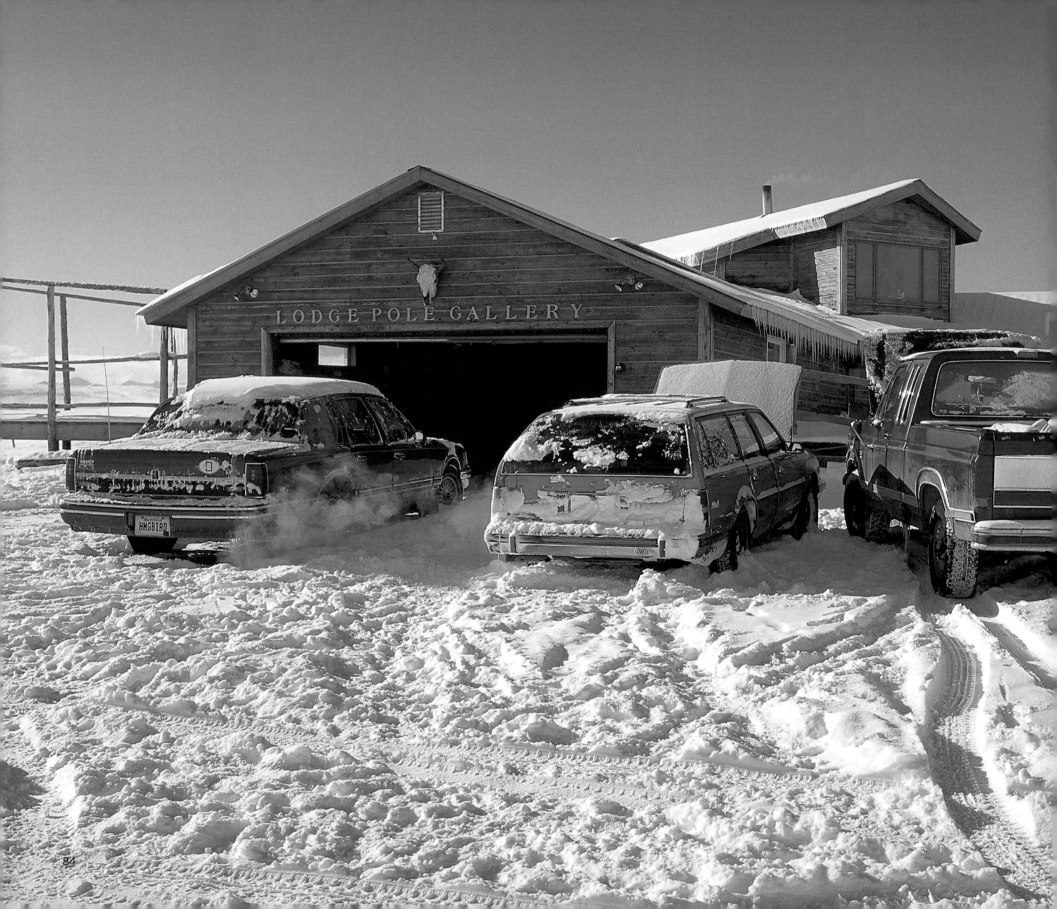

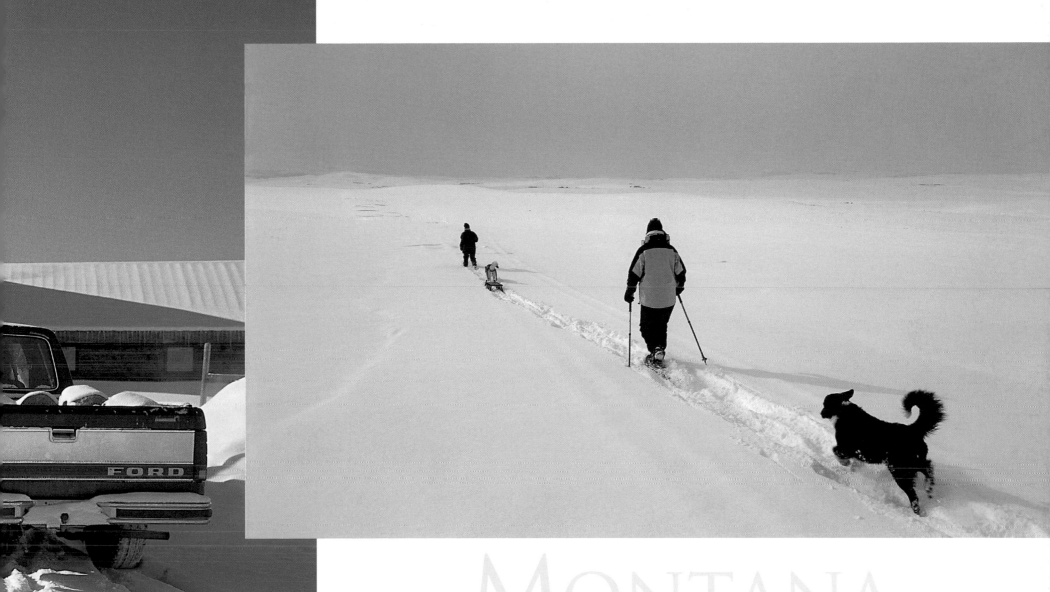

We had set out in the car and then on snow shoes. In temperatures of minus 30°C you should rewind films by hand to stop them tearing.

MONTANA

A BLIZZARD SWEPT OVER THE PLAIN.

THE HOUSE OF MY BLACKFOOT

FRIEND WAS OUR LAST HOPE.

PILGRIMAGE

YOU CAN ONLY TAKE PHOTOGRAPHS OF SOMETHING

YOU ARE ALREADY INTERESTED IN. THAT GOES FOR

ALL PICTURE REPORTING, WHETHER YOU START IN

SALZBURG OR CHICAGO.

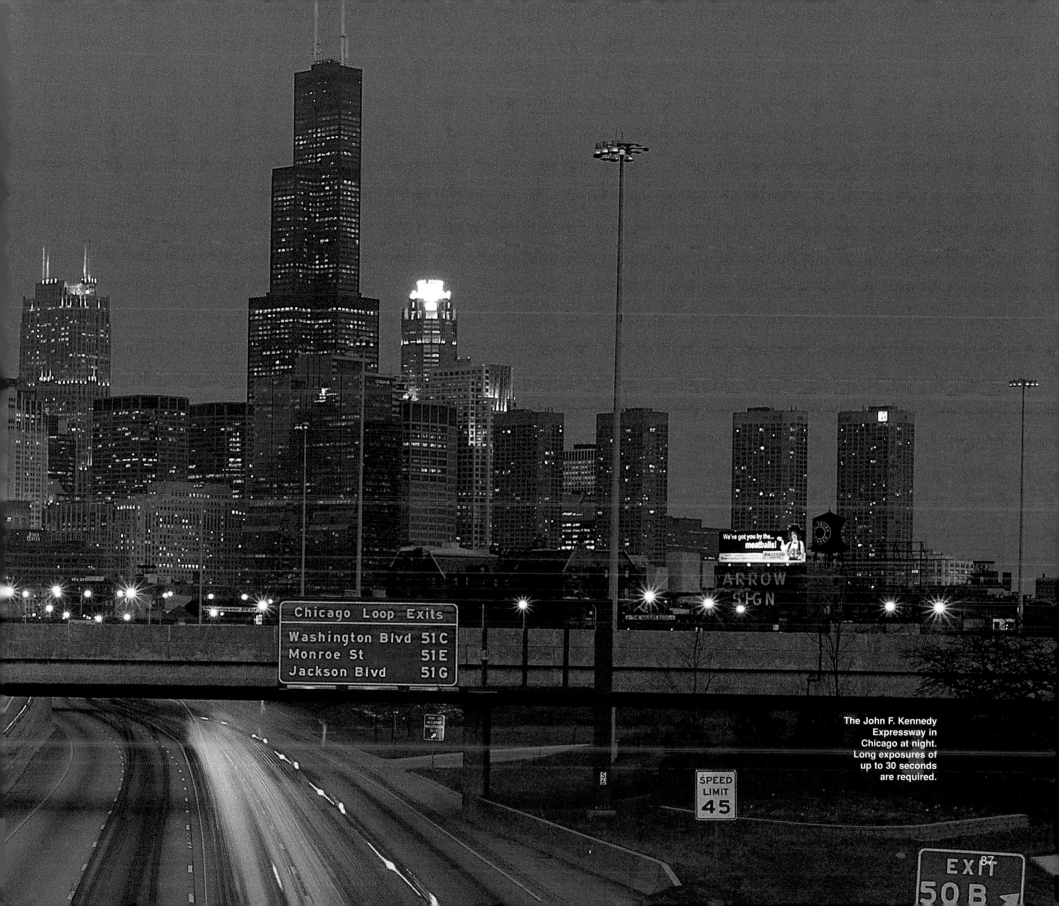

Chicago Loop Exits
Washington Blvd 51C
Monroe St 51E
Jackson Blvd 51G

ARROW SIGN

We've got you by the... meatballs!

SPEED LIMIT 45

The John F. Kennedy Expressway in Chicago at night. Long exposures of up to 30 seconds are required.

EXIT 50 B

87

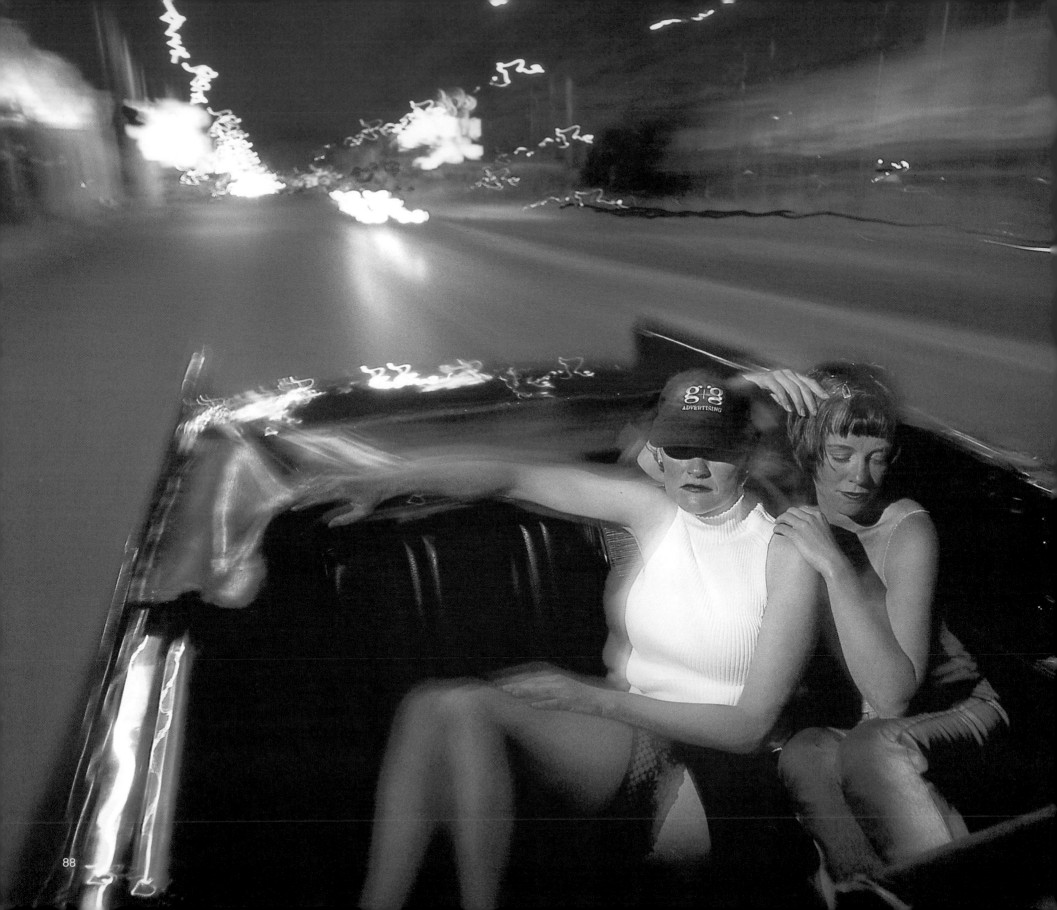

ROUTE 66 AND BLUES HIGHWAY

The highway winds like a dead snake in the marshy green Mississippi landscape. Cotton fields fly past outside my air-conditioned Chevy. I drive past a rickety barn with an old rusty banger in front of it. There is not a soul around as far as the eye can see. A few kilometres to the south lie Clarksdale, Mississippi, the birthplace of the Blues, and Memphis with its Beale Street, Elvis Presley's Graceland and the Sun Studios. Millions of stories and legends are there, waiting to be discovered behind the next range of hills.

You can only take photos of something you are really interested in, a fact that is driven home to me again here in the Mississippi Delta, where there is nothing, absolutely nothing, to suggest that this is the cradle of the Blues. For me it's a sort of photographic pilgrimage. My interest began in my youth, when I was inspired by the of music of John Lee Hooker, of B.B. King, of Elvis, the first white Blues boy, and of Memphis Slim and Stevie Ray Vaughan.

You can find subjects for pictorial essays anywhere in the world. For me, Route 66, the Blues Highway, symbolizes my longing for America. The Silk Road, the Romantic Road, Goethe's footsteps or Mozart's Salzburg all make perfectly good subjects for photographic essays – but not for me, because I can only take photos of something which really fascinates me. Asked why he had stopped taking photos, Robert Frank answered: 'I lost interest.' That says it all.

A good photographic essay conveys the essence of the chosen subject in a few pictures. A black face, a close-up of a guitar, a lonely highway at night, a stall with dismantled neon lights, cotton fields:

all these sum up the Blues Highway. For me, photographic essays must come from the heart.

All photographers must immerse themselves in their chosen subject and take time to get a feel for it, before they can think of photographing it. A photo always shows the subjective view of the photographer. Sometimes, the camera *does* lie. By knowing what to leave out you can strengthen impressions, detract from the truth or change it completely. Skilful editing makes or breaks a photographic essay. The observer of the pictures does not have the same emotional involvement as the photographer, so cut out your personal impressions of the trip. Try to assess your subjects and pictures rationally from the point of view of the uninformed observer.

Photographic essays require good motivation and intellectual willingness. Concentrate on subjects that really interest you. Here too, it's quite right to say that you can only photograph something which you have gone into thoroughly. Basic research is absolutely essential.

Amateur photographers are often one picture photographers – a good photographic essay can set you apart from the usual run of occasional snappers. Publishers and magazines are always interested in seeing a well-rounded set of pictures. A single picture of Tuscany will be difficult to sell, but a good photographic essay on Tuscany has a fair chance of being published.

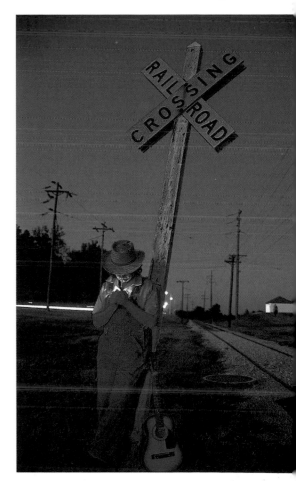

Left: **In an open Cadillac on Route 66, the girls were lit by flash from the side and the background was given extra exposure.**
Below: **A car's headlights show up the face of the Blues singer.**

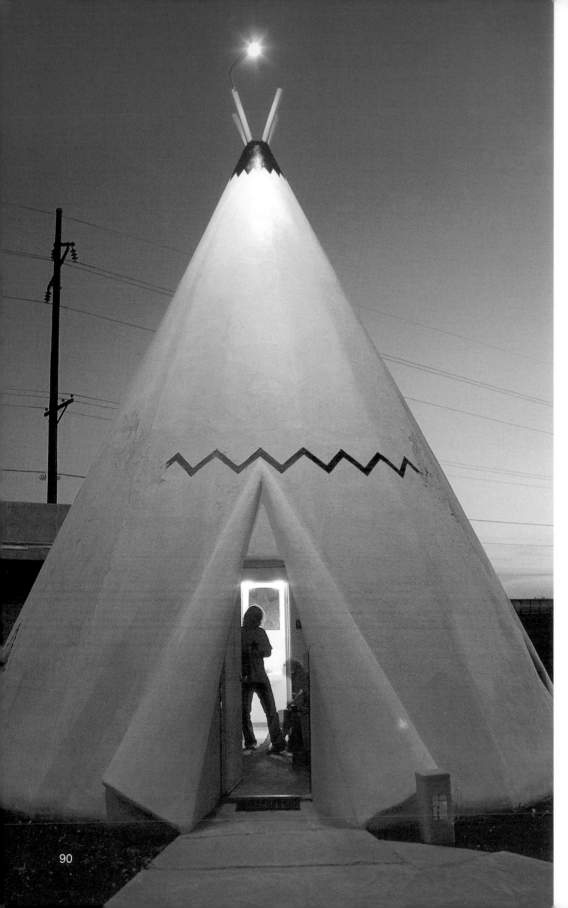

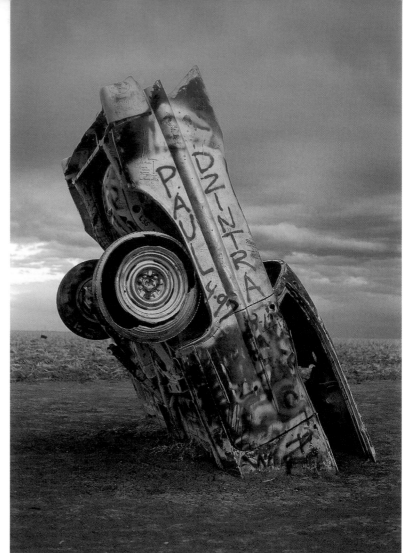

Left: **I wanted to photograph this historic wigwam on Route 66 at twilight, the magical time of day. The figures bring out the romantic effect of the picture.**
Above: **Cadillac Ranch, Amarillo, Texas. This homage to American highway culture is to be found on the western approach to Interstate 40.**

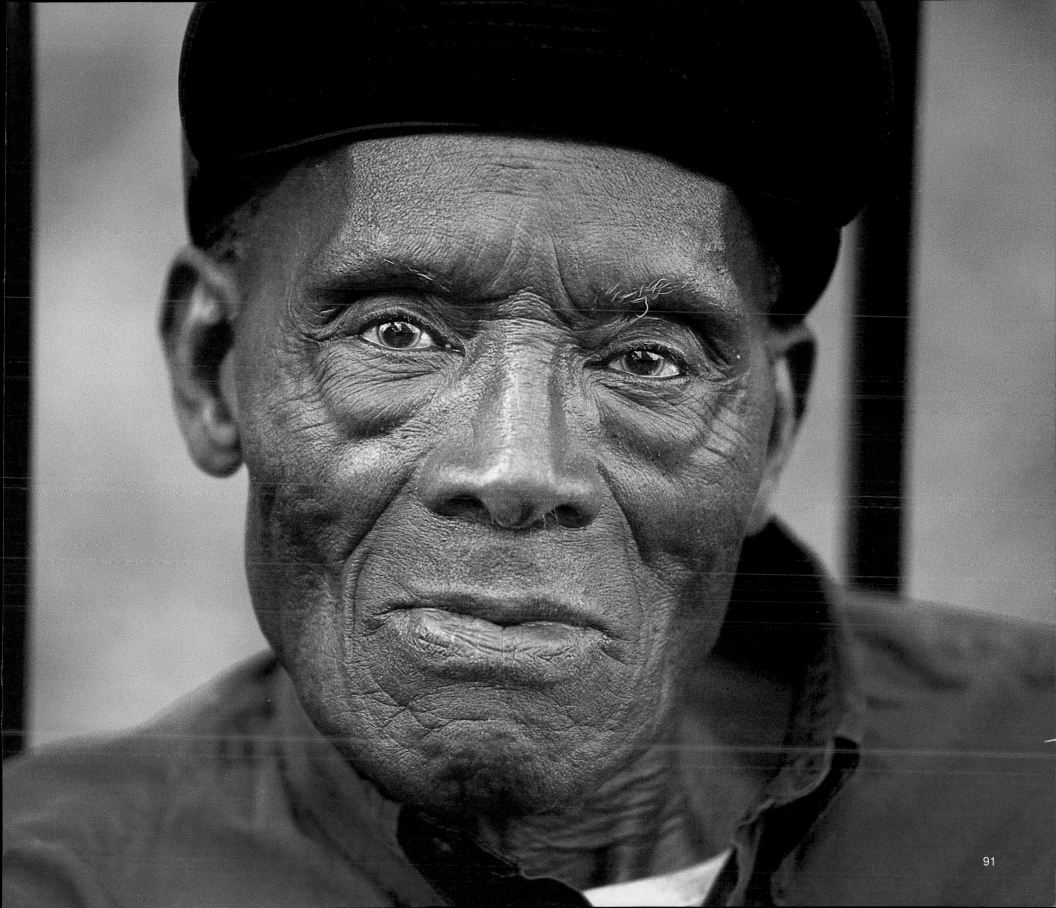

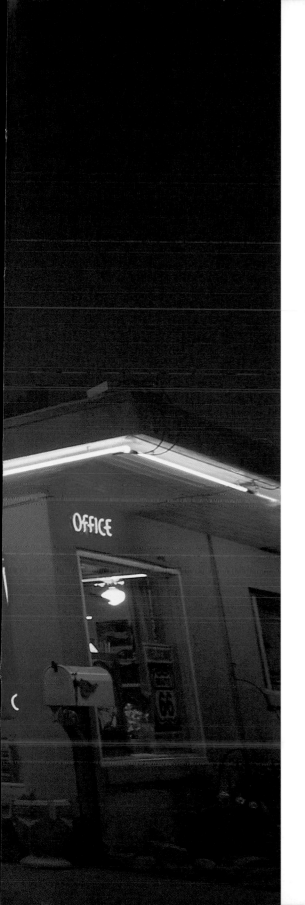

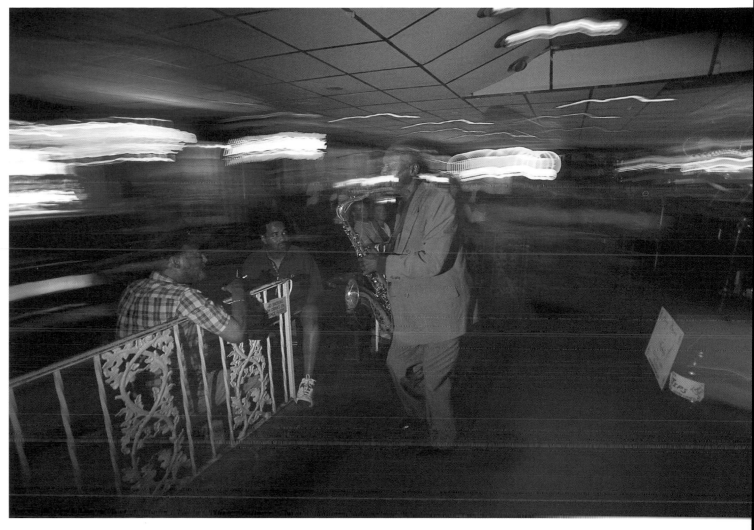

Left: **The Blue
Swallow Motel in
Tucumcari, New
Mexico, is a
historic landmark.
The photo was
taken with a tripod
and exposure
adjustment.**
Above: **This blues
joint in New
Orleans was taken
with a TT lead
release and 1-
second exposure.**

ROAD TRIP

A PHOTOGRAPHIC ESSAY WILL BE EASIER

TO SELL IF IT OFFERS MORE THAN JUST

A LOT OF PRETTY LANDSCAPES.

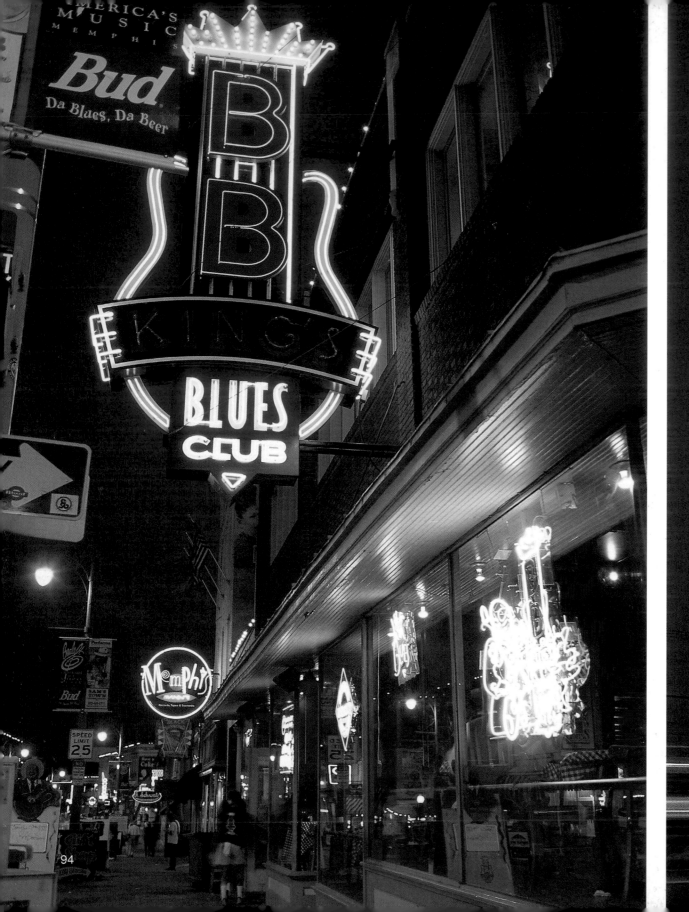

Highway 61 – the legendary Blues Highway in the Delta of Clarksdale, Mississippi. Exposure of about 20 seconds on a tripod. The street sign is lit up by a torch.
Left: Beale Street in Memphis, with BB King's Blues Club, a mecca for Blues fans. Taken on a sultry September evening.

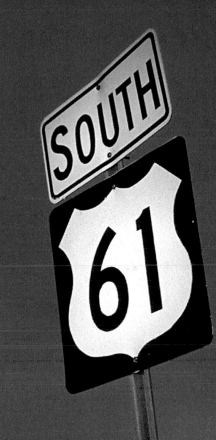

TECHNICAL DETAILS

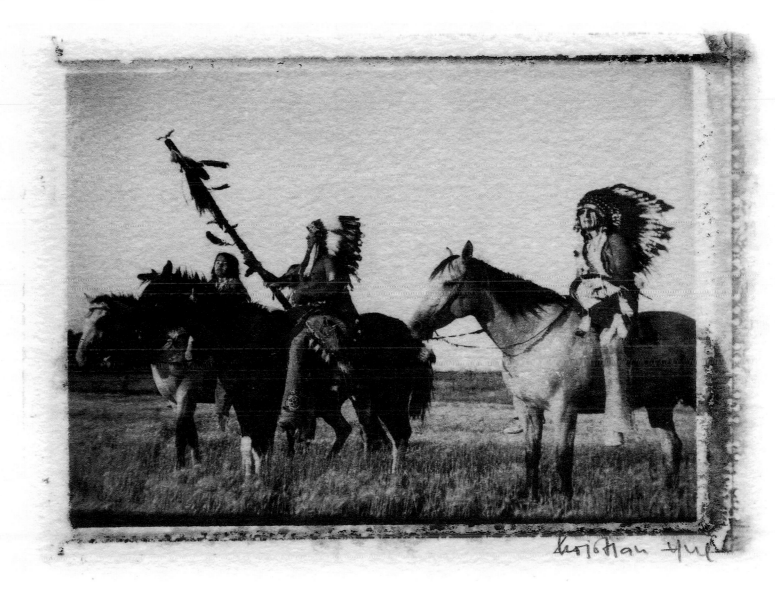

PREPARATION AND PHOTOGRAPHIC EQUIPMENT

A clip-on flash is indispensable for brightening up subjects and longer flash periods.

A good bag is essential when travelling with your camera in inhospitable terrain.

Bulky, but not to be left behind, a steady tripod is almost always necessary.

I now use Fujichrome Provia and Velvia films.

PLANS FOR A TRIP BEGIN IN YOUR HEAD. ASK YOURSELF THESE QUESTIONS: WHAT DO I WANT TO PHOTOGRAPH, AND WHAT EQUIPMENT WILL I NEED?

Once you know your exact objective, you can select the most suitable equipment, plan your route and establish a fairly accurate schedule.

Let's assume that you want to take pictures and sell them to magazines, photographic agencies or book publishers. Your first move should be to find a decent bookshop and have a good look at picture collections, travel guides and travel magazines. Even calendars can give a good insight into the range of possible subjects in the relevant area.

Find out about the best times for travel, vaccinations, permits and so on. A travel guide – these are now available in all

shapes and sizes – will provide you with logistical information, while a picture book will fire off your imagination. You will now be in a position to plan a route, using the information and pictures for guidance.

In my experience it has proved to be worth spending at least two nights in the same place to have enough time for photos. As a travel photographer, if you want your picture collection to be attractive to buyers, you need to be able to cover as wide an area of a country as possible. Even for a calendar covering a particular country you will need pictures of all its far-flung regions, or of a particular region. Subjects such as Tuscany or

Provence, or urban subjects, such as New York, have obvious advantages, in that you can photograph a fairly small region from all angles, and only have to travel short distances. If you choose subjects like the USA for your calendar or book, you will have to spend months travelling through the country, as I do.

As an amateur photographer, you are free to choose any subject you like. Instead of travelling through a whole country, a more leisurely stay in a town or region can give you a deeper understanding of the country and its inhabitants, and this will ultimately reward you with better pictures. Before I got started on a large illustrated book of Mexico for the first time, I spent three weeks in a language school in San Miguel de Allende and ended up having the most fantastic time in Mexico.

Travel guides are, of course, full of detailed information about preparing for a trip, but you are unlikely to find much about technical photographic problems.

As a full-time travel photographer, I reckon on about five 35mm films per day on average. My favourite slide film is Fuji Velvia 50, which I usually expose at 40 ISO. If I need a higher aperture value I often take Fuji Provia 100 and Fuji Provia F pushed to 200 ISO. When travelling by air I always keep films in my hand luggage, stored in plastic bags fastened with a clip, so that I can have the films checked by hand at almost every airport. I send exposed film home for developing by Fedex (so it hardly ever gets X-rayed). I send about 100 films at a time, and in this way I reduce the risk of losing films en route considerably.

The number of films, cameras and accessories you take depends on the region you are visiting and the method of travel. If you are travelling by bus and train, you will be quite restricted for luggage. Whenever possible, I hire a car locally. In the Caribbean I book a car and

If, when selling my pictures, I want to show partioularly impressive slides, I go for the 6 x 7cm format. The range of lenses should not be too large . . .

LENSES

. . . but be able to cover as many different focal lengths as possible. That means a zoom lens, a wide-angle and a telephoto lens, always high-speed.

The 24–85mm has proved to be the most frequently required zoom lens for travel photography – I use it for most of my subjects.

LENSES

For shots 'to infinity and beyond' I usually take an 18mm lens and make sure I get a good foreground. For portrait photography the high-speed 105mm lens is my choice on almost all occasions.

driver, or a taxi for day trips.

Now that it is becoming increasingly common for pictures to be sold in digital form, the number of slides needed is falling significantly, as the information can often be copied as many times as you like without loss of quality. This means you can cut down on the number of films you need to take with you. I used to photograph any good subject up to 20 times, so that I could supply the various agencies and publishers with original slides. Now the average is around five slides per subject. A lot of agencies will only accept the relevant image data on CD.

To be sorted out before departure:
• Vaccinations
• Visa
• Customs regulations for taking cameras and films into a country.

Permission to take photographs in museums or cultural sites:
Anyone wanting to take photographs in a museum will nearly always need a commissioning client. This can be a well-known travel magazine or just your local daily paper, and sometimes you can even get by with a commission from a company or camera club magazine.

Try and write some short articles beforehand, even if you might not get paid for them. Take your visiting card and a copy of your article with you – even a visiting card from a camera club can sometimes open doors. Tell them why you want to take photos: perhaps you're producing an article about this region for your club magazine and would like to feature the museum in it. *Always* ask for the press office or the marketing person; if the receptionist tries to get rid of you straight away, be persistent! Ringing beforehand can also help.

Tourist offices and embassies, and the marketing agencies of the relevant countries, can provide information. Many

travel destinations have their own marketing offices, which organize press visits and provide logistical support for journalists. But to qualify for this kind of service you must have an actual commission from a major magazine.

The professional photographer cannot do his job without camera equipment that works properly. I usually take up to three packages with me: normally two Nikon F5s and a Nikon F3 or F90. Then there are lenses from 18 to 500mm; I have two of virtually all focal lengths, some of the lenses with fixed focal length and the same number as zoom lenses. I also take the precaution of packing two flashes and a tripod with a spare tripod head.

In countries such as Canada or the USA spare equipment is not so important, since it's easy to buy replacements, but in the Third World bringing your own spare lenses and cameras is crucial.

I would recommend a manual camera for adventure tours, something like a Nikon FM2, with a small selection of sturdy lenses with fixed focal lengths. I prefer taking lenses from 28 to 104mm.

Deciding when to time your photographic trip is important. The success of my trip often depends on the season. Ideally you should make several photographic trips at different times of the year, so that you can present the various facets of your chosen area. If this is not possible, you should opt for the best time for taking photos. You can fine-tune your portrait of the country later by going back now and again.

The winter months of January and February are ideal for travelling round a country like Mexico: crisp, blue skies and cool temperatures mean that you can photograph the whole country in one go, in relative speed and comfort. Summer is a good time to visit South Africa, which also means January and February, when the bush is green and the birdlife is at full

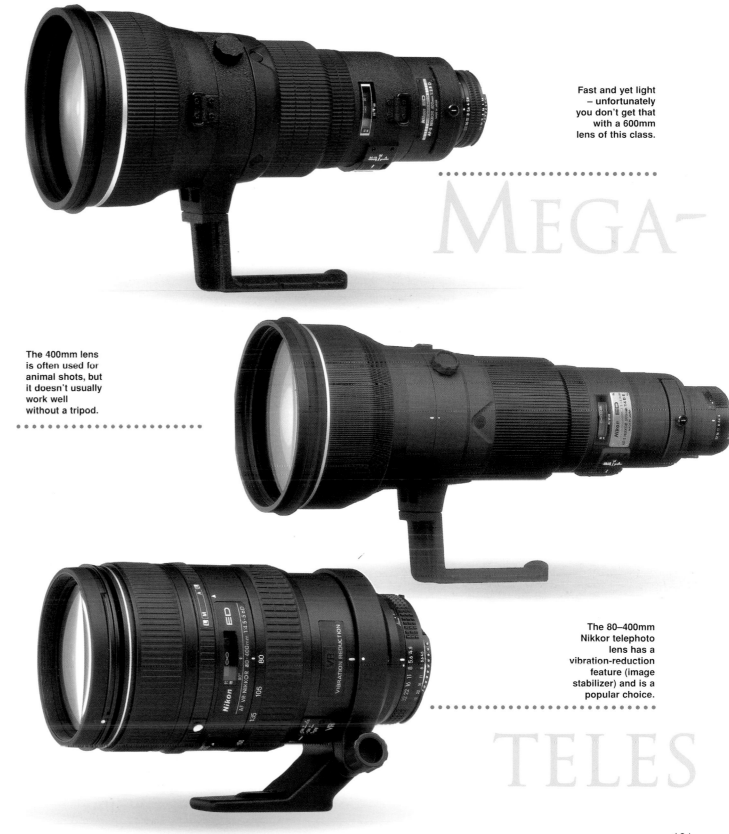

Fast and yet light – unfortunately you don't get that with a 600mm lens of this class.

MEGA-

The 400mm lens is often used for animal shots, but it doesn't usually work well without a tripod.

The 80–400mm Nikkor telephoto lens has a vibration-reduction feature (image stabilizer) and is a popular choice.

TELES

Before each trip I decide afresh which package to take. I always have the reliable Nikon F3 to hand for strenuous use and extreme temperatures.

The Nikon F5 has all the latest features, but the sensitive electronics don't always like it if you spend too long taking sandstorms in the desert.

CAMERAS

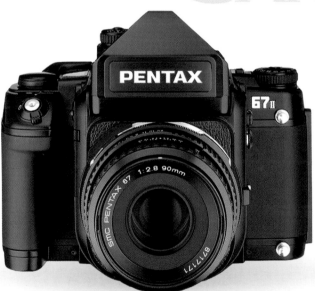

The Pentax 67 looks like an SLR camera and you use it like an SLR camera, but it is actually a pukka 6 x 7 camera, revered by entire generations of photographers. It still has everything going for it.

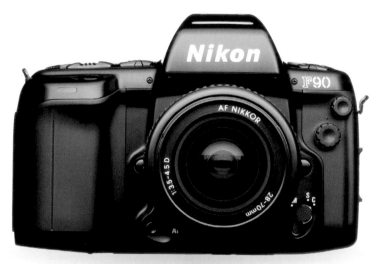

This Nikon is always there as a second camera. A second or third camera pack is more important than lots of lenses – what use is a lens if the only camera suddenly goes wrong?

strength. Conversely, the risk of catching malaria is high in the north of the country, and the heat can be overwhelming.

Photographic considerations will often influence your decisions. The low season has the advantage of fewer tourists and better deals in the hotels. But then, for example, you must expect to find the beaches deserted and many of the bars shut. Anyone wanting to take conventional beach snaps will have to come during the high season.

These are all things to be considered *before* starting the trip. When you travel round a country, taking photographs, you need to get a good insight into its culture, history and geography. This can even include a country's literature and music. To get in the mood I buy music CDs and books about the country, and during the trip I read books on a variety of subjects. To be able to do justice to a country in my photographs, I have to get a feel for my subject. Photography is a sensual art form – you should be able to operate your technical equipment with your eyes closed, and be guided by your emotions.

My motto is: you can only see what you really know. Knowing the true character of a country is fundamental to a successful photographic trip. For example, to the commercial travel photographer, going to Mexico and coming back without any pictures of the Mayan sites such as Uxmal, or without slides of the Mariachi Chapels is inconceivable. Mexico is also the country of Diego Rivera's 'Murales', the art of Frida Kahlo and the books of Carlos Fuentes.

Someone who is only taking pictures for him- or herself, or for the art world, in other words for exhibitions and portfolios in photographic magazines, can take the completely opposite route – creating photos of unusual subjects! So, forget the Mayan temples, and capture the less familiar side of Mexico, the subjective view of the photographer: the empty beaches in

the low season. Those who turn the old familiar clichés and icons of the country on their head in a new and creative manner, will undoubtedly reap the most financial rewards.

Look for the same picture taken in a new, different light. The market is always demanding the same subjects – but at the same time they have to look *different* – a demand that has had some professional photographers tearing their hair out.

In any case, planning your trip is half the battle. A comfortable rucksack and a camera that you can operate with your eyes shut are the essentials. I always have the equipment which is best for my method of travel, and, of course, an itinerary planned out to the last detail.

Medical precautions:

Sun protection, emergency first aid kit, malaria tablets and the like can be crucial for survival. You can only work properly if you stay healthy. Avoid overeating and too much heavy food, alcohol and exotic dishes, at least until your body has got used to the country.

Internet and couriers:

The Internet is an excellent tool for planning your trip. Most operators, hotels, guide services and so on can easily be contacted via the Net. A palmtop is also useful in unfamiliar countries while you're away, so that you can keep in touch. Internet cafés are now cropping up all over the world.

Couriers such as Fedex or DHL will carry your films and cameras anywhere in the world. However, before sending them off, don't forget to check the customs requirements in the relevant country. Sending films and cameras to the USA normally presents no problem – if you do it properly. On the other hand, customs in Australia can impose statutory fines if you make a false declaration or try to do it without one!

Stages in planning your trip:
- Study travel guides carefully
- Work out your precise itinerary
- Always take camera equipment that is suited to the country you will be travelling in. Work out how many films you are likely to need.
- Don't forget health precautions. Decide on your travel time.
- Book travel companions, hotels, guides or hire cars in good time
- Arrange a poste restante service.

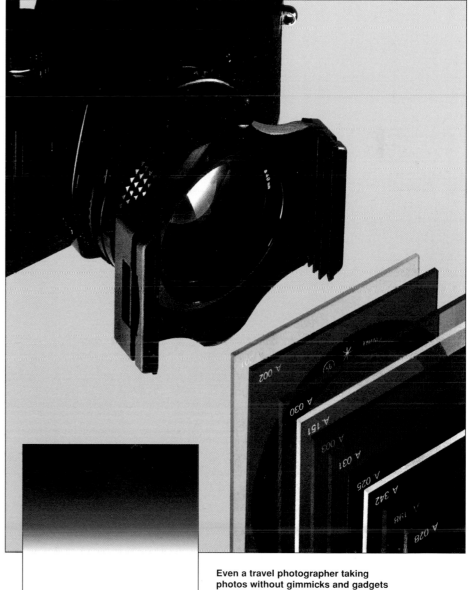

Even a travel photographer taking photos without gimmicks and gadgets can't manage without filters. I swear by the Cokin series for a number of reasons.

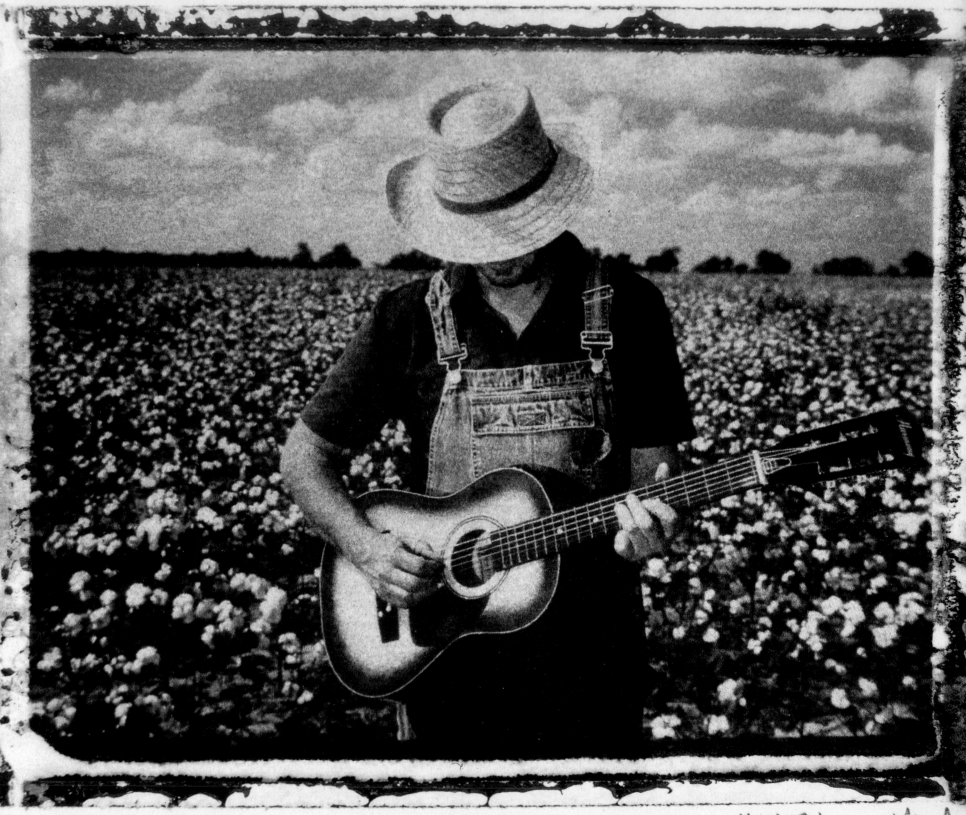

1/104
1/50 **Subjects treated with the Polaroid Transfer technique on watercolour paper give the impression of a painting.**

Kristian Hur

THE POLAROID TRANSFER TECHNIQUE

PHOTOS CREATED USING THIS TECHNIQUE SEEM REFINED, ALMOST LIKE PAINTINGS. THEY REINFORCE WHAT THE PHOTOGRAPHER IS TRYING TO SAY – AND THEY SELL WELL.

It's now 12 years since my first Native American photos were published in Germany for the first time at a profit. Since the first large-scale publication of my work in *Foto-Creativ* magazine I have become a successful travel photographer, specializing in North American material. My seventieth book, *Magical Indian Country*, came out in spring 2002. For some of the photographs in that book I used a refining technique which reinforces the picture's message – the Polaroid Transfer Technique. The way to do it is shown below.

Polaroid Transfer Technique
I have been photographing Native Americans for years. As a big fan of the artist Karl Bodmer, however, I realized that my pictures often lacked the 'artistic' element. Of course, the world of the Native American as depicted by Bodmer no longer exists, and in any case I wouldn't be able to match the romantic quality of this Swiss artist's paintings with the realism of modern colour photography. Nevertheless I was still keen to experiment with the Polaroid Transfer Technique. Once we moved to the USA, I finally had the opportunity to do so.

In hardly any time at all I was able to achieve satisfactory results, as demonstrated by exhibitions in Oregon, London and Switzerland.

The Polaroid Transfer Technique proved to be the best method for my artistic photographs of Native Americans. What

was to stop me using it for other subjects? I also got presentable results with my work on 'Romantic France' and 'New York City'.

Adventure and Travel magazine published a whole article in Florida, and another publisher even published my New York photos as a calendar. If you don't mind experimenting with your slides, this technique and another modifying one – offer plenty of scope.

You will need the following:
Polaroid's Daylab No. 2 enlarging head, designed for the 4 x 5in format, is ideal. Instead of this rather costly investment, you can of course use a conventional enlarging head for colour – but this isn't quite so easy.

You will also need:
• a 35mm slide

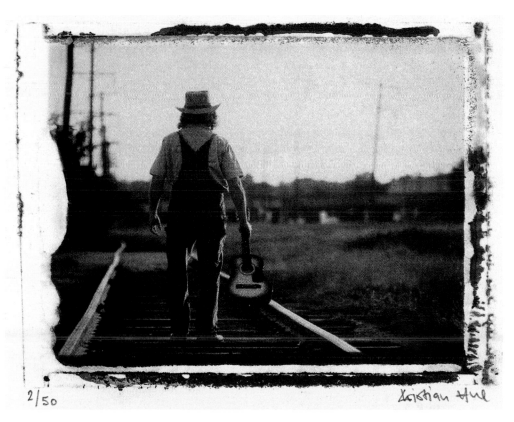

2/50

Kristian Hill

This edge is a characteristic feature of the technique, helping to give the impression of a painting.

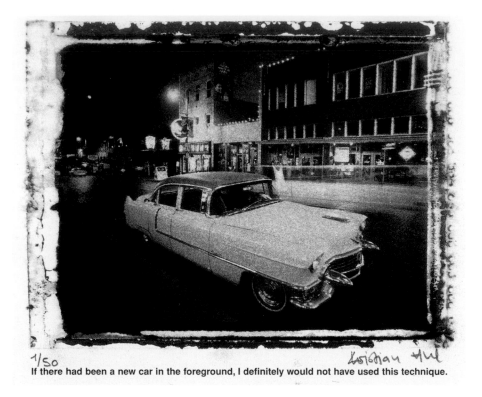

1/50

If there had been a new car in the foreground, I definitely would not have used this technique.

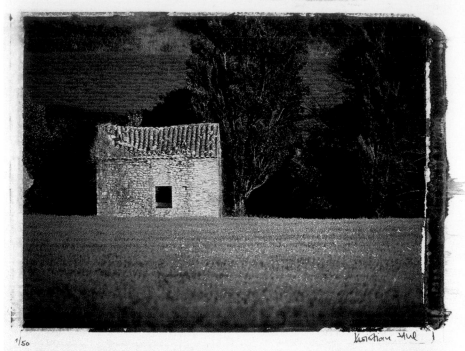

1/50

In the south of France I found many subjects which I could later convert into Polaroid transfers.

- a Polaroid 59 film
- a Polaroid 545i film holder
- Hot-Pressed (HP) watercolour paper (300gsm/140lb) or deckle-edge paper
- a metal basin (min 25.5 x 30.5cm/10 x 12in)
- a plastic roller
- a rubber window cleaner
- a really sharp pair of scissors
- white distilled vinegar
- a hot plate

Procedure:

1. Select a subject that seems suitable for this technique from your slides: a richly coloured picture, without too many contrasts, normally works well. The colour tones of the subject should produce a good effect – brown and red tones work better than blue and green.

2. Put the slide, free of dust and fluff, into the enlarger.

3. Follow the manufacturer's instructions. If you are using a conventional enlarger, arrange the photo as you would for a normal enlargement. The exposure then has to be measured manually.

4. Before taking the exposed film out of its cassette, everything else should be ready:

- a clock for timekeeping
- a pair of scissors
- a waste bin for the Polaroid chemical and waste paper
- a ruler or strip of wood for removing the Polaroid
- the basin filled with warm water. Immerse the watercolour/deckle-edge paper in this for 1 minute., then lay out the soft, well-saturated paper on the table and remove any excess surface water quickly using the rubber window cleaner.

5. Take the film out of the cassette, so that the chemical is squeezed over the negative. Cut the metal part of the film off and separate the paper from the negative. Throw the undeveloped picture and the casing in the bin, and place the negative onto the wet paper with the coating underneath and the shiny part of the negative uppermost. Run the roller over the negative, smoothing it onto your chosen paper. Now lay it on the warm water in the basin, to keep the paper damp.

6. After 80 to 90 seconds remove the negative from the paper using a ruler. The longer you leave the negative on the paper, the stronger the print becomes, and vice versa.

Keep the paper damp at all times to avoid parts of the coating layer peeling off – the damper you keep it, the less the layer will break up, but then it's more difficult not to let anything slip when

peeling off. Leave the finished Polaroid transfer to dry.

7. Once the paper is dry, say after about 2 to 3 hours, fix the picture in a vinegar solution of 4 parts warm water to 1 part white vinegar. Then wash it well with warm water and hang the paper up to dry.

8. If the picture is dry, it's more difficult to get the paper smooth. The Polaroid can be adjusted later with watercolours. Although it's now possible to create similar effects on your PC, the 'Polaroid original' on deckle-edge paper will be hard to beat.

Romantic modifying technique

I applied a simpler technique to enhance my 'romantic' New York series, seen on pages 109–113, which were taken using a Scotch 400 ISO slide film pushed to 800 ISO. To take the shots I used a Cokin sepia filter and a filter which I had smeared with Vaseline.

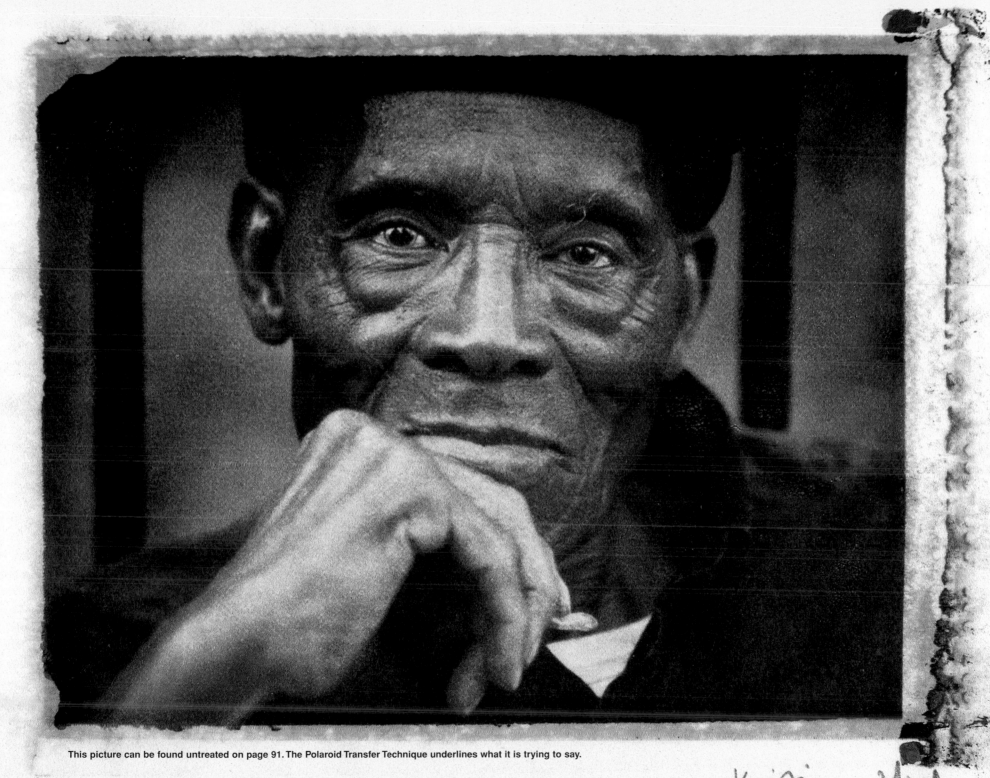

This picture can be found untreated on page 91. The Polaroid Transfer Technique underlines what it is trying to say.

1/50

Kristian Hul

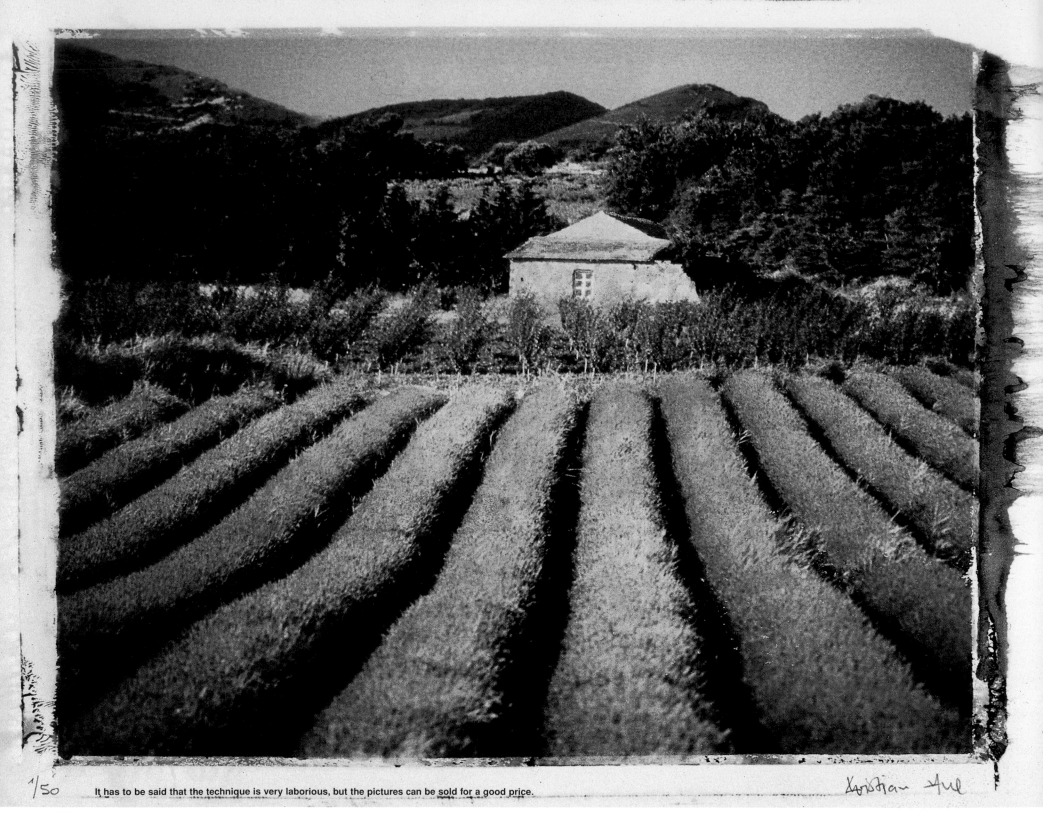

1/50 It has to be said that the technique is very laborious, but the pictures can be sold for a good price. Kristian Aul

It wasn't that easy to find suitable subjects for this modifying technique, because it wouldn't be suitable for the skyscrapers to be too modern and the cars to look too new. After I had taken a number of shots the best 35mm slides were later recopied onto 70mm duplicate film and filtered again, in order to avoid a predominant red tinge.

My tip here is that there are lots of other techniques which can be used when taking photos for articles.

ROMANCE

No process should be an end in itself, but should help to emphasize the picture's message.

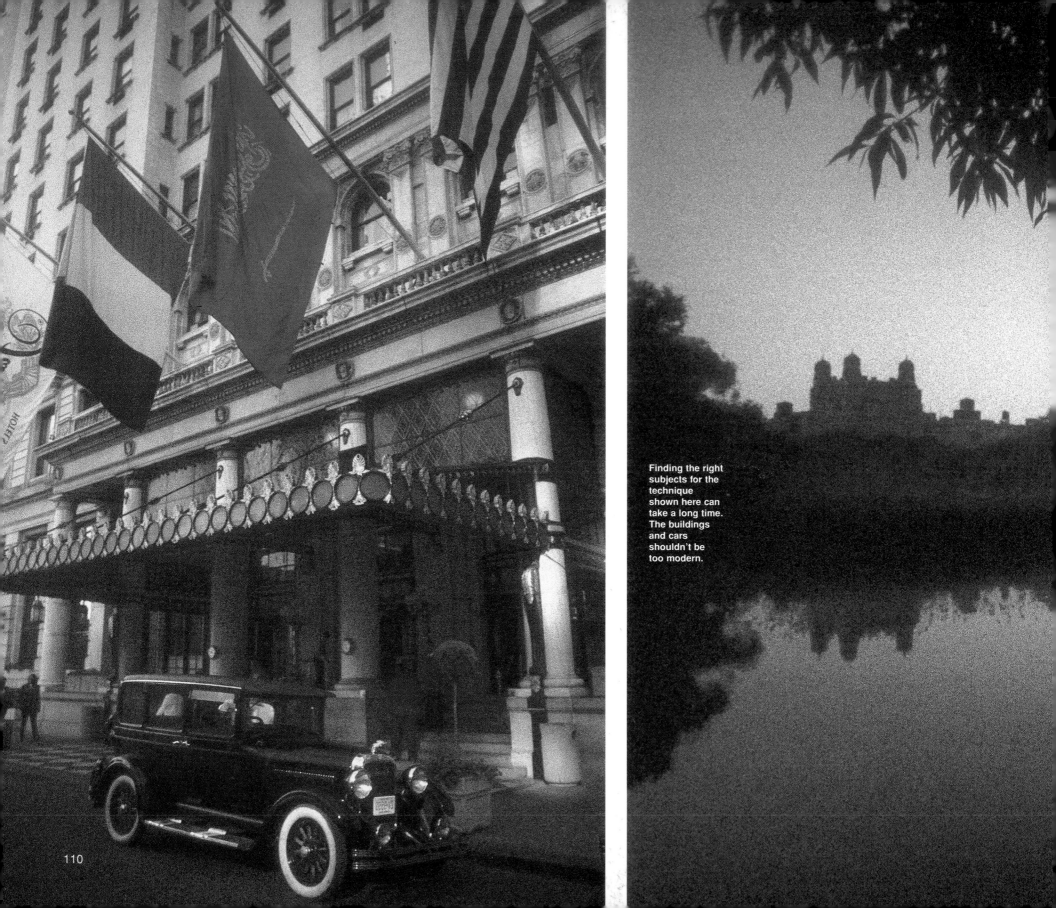

Finding the right
subjects for the
technique
shown here can
take a long time.
The buildings
and cars
shouldn't be
too modern.

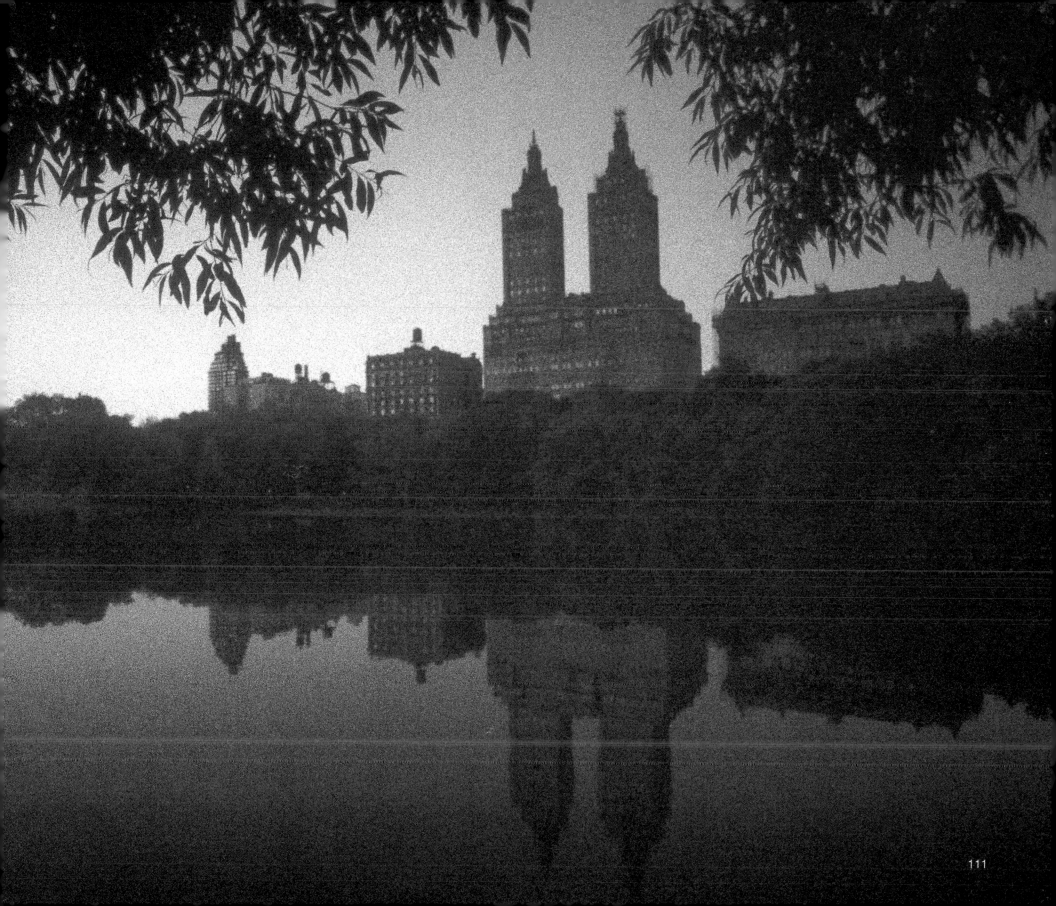

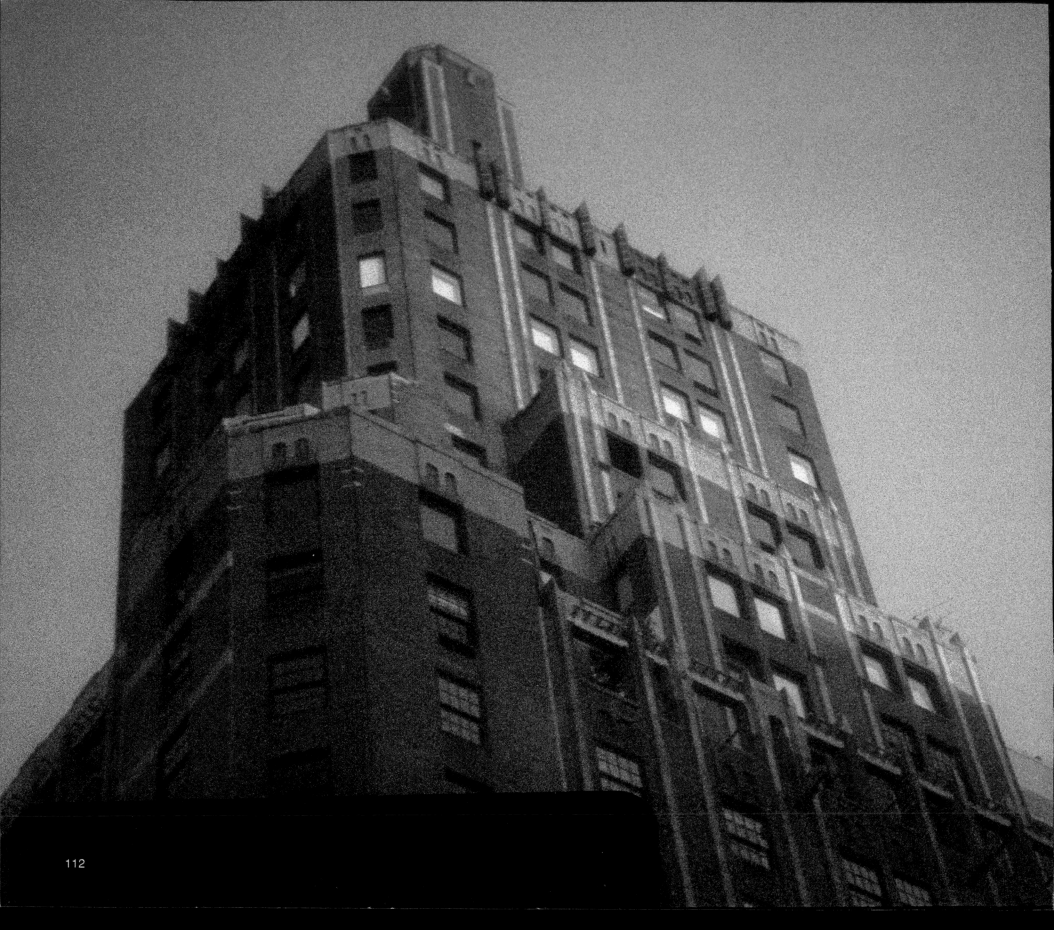

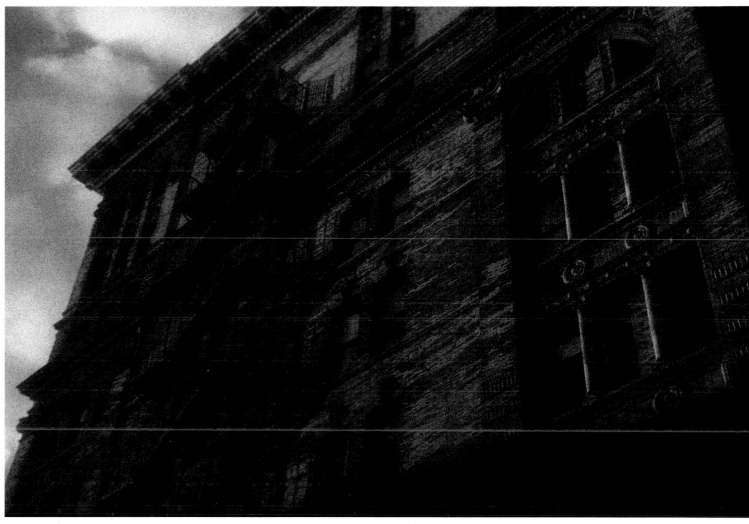

Even high-rise buildings and emergency exit stairways can look interesting using the right technique.

THEN...

BOLD, STRIKING PICTURES ARE IN. I OFTEN GO AGAINST THIS TREND WITH MONOCHROME IMAGES, MADE TO LOOK OLD.

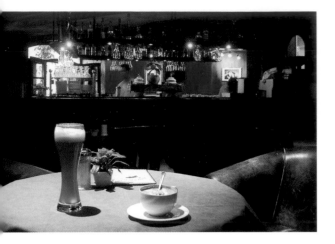

THE DIGITAL FUTURE

IS TRAVEL PHOTOGRAPHY THE LAST BASTION OF 'HONEST' PHOTOGRAPHY, OR WILL THE LATEST TECHNOLOGY CATCH UP WITH IT IN THE YEARS TO COME?

All the photos in this book were taken using the old-fashioned method, that is to say I used 24 x 36mm and 6 x 7cm slide film. I didn't use a PC or Mac, even for my experimental pictures, although it would often be easier to manage them using an image-editing program – but you can normally only find buyers for a Polaroid Transfer Technique photo if it's 'original'.

Subsequent image editing, which is increasingly making the darkroom redundant, hasn't quite taken over all aspects of photography. Animal and landscape photographers are still sceptical about the new medium, and picture agencies and competition organizers are constantly complaining about the poor quality of landscape and animal photos presented by some photographers.

The digital revolution marches on, however. Why take vast quantities of film with you, which have to be kept cool, when a CompactFlash or SmartMedia Card will do the job? Cameras have become no more than a vast quantity of pixels, and their quality has long been more than adequate for making prints in magazines. And the revolution is still only just starting... it won't be long before editors will start demanding 'fast photos' from travel photographers as well. Mardi Gras in New Orleans? – must be in the magazine the next day. Carnival in Venice? – by tonight if possible!

For many a magazine, technical quality now plays second fiddle, and topicality is the watchword. This also means that nowadays a lot of pictures can only be

A church – transformed in two minutes with a digital filter. Once you start, you will succumb to this type of manipulation over and over again.

taken with cameras that don't attract attention. What professional photographer can afford to wait weeks for permission?

Digital cameras are always lighter and therefore less conspicuous. You can get round obtaining permission, and you can nearly always take a picture without attracting any attention, whether you're photographing a Christmas market, an organized event, a market or an interior. Just try that with an SLR camera!

Even the travel photographer will eventually be steamrollered into going digital. Many travel photographers already use a digital camera as a second camera, along with a scanner. The picture can be copied almost immediately and goes round the world in minutes. The advantages and disadvantages are closely bound up with each other.

What's in our camera doesn't really matter be it film or a SmartMedia card – the important thing is the picture's power of fascination and the fact that the photographer is really trying to say something through his pictures. But I'll probably still be loading slide films into my Pentax or Nikon, until one day I hear those fateful words: 'Sorry, we don't stock films any more...'

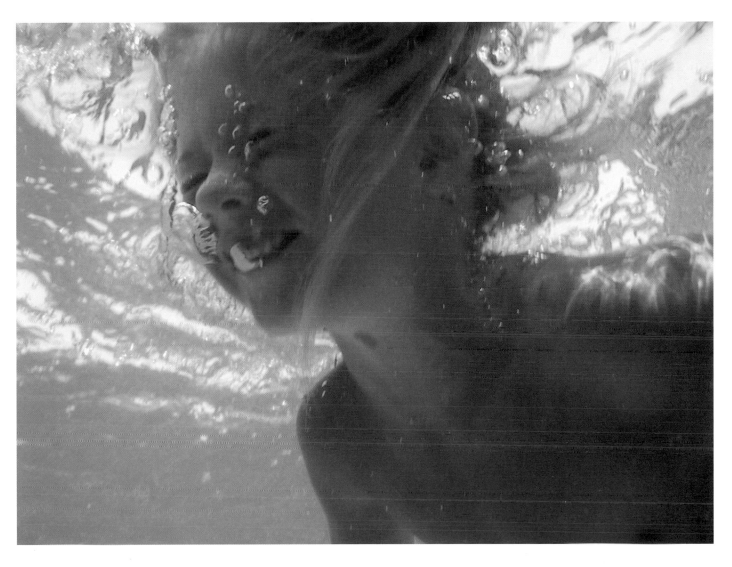

Honesty is rarely questioned. Effect comes before truth. If a travel photographer wants to keep up he has to bend certain rules. Lightweight cameras and lenses mean that the digital camera is ready for every opportunity. The photos at right were taken with a Pentax Optio (4 million megapixels), and above right with a Canon Digital Ixus with underwater case.

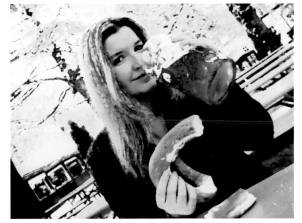

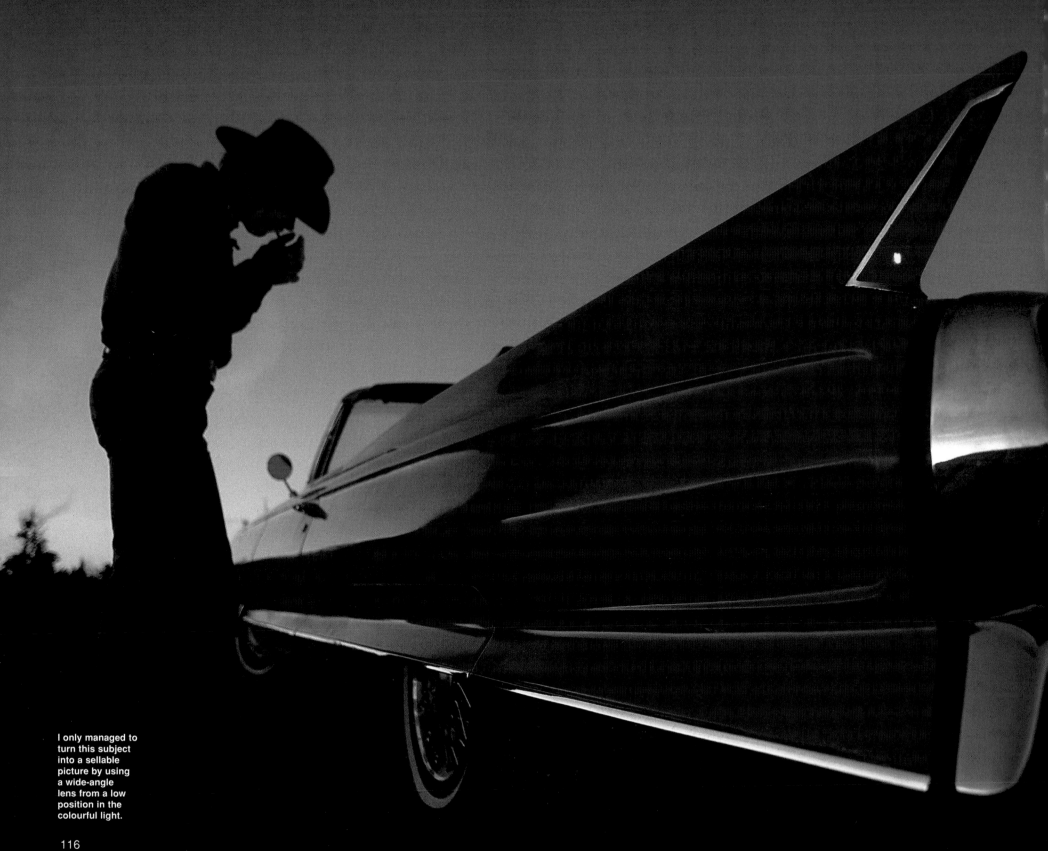

I only managed to
turn this subject
into a sellable
picture by using
a wide-angle
lens from a low
position in the
colourful light.

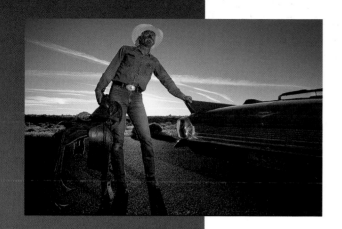

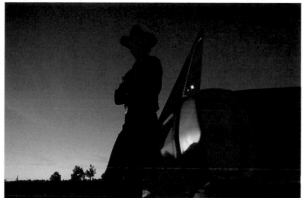

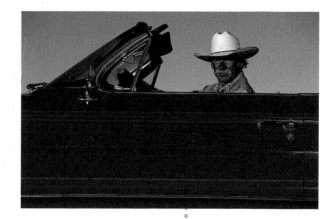

HOW DO I SELL AN IDEA?

A PUBLISHER CAN'T DO MUCH WITH PRETTY LANDSCAPE PHOTOS ALONE – YOU NEED AN IDEA.

Anyone who wants to sell his pictures must offer something special, and won't get far with pretty one-off pictures. Lovely shots of Tuscany may be attractive, but they are not enough for a book. The main thing is to get local colour, the bars, architecture and, of course, the people. A person can't just be photographed, he or she must fascinate the observer in some way, either by charisma, or by a particular light effect.

Finally, you must always obtain *written* permission for a picture to be printed. Photographers who go on to offer their pictures to an agency and can't produce permission from the subject of the pictures might as well forget it.

There's no point in going to a publisher with a little bundle of 13 x 18cm photos in a plastic bag. Obviously your pictures must be of the highest quality, but you must present them persuasively – 24 x 36mm to 6 x 9cm slides make a good impression. It's only worth bringing prints if these are top-quality prints produced by a specialist laboratory, or if a specific technique has been used, such as Polapan.

You see, just taking a load of snapshots simply isn't good enough to go with a magazine article. Travel photography is not really about holiday photos, and this is often misunderstood by amateurs.

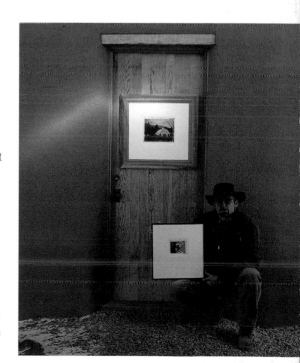

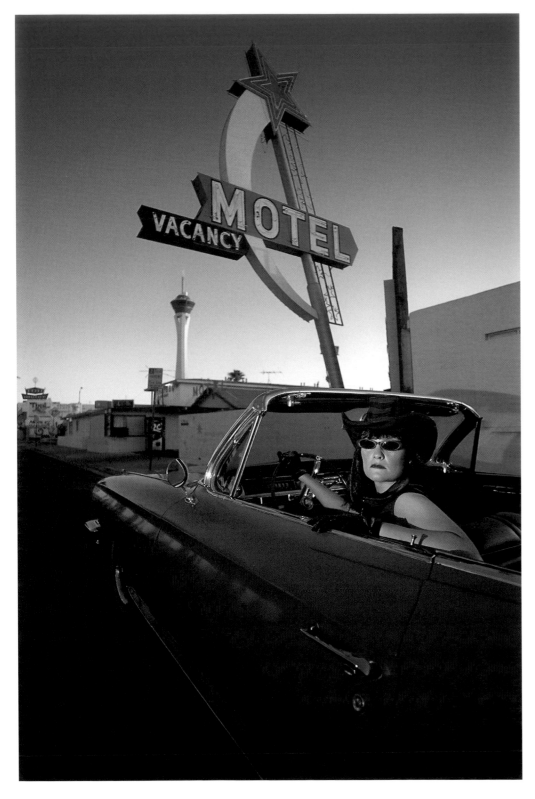
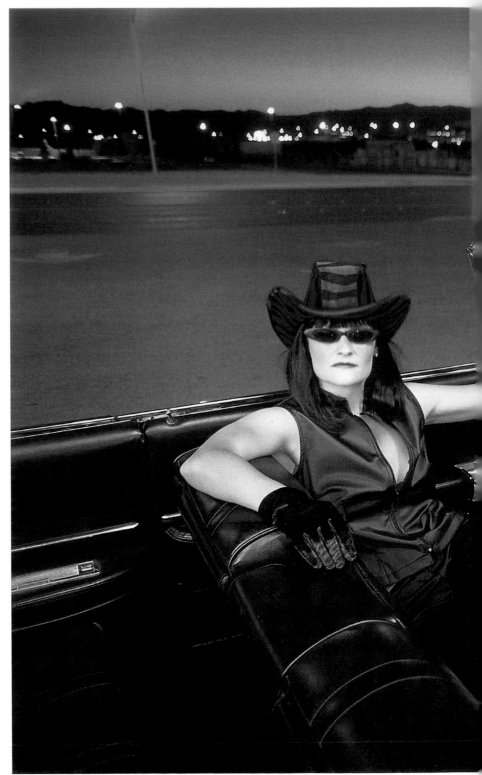

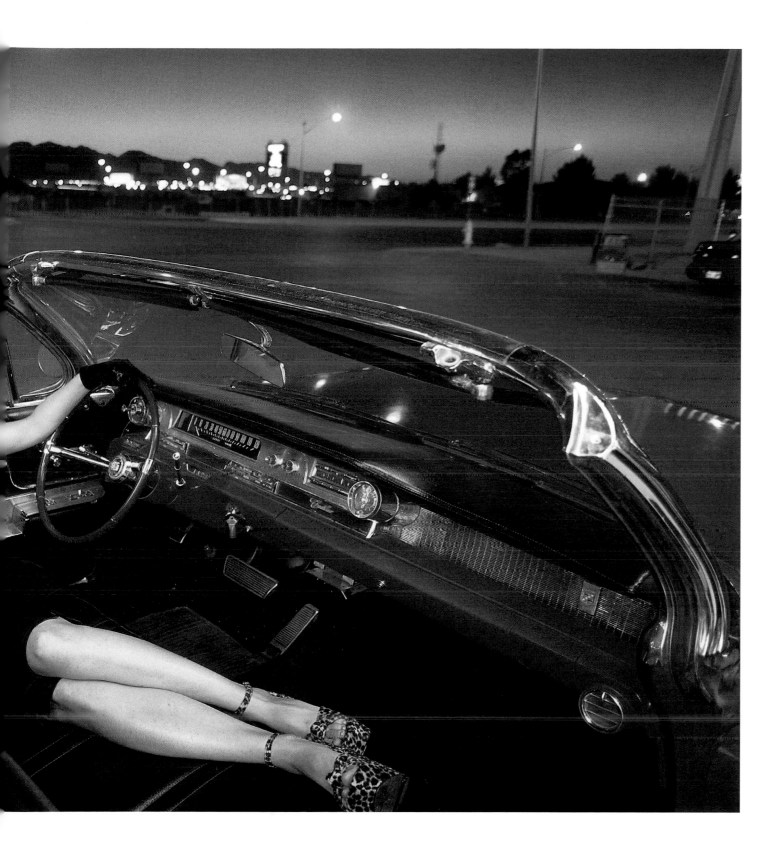

You don't get a very good picture without preparing everything in advance and fixing a time for the model and photographer. And even here I felt the mood was only worth capturing at twilight. I also used a flash and various colour effects.

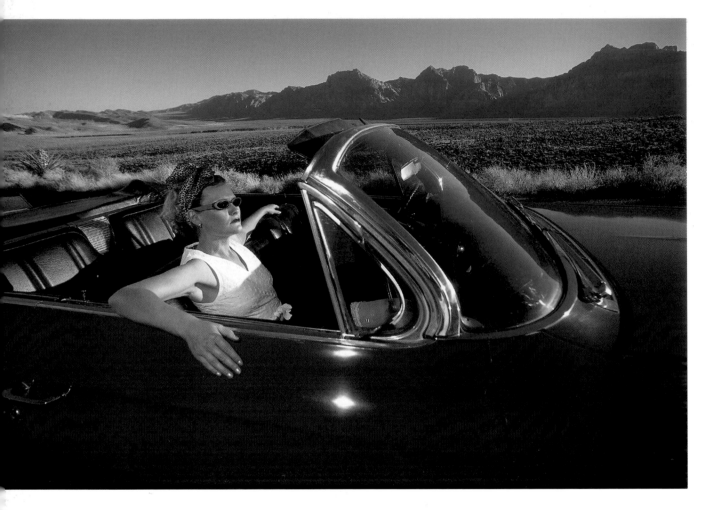

PEOPLE

MANY LOCATIONS ONLY BECOME

INTERESTING WITH FIGURES IN

THE FOREGROUND.

You can't just record a mood by photographing the landscape. A collection of pictures with no people would soon get boring. The photographer should include local people in the relevant locations. This makes a series more attractive to buyers.

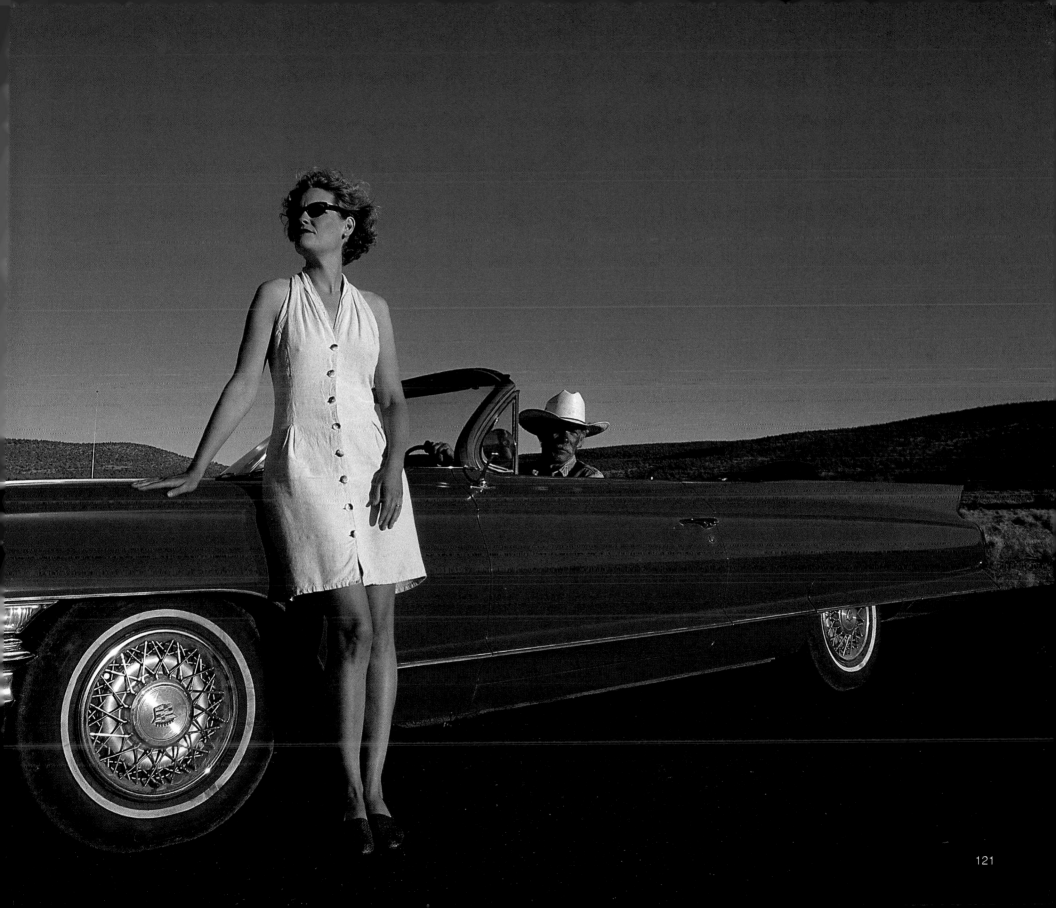

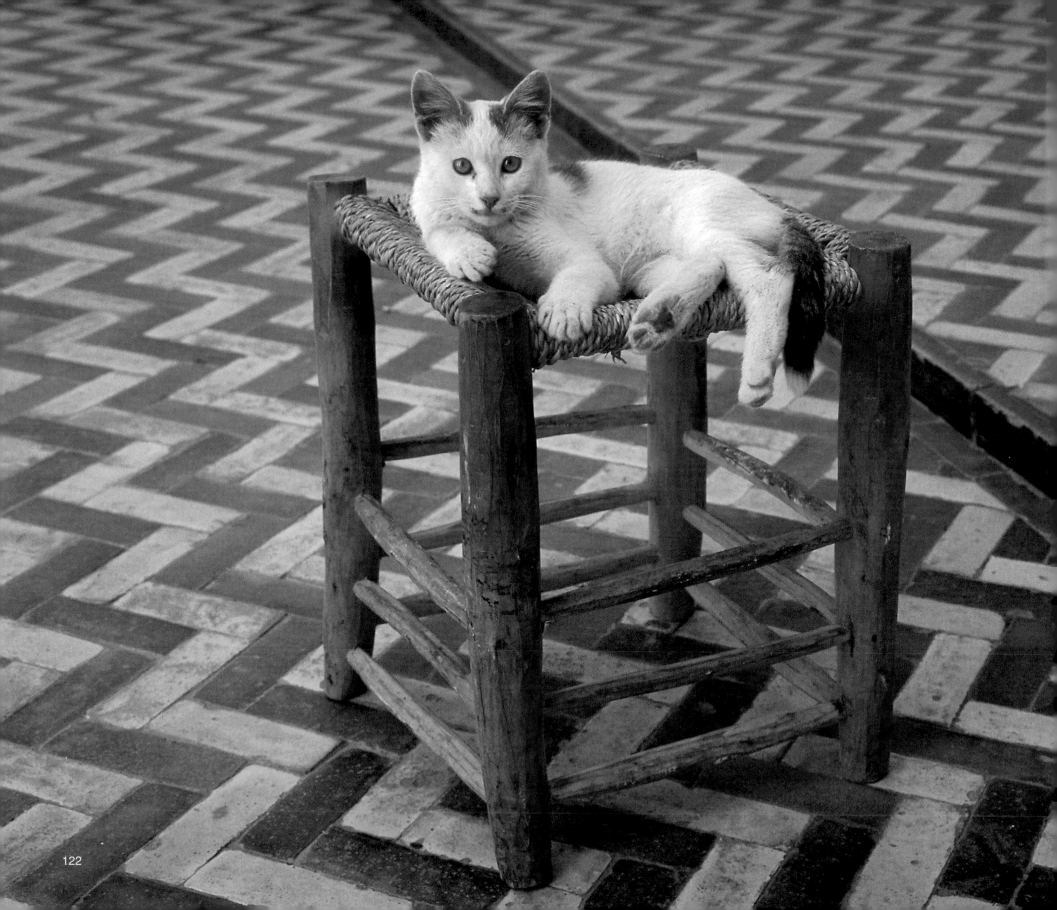

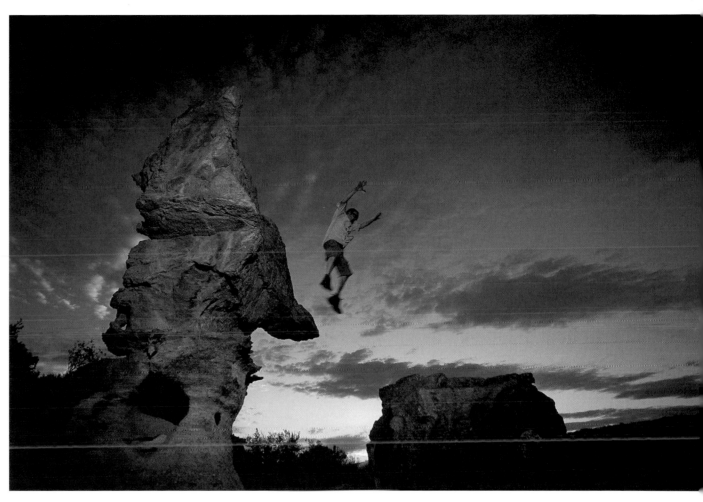

EMOTIONS

No travel book should be without animals, children and sunsets. These are still the favourite subjects of many a photographer and the magazine-buying audience.

A PHOTOGRAPHER HAS TO ACT ON PEOPLE'S FEELINGS WITH HIS OR HER PICTURES. THIS IS THE ONLY WAY TO SUCCESS.

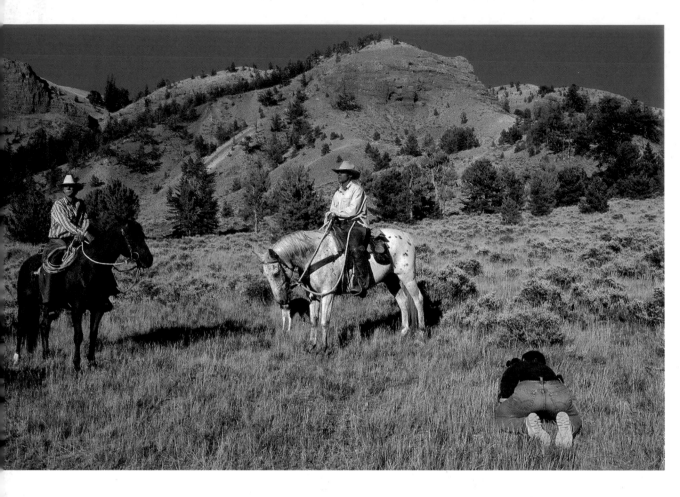

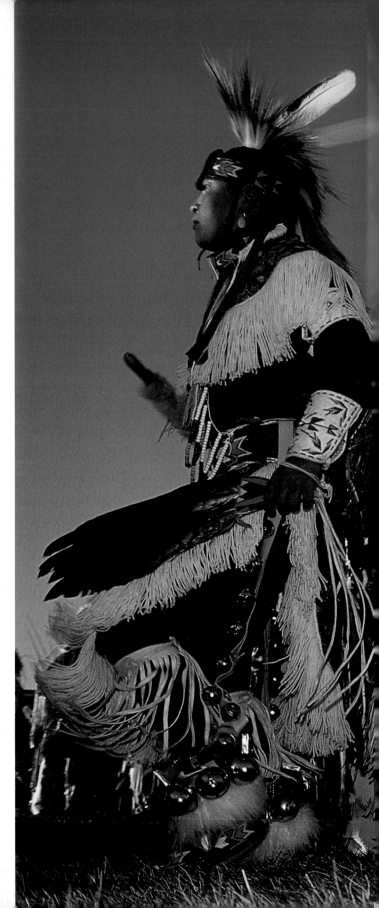

Above: **You only get exceptional pictures from an exceptional vantage point – and you shouldn't stint on good-quality film equipment.**
Right: **A simple spot of light can often improve a picture tremendously. But the most important motto is always to get as near as possible, right next to the subject.**

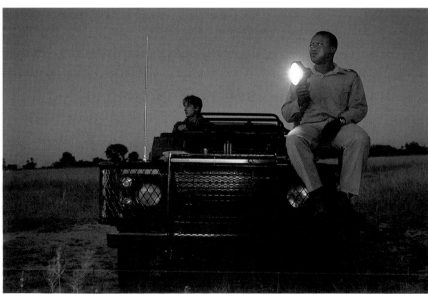

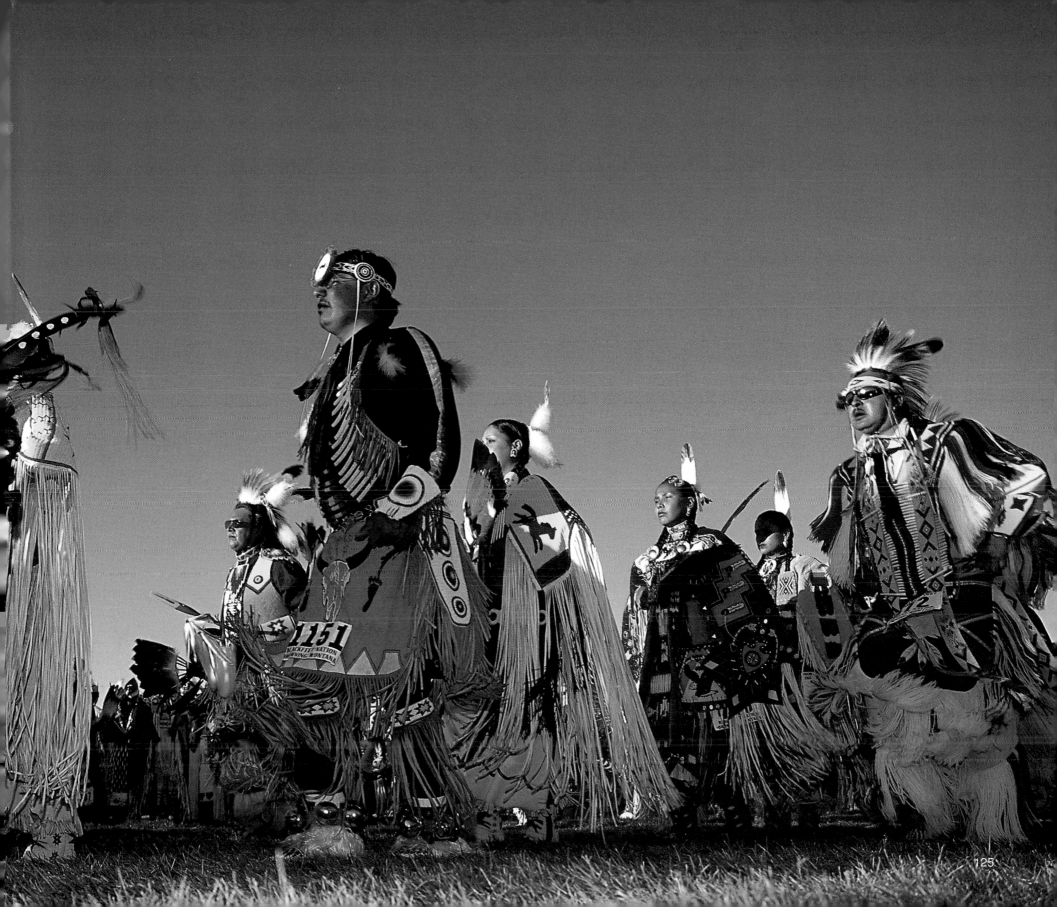

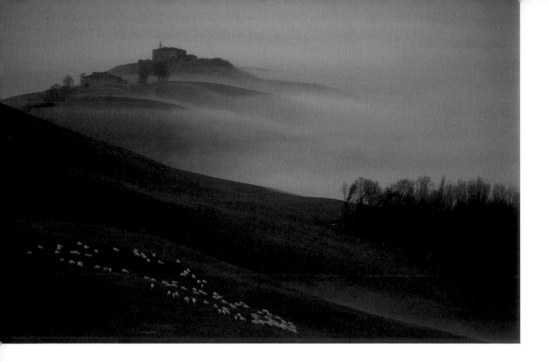

PHOTOGRAPHY AS AN OBSESSION

WWW.DETLEVMOTZ.DE

Detlev Motz, born 1946 in Isny/Allgäu, Germany

The 35mm obsession has ruled my life, first as a reel of film in the cinema, then as a slide film in an SLR camera. At the age of 14 I was a permanent fixture at films which are now shown for pensioners, but which at the time were seen as outrageous and X-certificate. Some of the films starred Brigitte Bardot, to be sure, but there were also Edgar Wallace and Westerns. I had my career all worked out – I wanted to be a cameraman! As so often happens, things turned out differently. I studied publishing in Stuttgart and made films in my spare time using a Nizo 8mm camera, which I painstakingly saved up for in instalments from my trainee's wages.

The move to Das Beste publishing house involved changing from a home movie maker to an amateur photographer. 15 years later I ended up, by chance, at *Color Foto* in Munich, and I started working as editor for *Foto Creativ* magazine. For 22 years I have been running the biggest monthly readers' photographic competition in the world.

My work in photo editorials has given me the chance to meet photographers from all over the world and compare the work of professionals and amateurs. I have visited clubs and associations. Some of my best tips were presented in my book *Creative Images*, which was awarded the Kodak Photo Book Prize. In 2002 I appeared as presenter and photographer in the eight-part series 'An ABC of Photography'. My life has now turned full circle. The obsession with 35mm still keeps me going. The fact that there is normally a video tape in the film camera and a smart card in the camera makes no difference – what is important is being involved with film and photography.

Christian Heeb, born 1962 in St Gallen, Switzerland

My career as a photographer started with my mother's Kodak box camera in the forests of St Gallen. While I was training as a structural engineering draughtsman I used my father's Nikon F to get my first serious experience of photography. Even back then, my favourite photographic model was Regula, who is now my wife.

During my training I published shots of a trip to Greece in the Swiss photographic magazine, *Foto-Mein Hobby*. A set of portraits I conceived as the 'Peter Series' and various nude studies appeared as a portfolio in *Photografie* magazine. As winner of the 'Top Prize for Photo Reportage' in a Swiss newspaper, I was awarded some Nikon equipment. From then on this prize a Nikon F3 with three lenses – formed the basis for my photographic career.

Led by my passionate interest in Native Americans and my love for America, I spent 18 months travelling all over North America in 1986 with my girlfriend Regula. The pictures I took of Native Americans and North America during that trip helped me get a foothold in the hard-fought territory of travel photography. Really, I still approach professional photography as a hobby. I have the freedom to choose projects and collections of pictures which are produced without the pressure of commissioned work. In between I write for *Amerika Journal Abenteuer Reisen*, as well as various photographic magazines.

Together with Regula I designed the building of Rancho Las Hierbas at Bend, Oregon, where I now live. The unconventional straw bale house recently appeared as the main feature in the renowned *Oregon Home Magazine*.

My wide range of interests includes mountain biking, kayaking, trekking and skiing in the wilderness areas of the American West. And what with painting, extensive reading and a keen interest in the politics of US environmental associations, there's no room for a television in our household – we simply don't have the time for it. While my wife tends her herb garden (Rancho Las Hierbas means 'Herb Ranch') I work on our 160,000m^2 property: the thick, inflammable undergrowth has to be thinned out and we need wood for the winter as well.

In spite of this I have found the time to publish 70 collections of pictures and 12 calendars a year. Regula and I have founded the Cascades Center of Photography in Oregon. You can find out about everything from books and calendars to seminar programmes on my website, where you can also order books and calendars. I would be delighted to receive a message from you – write to me at: christian@heebphoto.com.

FACT FILE

WWW.HEEBPHOTO.COM

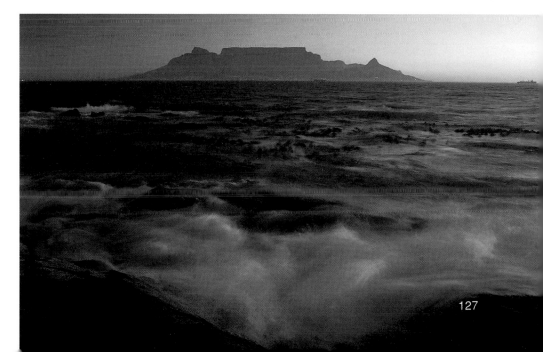

127